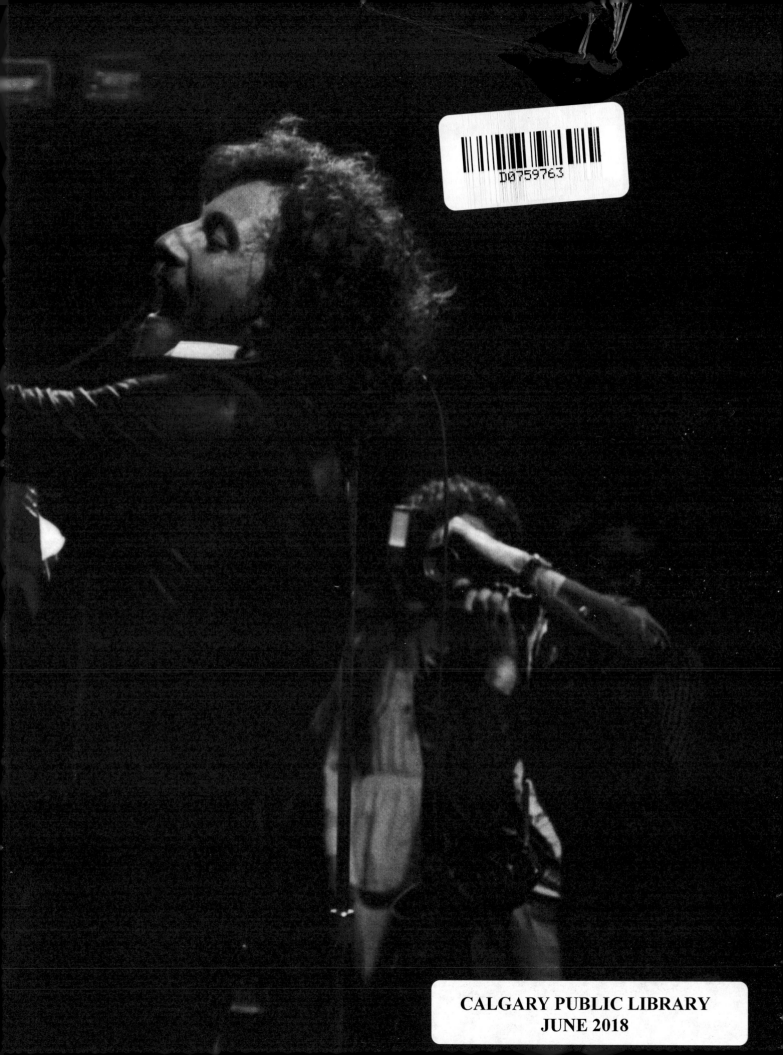

BRUCE SPRINGSTEEN

FROM ASBURY PARK, TO BORN TO RUN, TO BORN IN THE USA

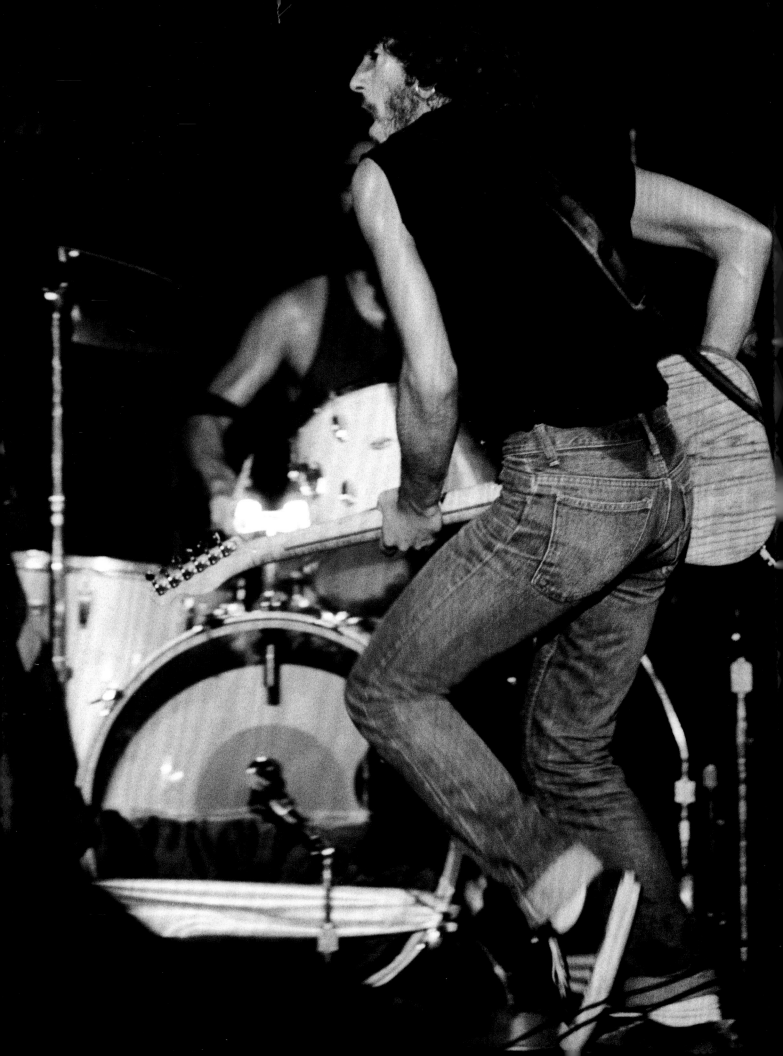

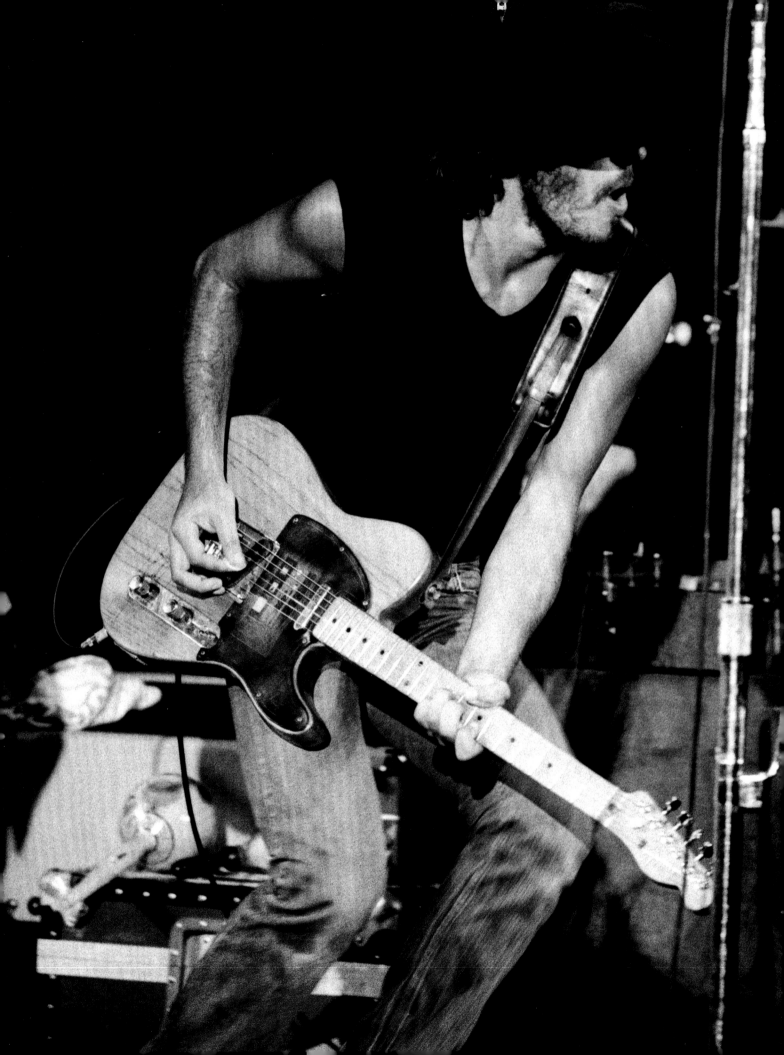

BRUCE SPRING

FROM ASBURY PARK, TO BORN TO RUN, TO BORN IN THE USA

PHOTOGRAPHS BY

DAVID GAHR

WITH
CHRIS MURRAY

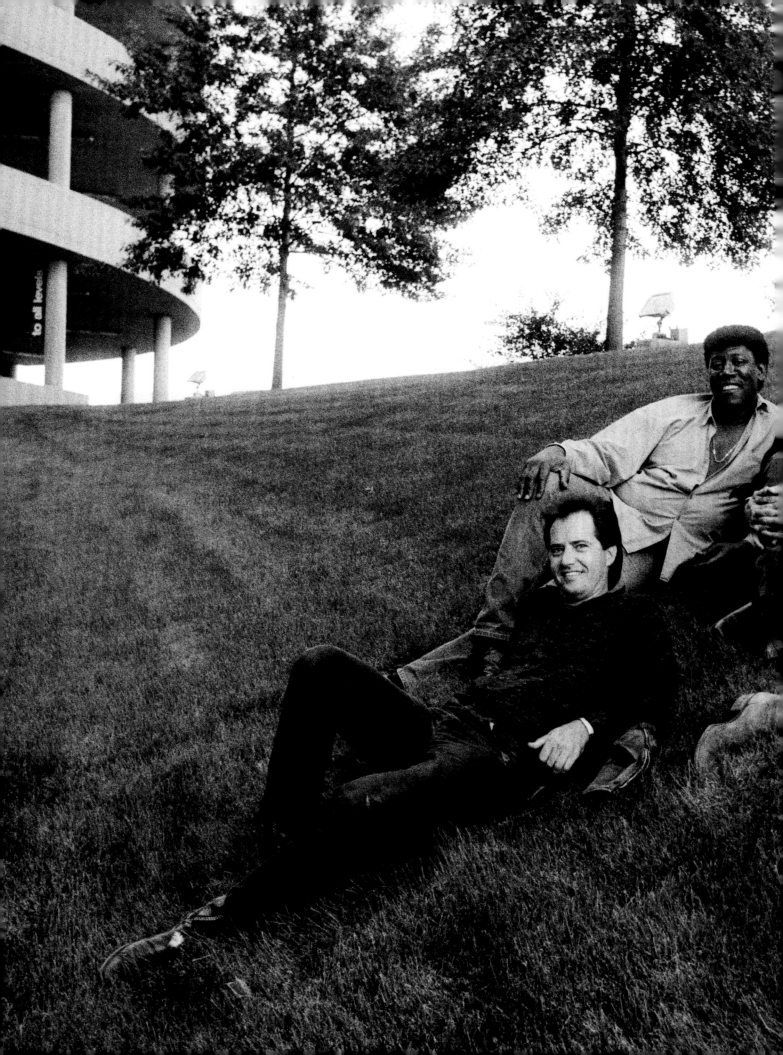

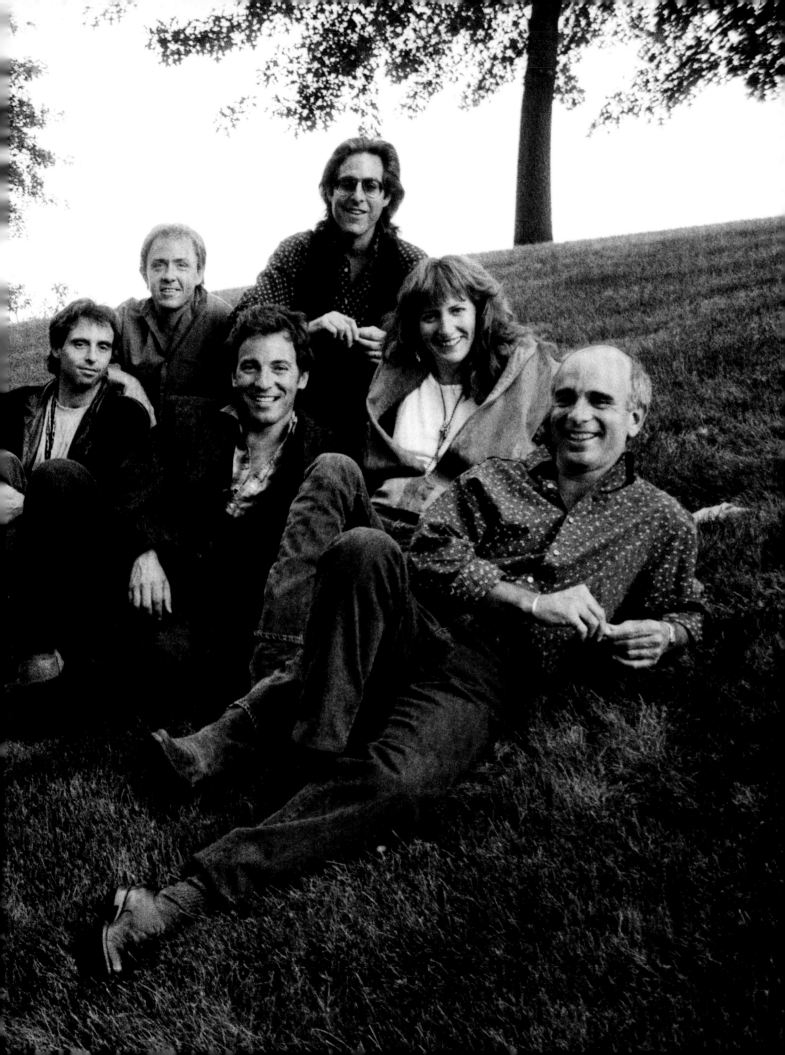

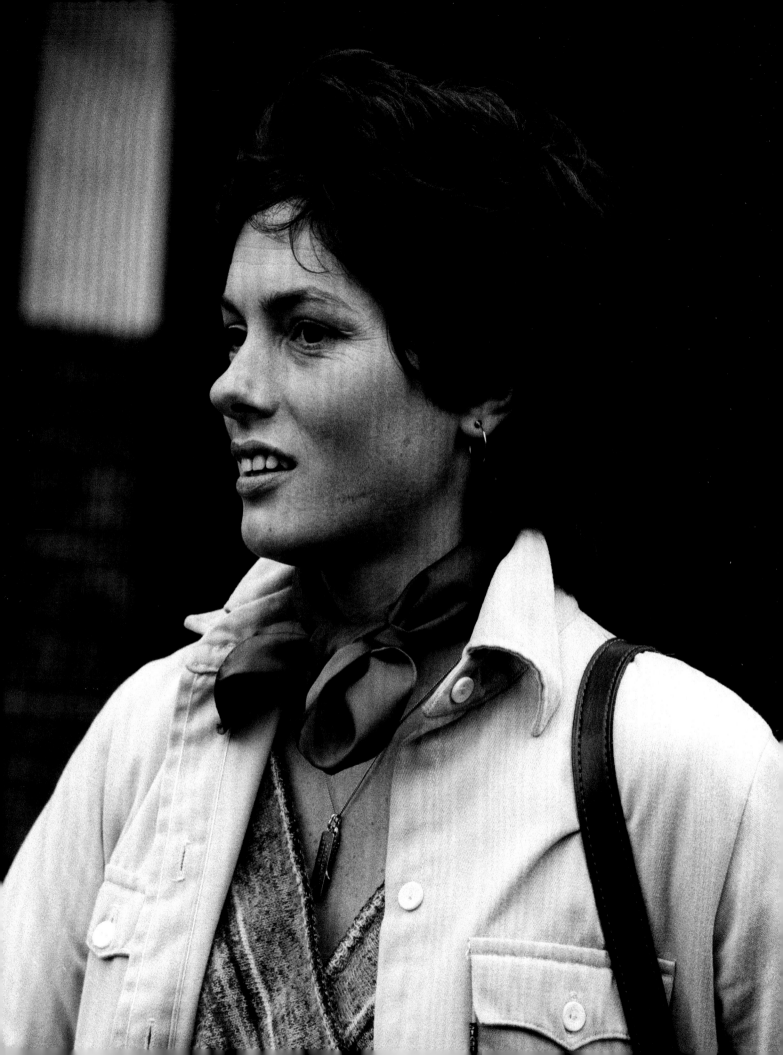

FOREWORD
MAUREEN ORTH

In September 1975, I had just returned to *Newsweek* magazine after five months in Rome working as an assistant to Italian director Lina Wertmuller, when my editors assigned me to do a cover story on this up-and-coming rock artist who was hardly the household name that usually got *Newsweek* cover treatment. I had never heard of Bruce Springsteen, but Columbia Records told the editors he was definitely the next Bob Dylan.

His appearance the previous July at New York's The Bottom Line had made a deep impression on the carefully selected audience of media and radio deejays who had heard him.

Bruce was then twenty-six, *Born to Run* was on its way up the charts, and I went to Red Bank, New Jersey, to meet the band and the reluctant interviewee—shy, scruffy, living in a cottage in the woods near the Jersey Shore where he grew up. He had a stack of vinyls on the floor. "Now this," Bruce announced to me dramatically, "is the sound of universes colliding." The room suddenly filled with the Ronettes singing "Baby, I love you." "C'mon," Bruce coaxed. "Do the Greaser two-step with me." He was nervous and using music to break the ice. "The first day I can remember lookin' in the mirror and standin' what I was seein' was the day I had a guitar in my hand." Later we went down to the famous boardwalk immortalized in one of my favorite Bruce songs, "Sandy," and I actually beat him in the shooting gallery and kept the plastic insect I won for years. Or maybe he let me beat him.

As part of my reporting, I was invited to a backyard barbeque in Red Bank, seen in this book. The vibe was very hometown: The E Street Band and Southside Johnny were there—so was Mike Appel, Bruce's then-manager, and Jon Landau, the influential *Rolling Stone* magazine record editor, who was soon to become Bruce's manager. Excitement was in the air—their longtime buddy Bruce was going to be BIG! I have this shadowy memory of a nice, unobtrusive photographer, an older man (everyone was older in those days) who pointed his camera at me and I laughed and said, "No, stop, I'm the reporter, not the subject." But David Gahr was shooting for *Newsweek* that day and one of his photos was included in that feature, and now I realize that it didn't hurt to shoot the reporter too.

I had been reporting the story about ten days when word came through that *Time* magazine, *Newsweek*'s archrival, would also be giving Bruce a cover! I was livid. I did my best to talk Bruce out of cooperating since we were first on the story but Columbia Records had other plans.

Five years later I met the man I would marry, Tim Russert, who became famous as the moderator of *Meet the Press* on NBC television. Tim was then working in Washington for Senator Daniel Patrick Moynihan, and was a huge Springsteen fan. We found that we both loved album number two: *The Wild, the Innocent & the E Street Shuffle*. Tim bragged to me that he in fact had booked Bruce in Cleveland for his old school, John Carroll University, in 1975, for $2500, and the money he got from that concert paid his way through his second year of law school. "Really?" I countered. "Well, I wrote the *Newsweek* cover story on Bruce." He didn't believe me and I had to show him the magazine.

Several months later, through Bruce's then-girlfriend, Joyce Heiser, whom I knew, I was able to introduce Tim to Bruce, and to breathlessly recount to Bruce the story of how Tim became a lawyer because of $2000 an old Buffalo guy won in a pinochle game and gave to him, and also because of the proceeds he got from that Springsteen concert. Tim could not have been happier. Bruce was incredulous. "You mean you became a lawyer because of me? That sounds like one of my songs."

One of the few perks of fame that Tim actually enjoyed and exploited was the ability to be front and center at any Bruce concert that he possibly could. He bonded with Bruce's drummer, Max Weinstein, a fellow political junkie. When Tim died suddenly in 2008, of a heart attack at age fifty-eight, Bruce was on tour in Europe, but he sent a video for the memorial service that was broadcast on NBC.

A few years later my son Luke and I were able to see Bruce, Patty Scalia, Southside Johnny, and the E Street Band up close at a special concert at The Stone Pony in Ashbury Park where Bruce had first begun. I proudly wore my old t-shirt that had the *Newsweek* cover on one side and the *Time* cover on the other.

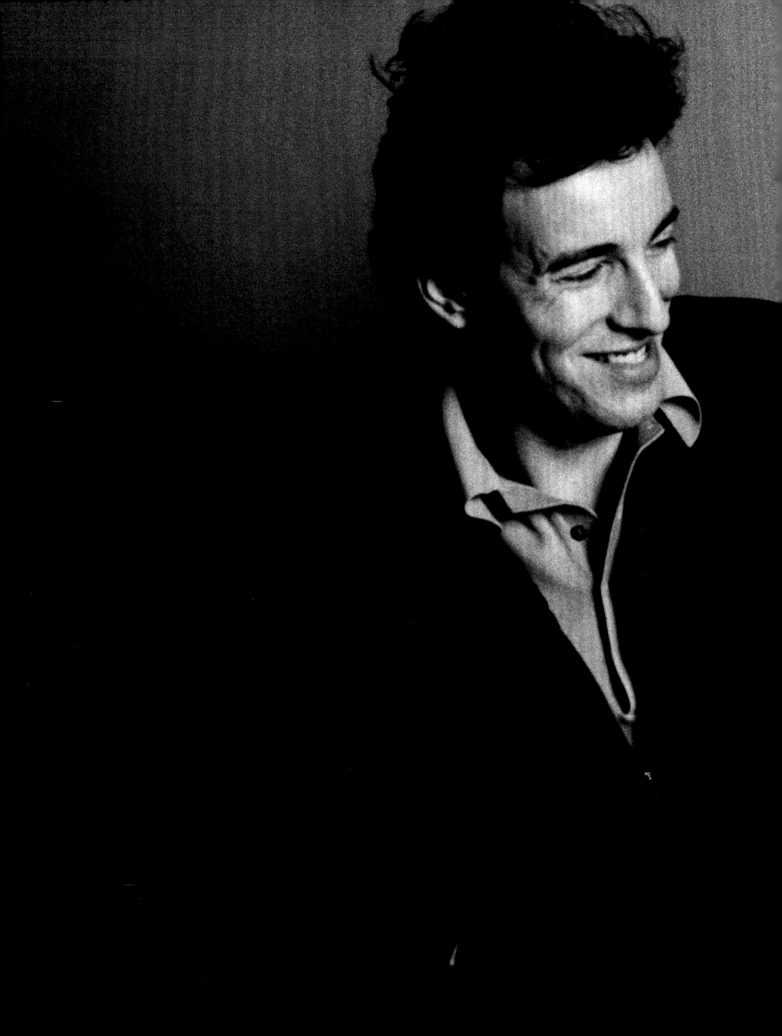

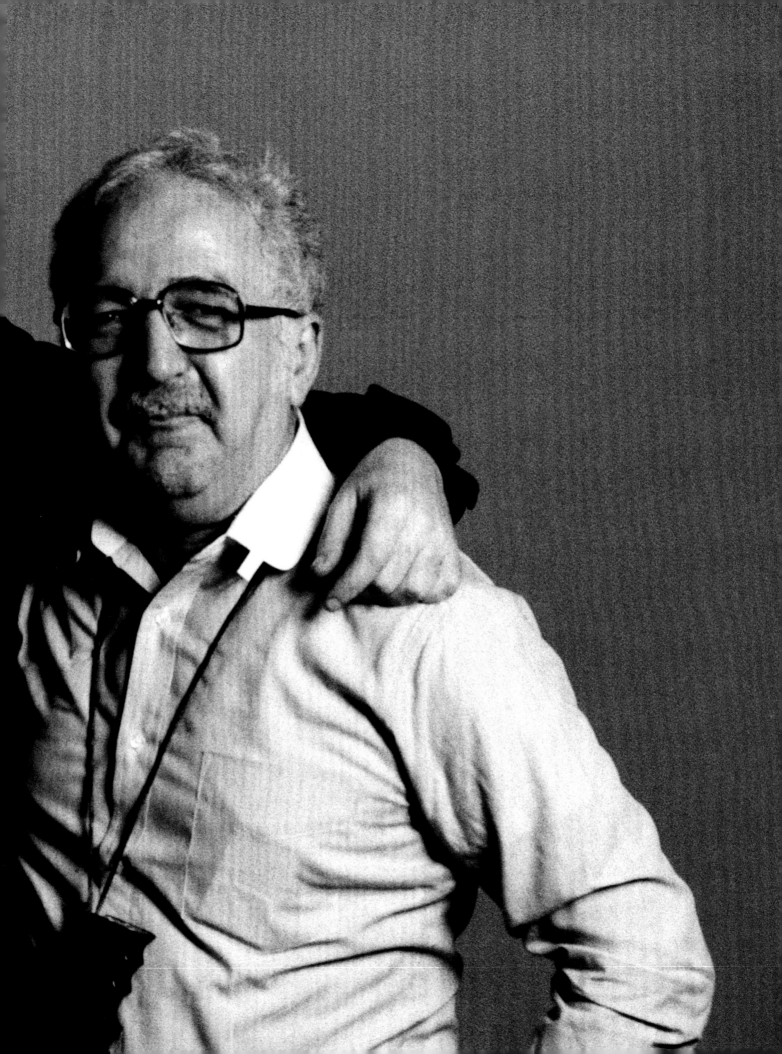

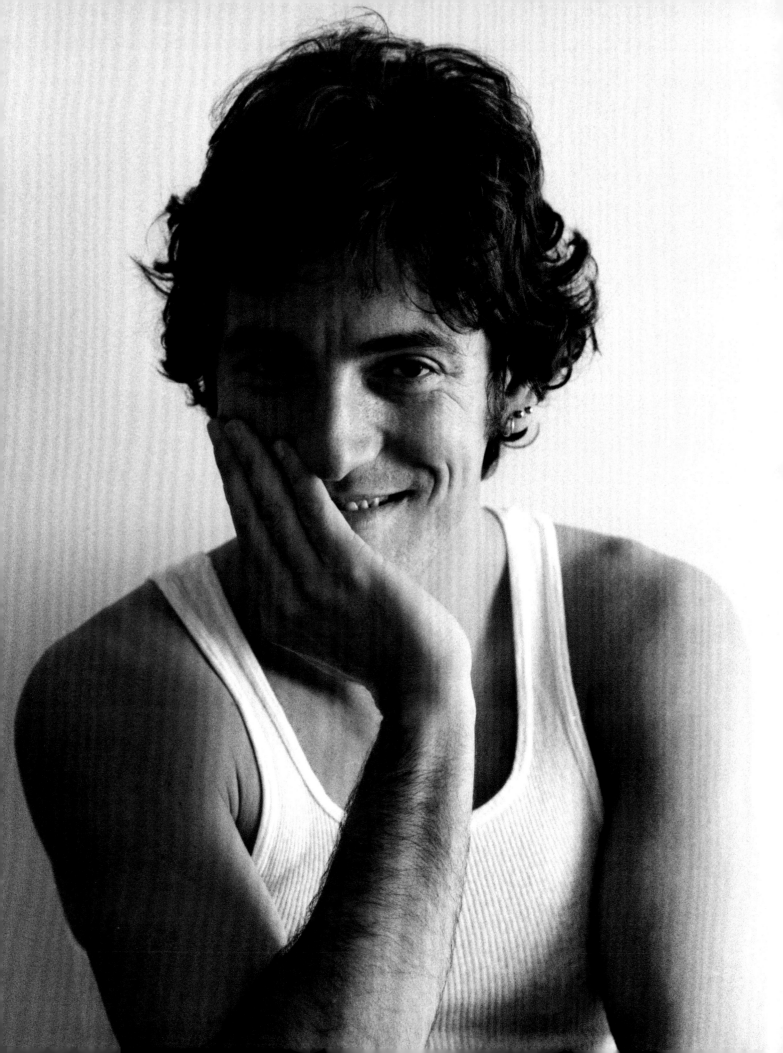

ALL IN A DAY'S WORK

CHRIS MURRAY

"I figure all any kid needs is hope and a feeling he or she belongs. If I could do or say anything that would give some kid that feeling, I would believe I had contributed something to the world." Elvis Presley

At the core of things with Bruce Springsteen is his passionate and undying love of rock 'n' roll. His heart was seized by the magic of Elvis Presley in the Fifties and then again with the arrival of The Beatles in the Sixties. Springsteen pays tribute to Elvis and The Beatles, along with Bob Dylan, Little Richard, The Rolling Stones, Otis Redding, Donovan, The Ronettes and many others, with his own musical artistry.

Springsteen's songs and performances are now embedded in that same lineage and tradition. Springsteen brought together The E Street Band with a deliberate vision, wanting a band that could do it all. Blessed with tremendous energy, Springsteen dedicated himself to the pursuit and the manifestation of an authentic rock 'n' roll—to be a soul man. Springsteen has said of his musical quest, "I wanted my music to be a music of transcendence."

The beauty of Bruce is that he is inspired by the great American musical forms of folk, blues, country, soul, and rock 'n' roll. Like Elvis and Dylan, whose artistry he admires so much, Springsteen synthesized these genres in his own style in his music, and of his own time. His artistry is not a casual thing. Meanwhile, photographer David Gahr was on his own epic journey, a truly awesome visual endeavour, over a period of five decades during which he photographed a veritable Hall of Fame of so many of our greatest musical artists. Gahr's photographs are remarkable for many reasons, but most importantly, like Bruce Springsteen, they capture the timeless essence of his subjects: their soulfulness.

Gahr's talent, energy, and focus with his camera and subject is abundantly evident in his body of work documenting Bruce Springsteen.

Beginning in 1973 when Springsteen was twenty-four years old, and continuing through 1986, Gahr photographed Springsteen and The E Street Band in more than twenty-five photographic sessions and settings, spanning a period of over a dozen years and several thousand black and white negatives and color photographs. Gahr's archive of Springsteen photographs includes live performances, recording sessions and portraits, along with candid and behind-the-scenes images. This in-depth output of David Gahr's photos of the rocker from New Jersey documents the arc of one of America's most admired performers, from artist to icon.

This is the first book of David Gahr's photographs in fifty years since his publication of *The Face of Folk Music* in 1968. Long out of print, that publication is considered by many to be the finest book on folk music, featuring text by Robert Shelton accompanied by David Gahr's photographs of Bob Dylan, Mississippi John Hurt, Judy Collins, Pete Seeger, Ramblin' Jack Elliot, Joan Baez, Odetta, and many more. Gahr went on to photograph John Lennon, Muddy Waters, Johnny Cash, Dolly Parton, Leonard Cohen, Buddy Guy, James Taylor, Thelonious Monk, Van Morrison, Dizzy Gillespie, Joni Mitchell,

Jackson Browne, and David Johansen, to name just a few. The United States Postal Service in 2014 printed sixty million stamps featuring Gahr's image of Janis Joplin and in 2012 sold twenty-three million stamps with Gahr's photo of Miles Davis on them. Though David Gahr may not have been a household name before his death in 2008, his work is widely known.

David Gahr's first photos of Springsteen, in 1973, along New Jersey Shore towns, include pictures of Bruce and The E Street Band lined up in a row for Gahr's camera, as any rock band might have done at that time. When Gahr photographed Bruce and The E Street Band during his final session with them more than twelve years later in 1986, on a lawn outside Giants Stadium in New Jersey, we see his subjects now gathered close together, a sense of intimacy reflecting the familiarity of making music together for over a decade, depicting what is now a legendary team of musical artists. David Gahr's photographs tell us the story of the origins and development of these musicians together, and of the phenomenon of Bruce Springsteen.

Co. Cavan
Ireland

BRUCE SPRINGSTEEN

1986

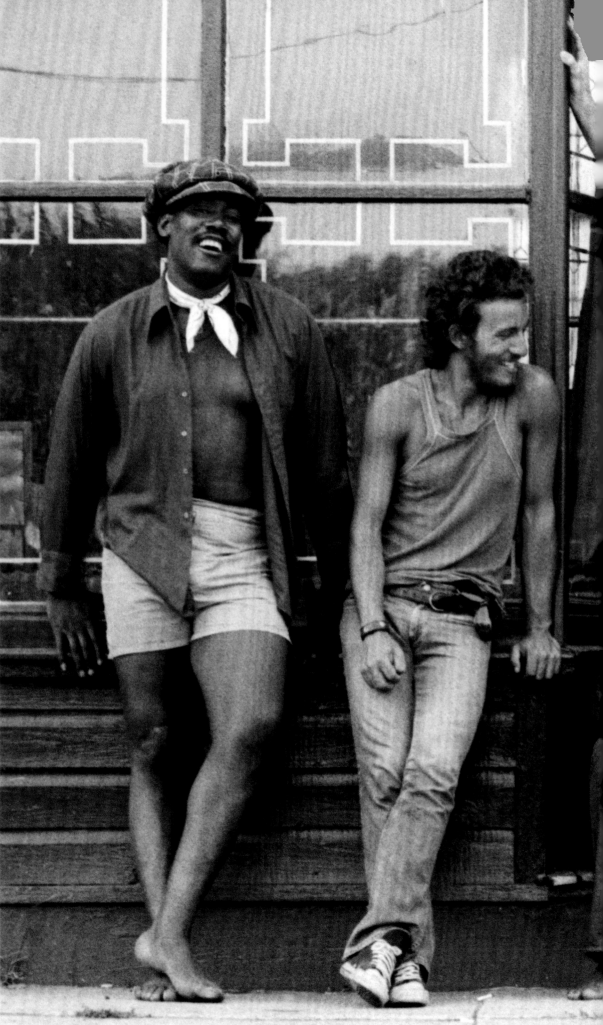

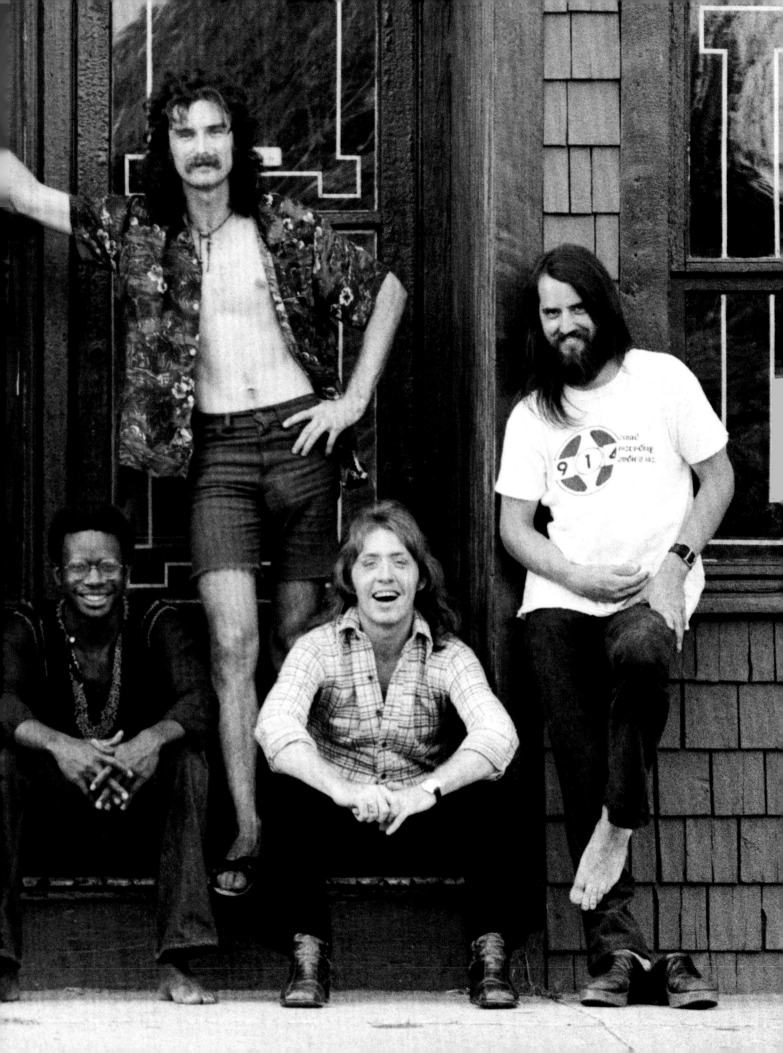

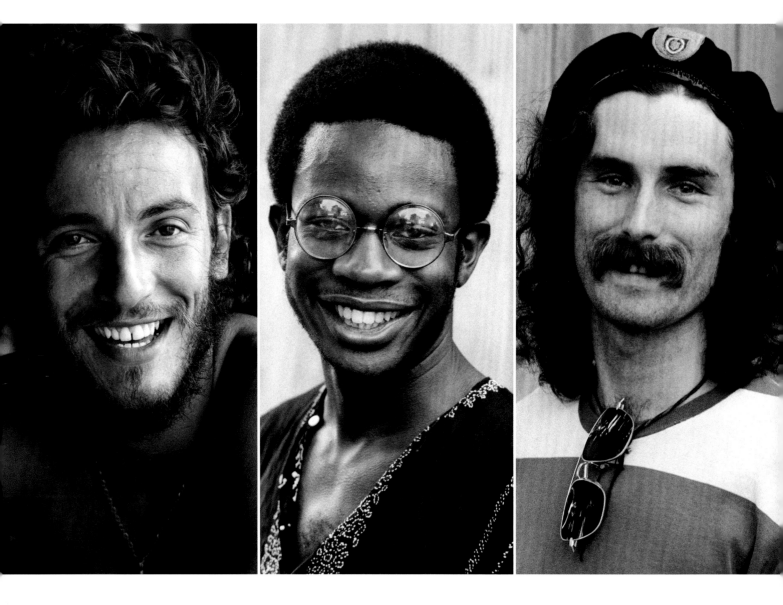

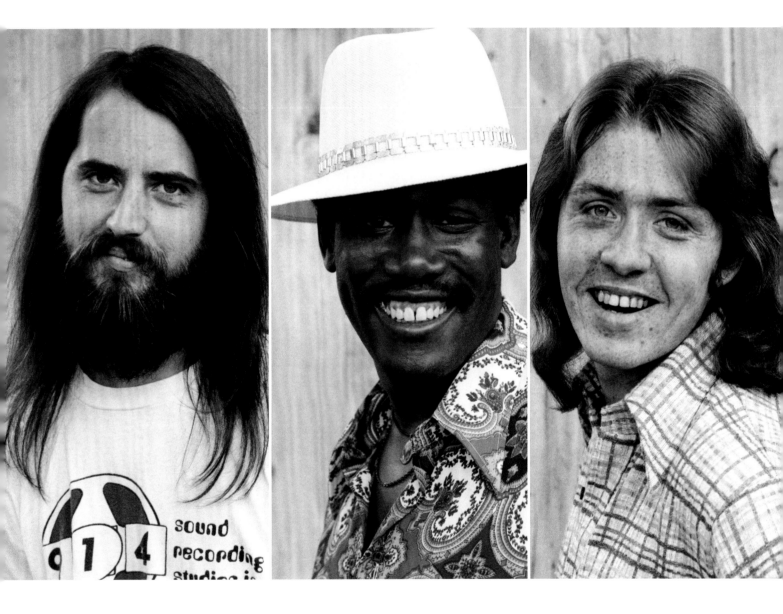

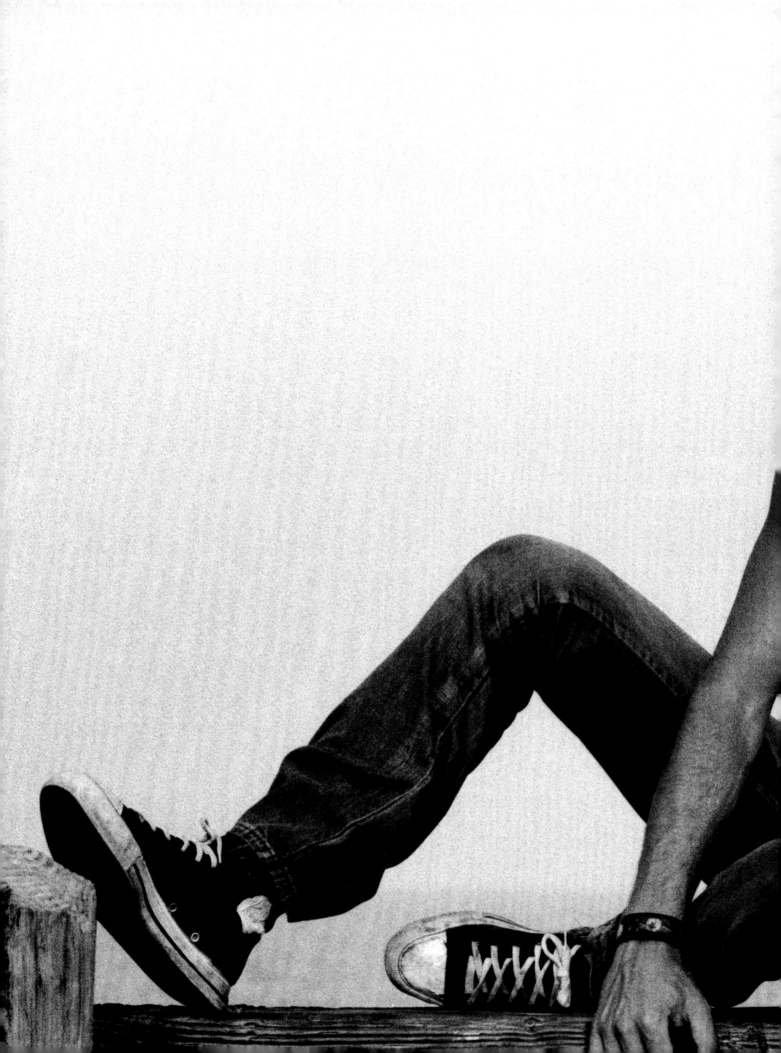

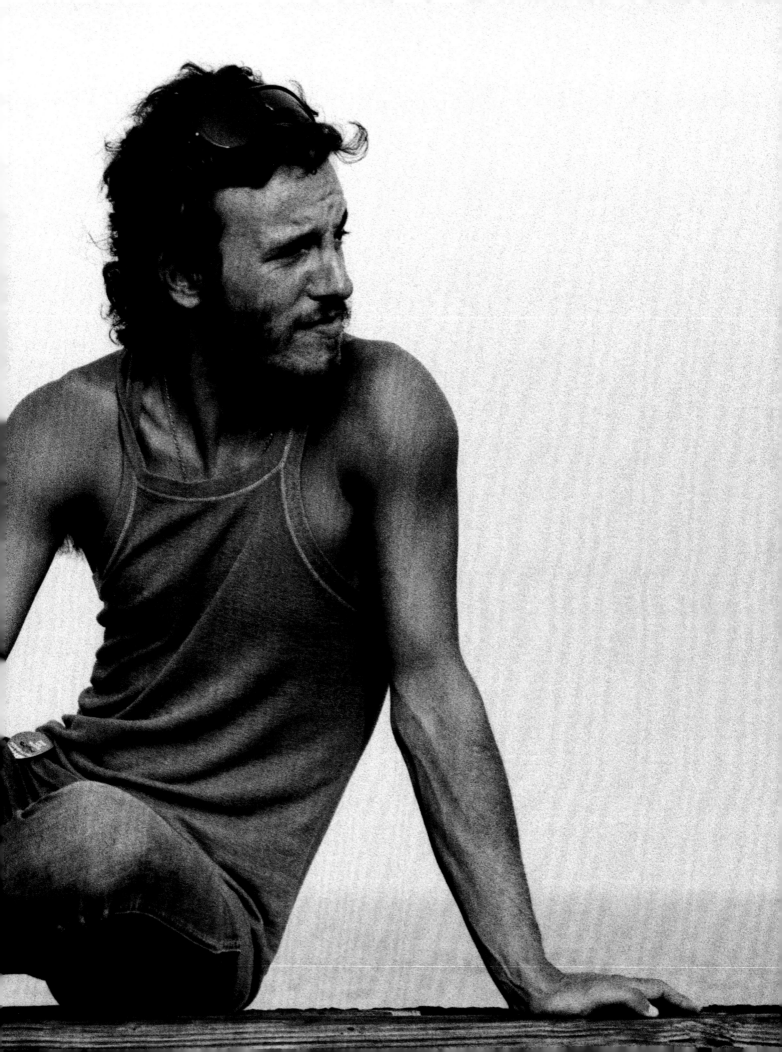

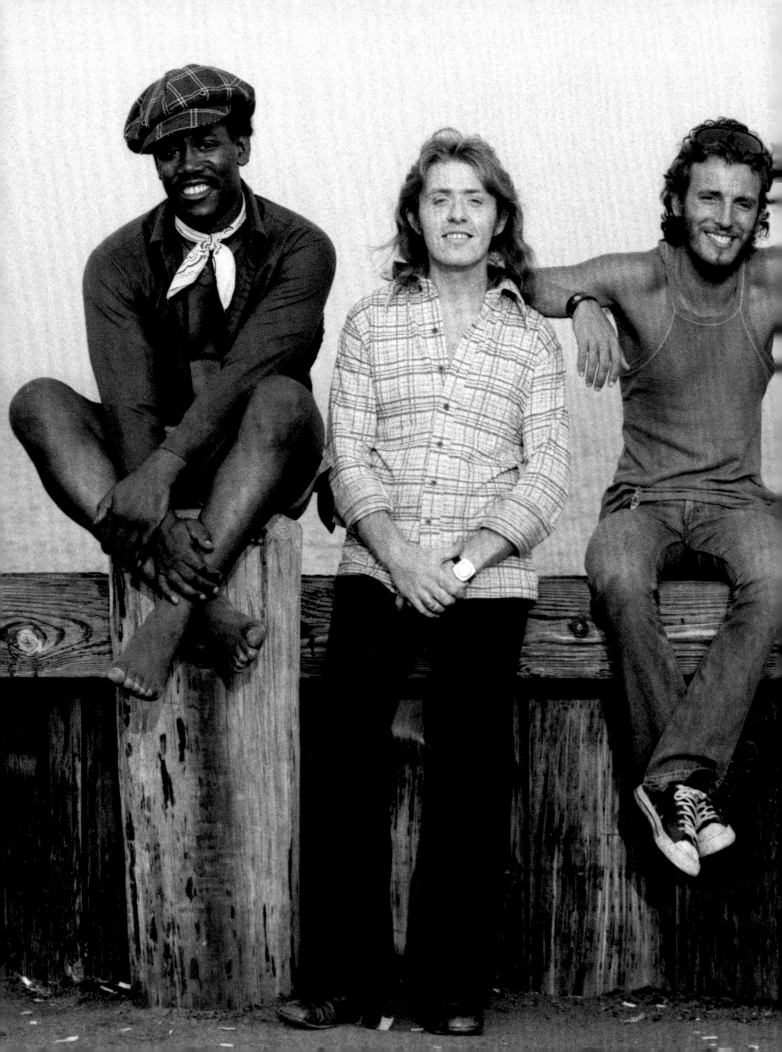

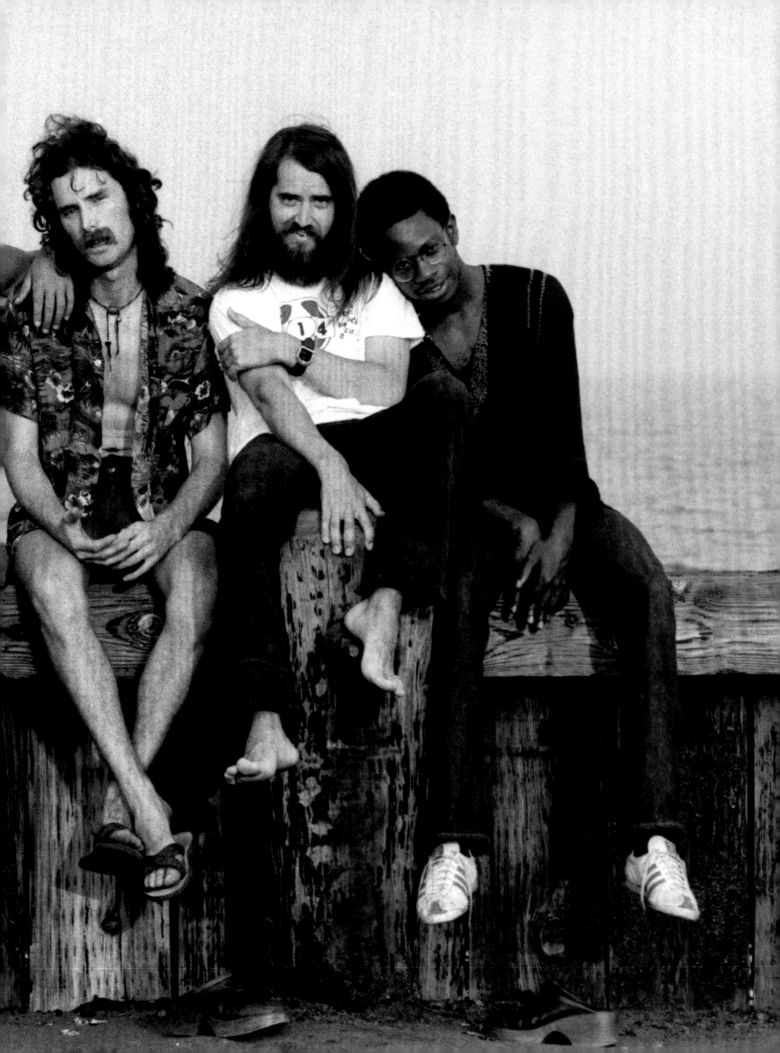

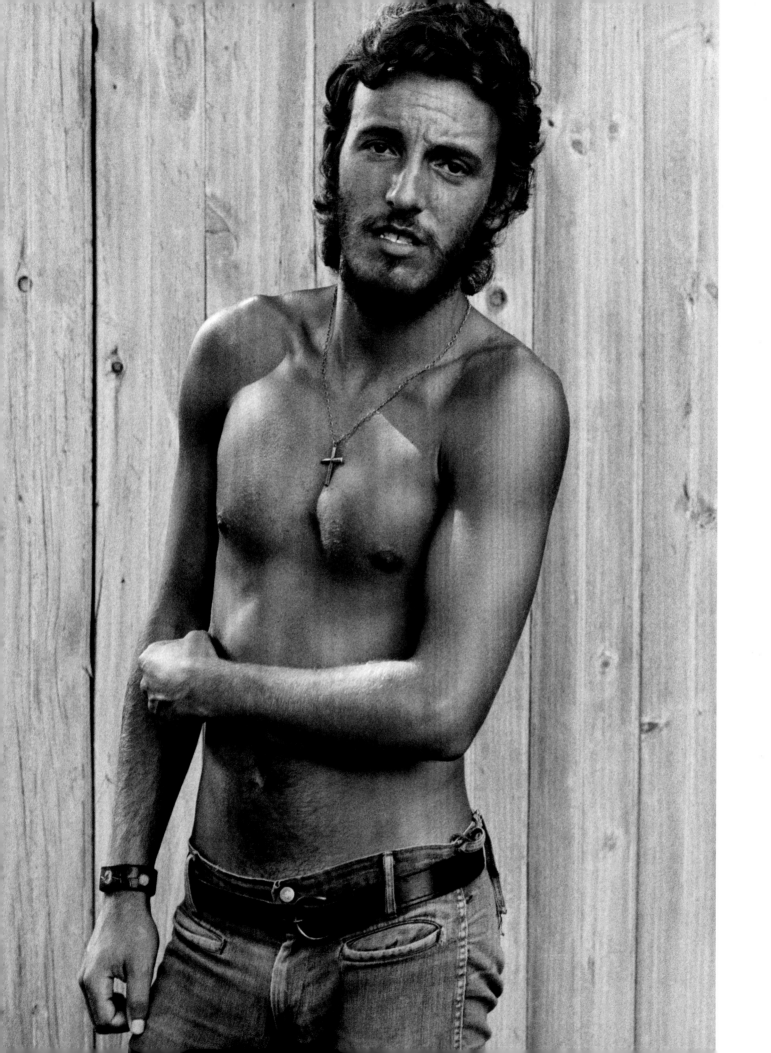

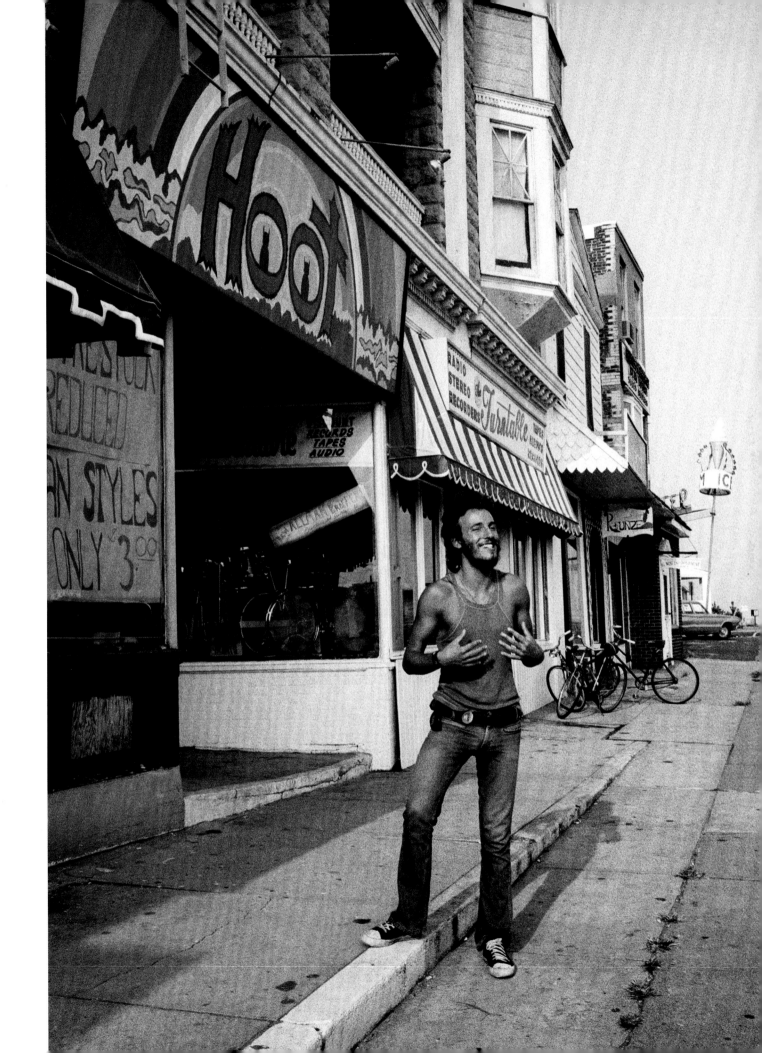

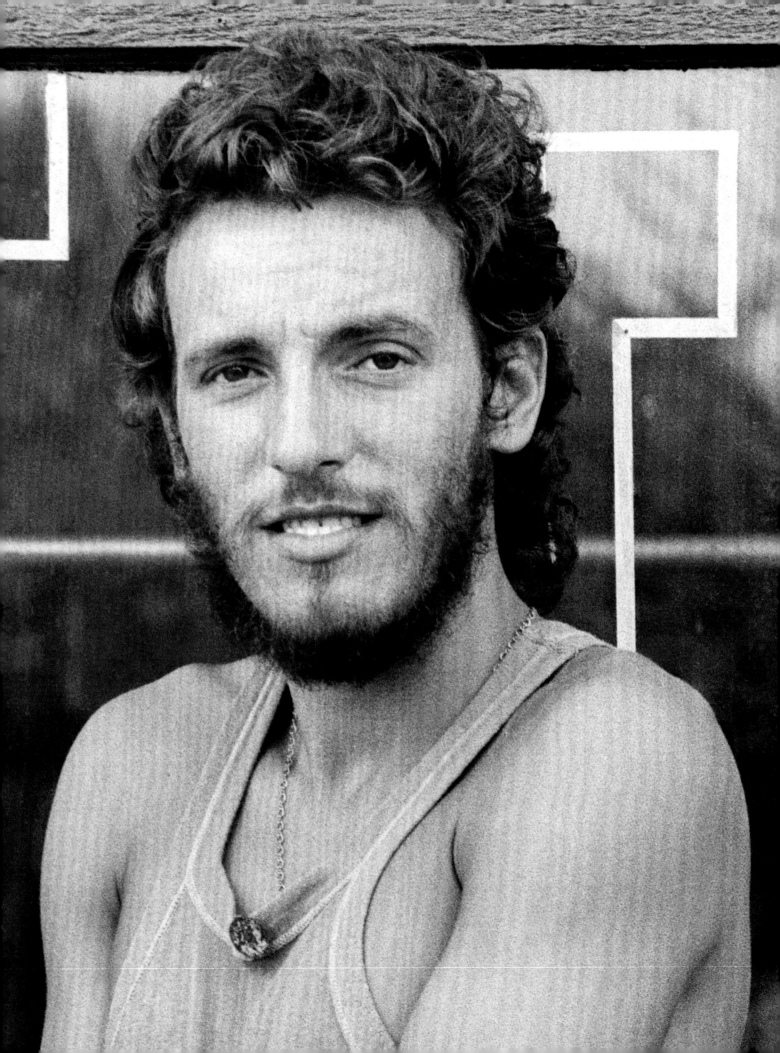

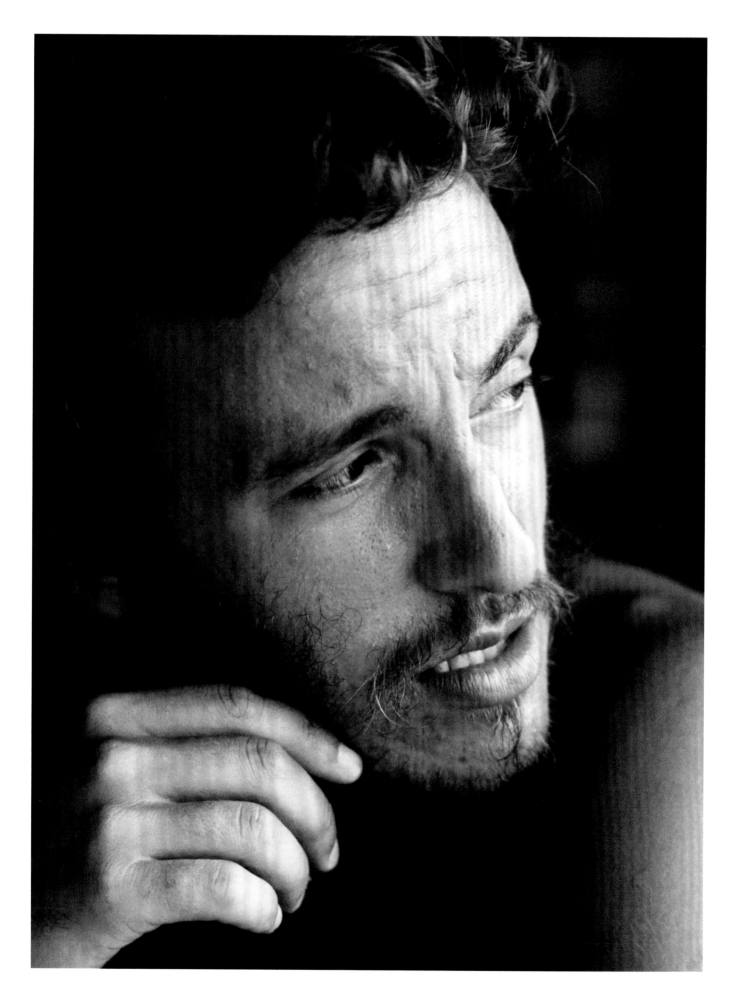

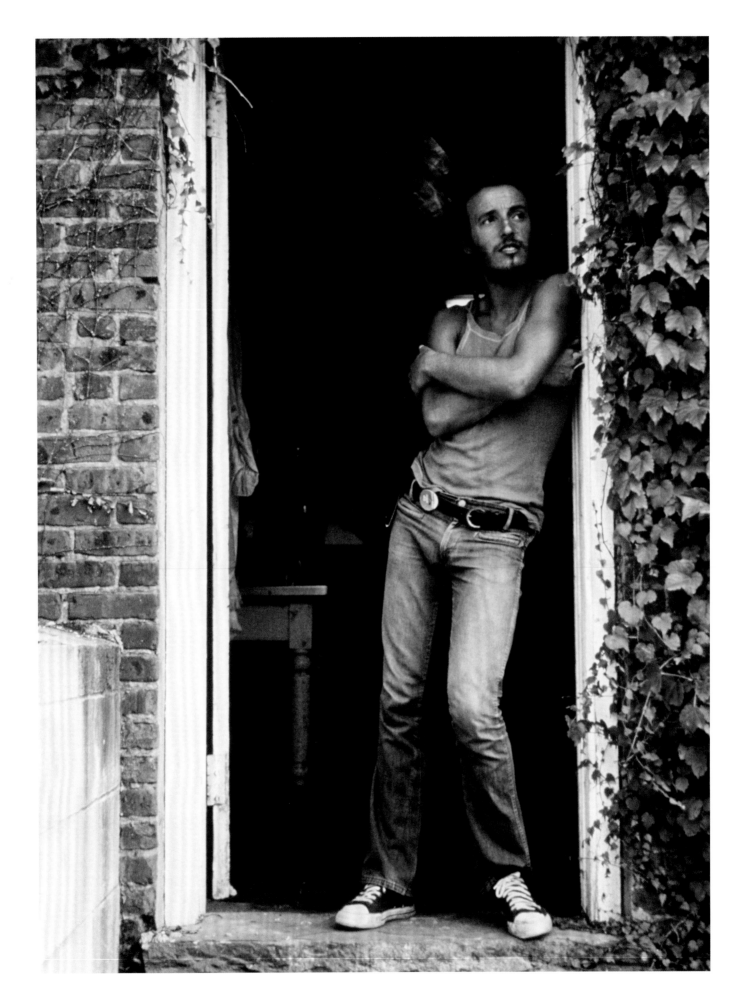

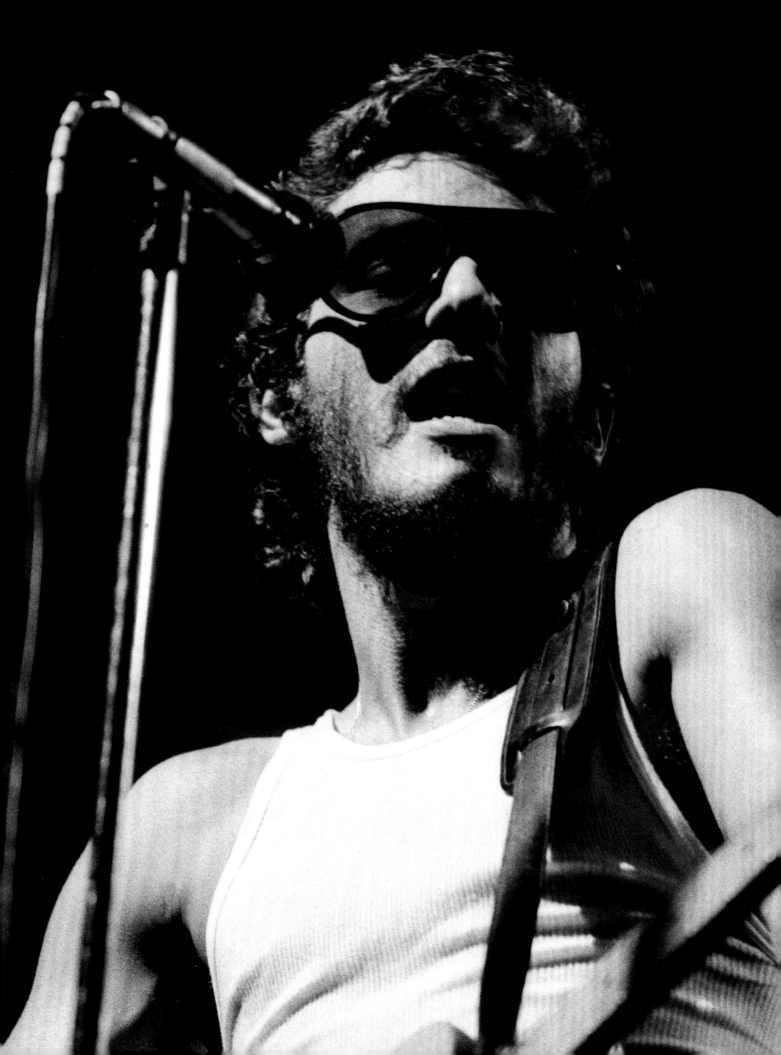

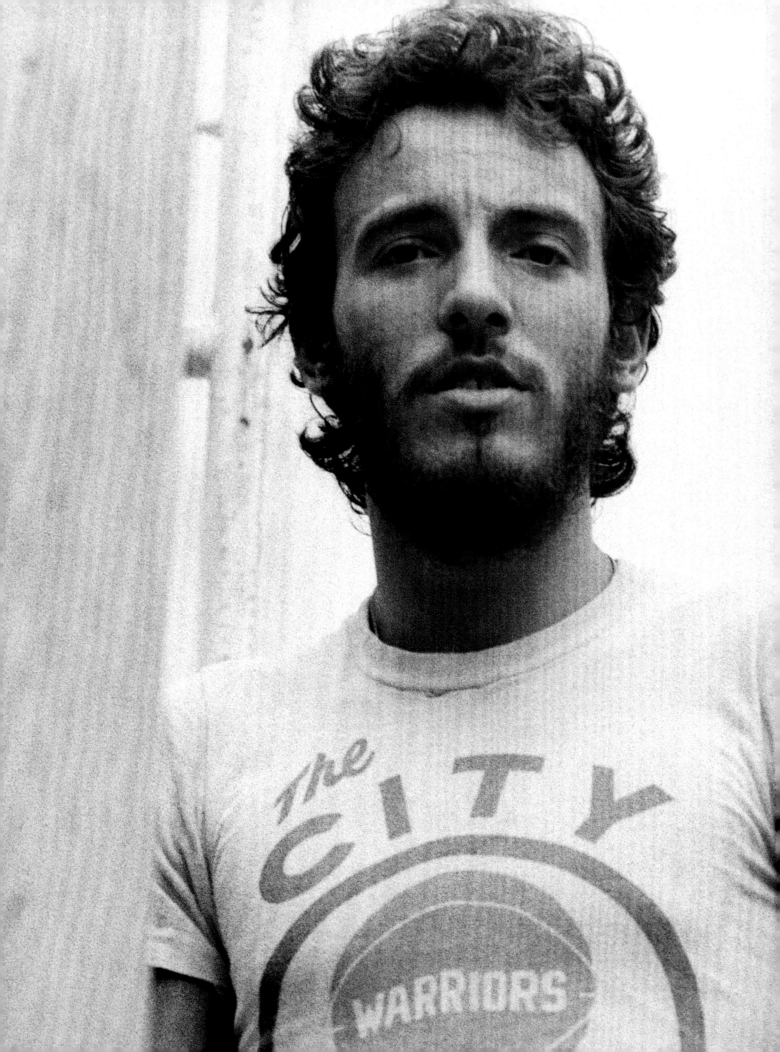

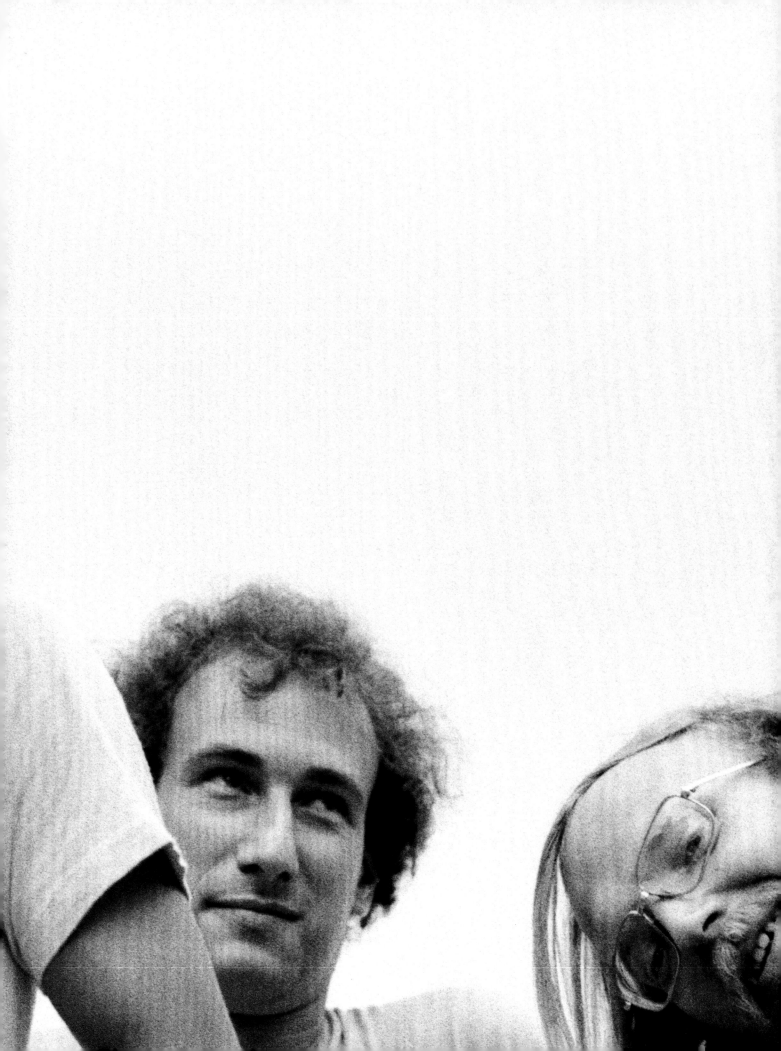

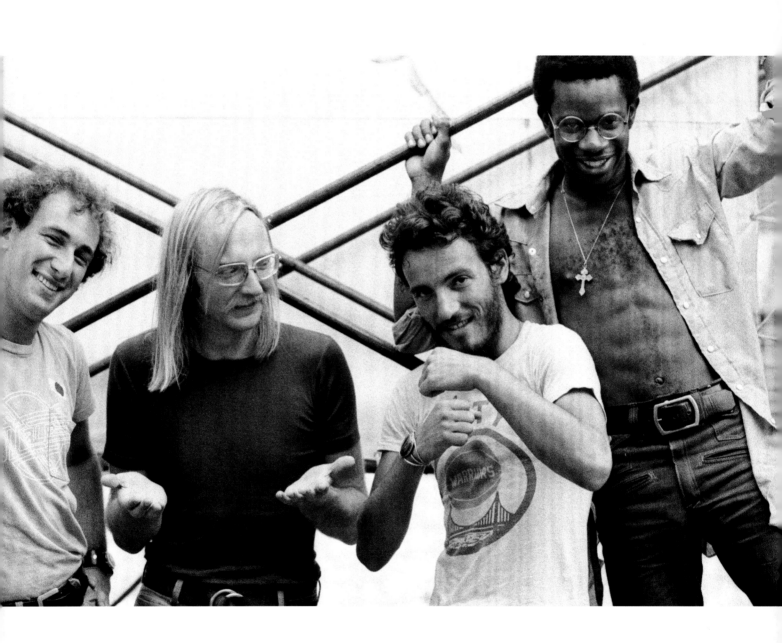

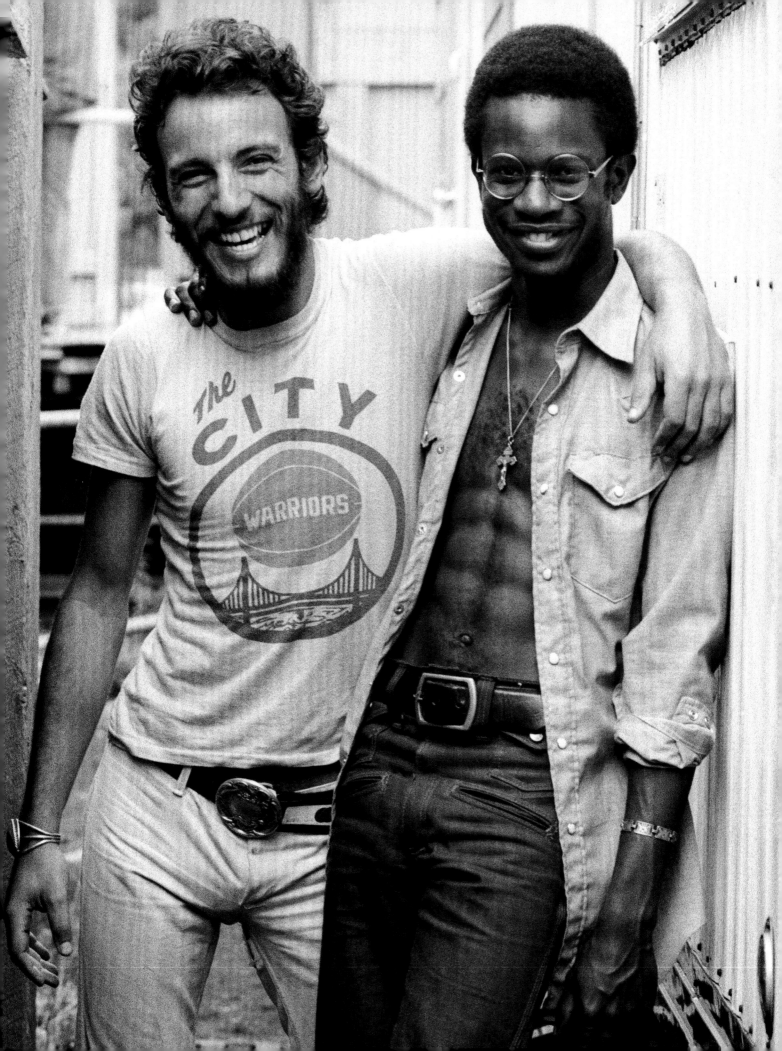

1974

LINCOLN CENTER, NYC

LINCOLN CENTER, NYC

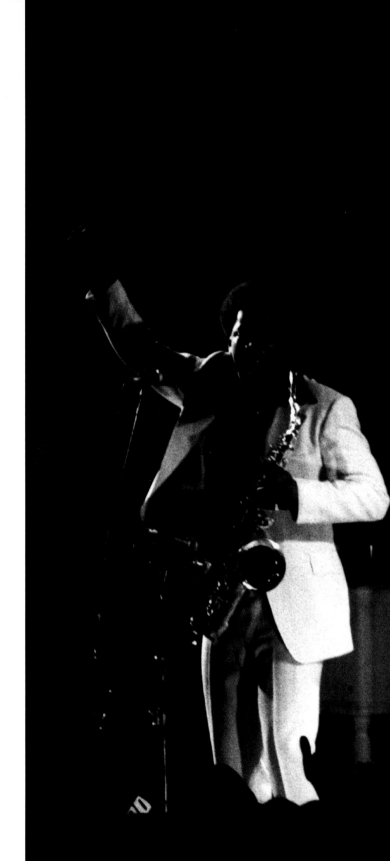

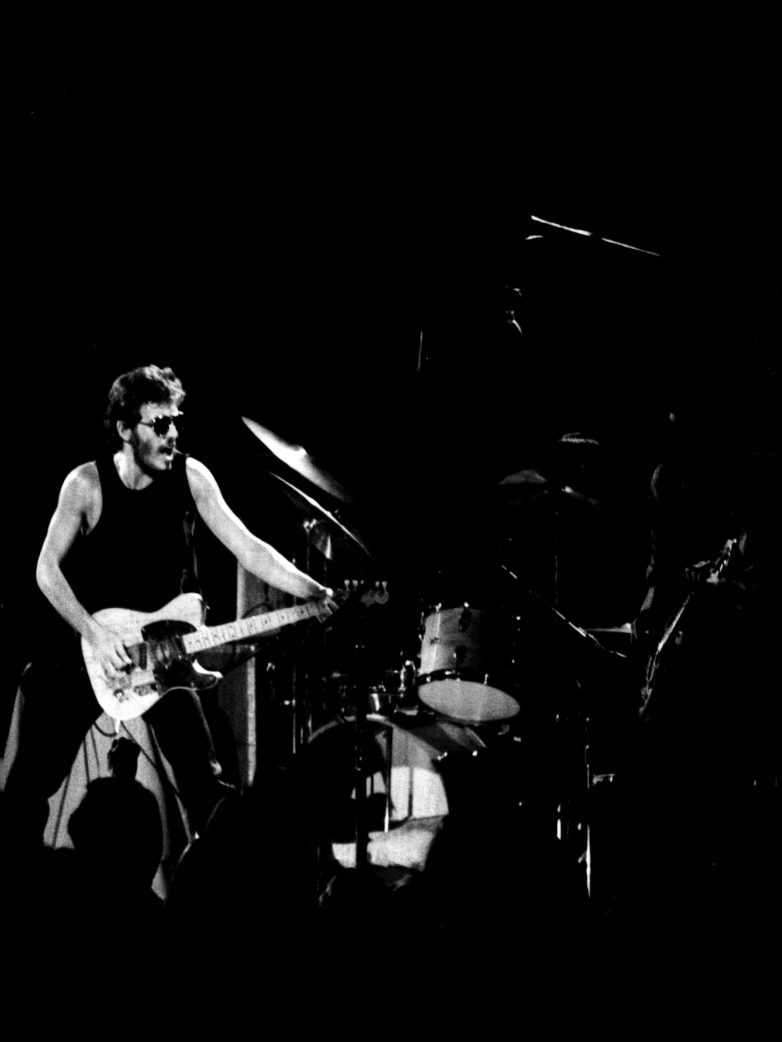

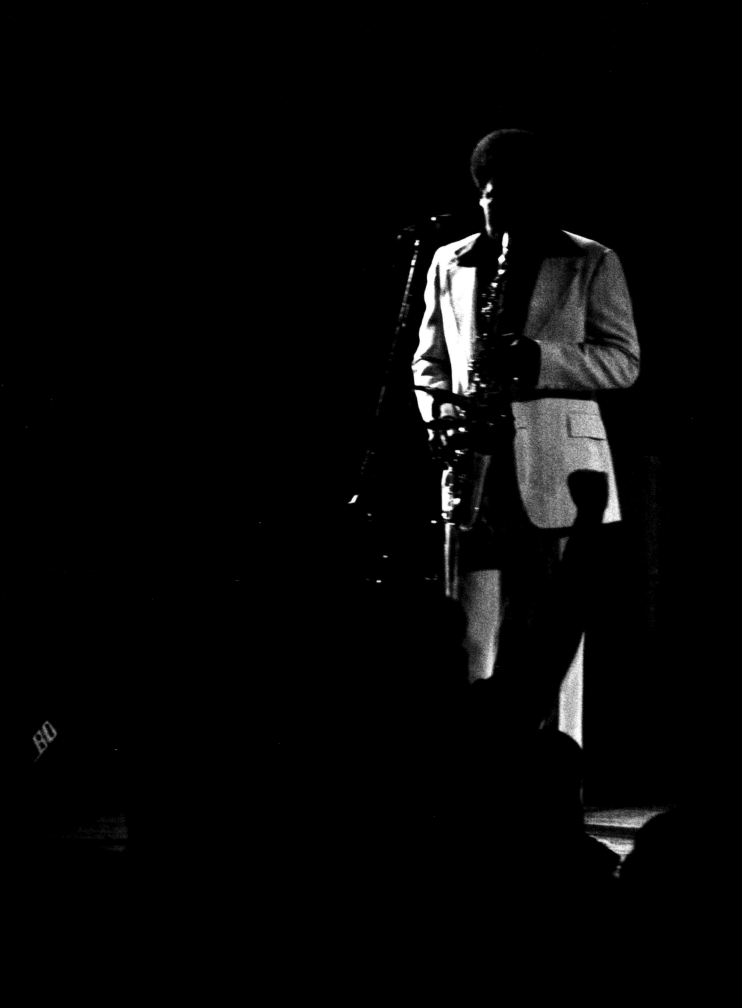

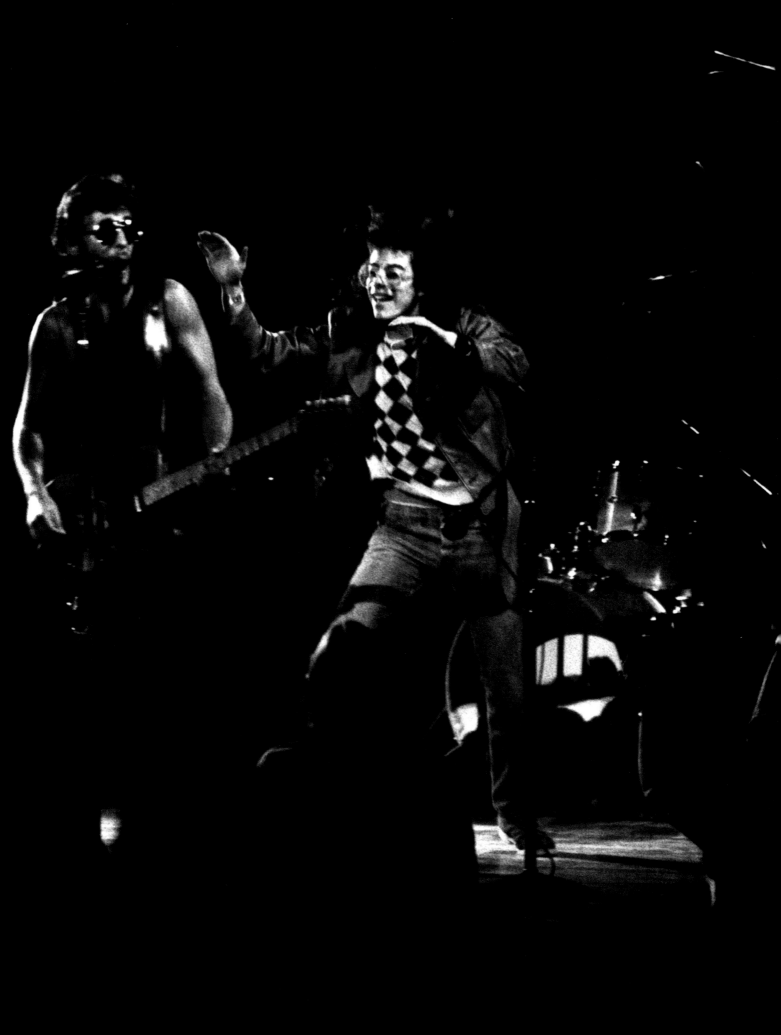

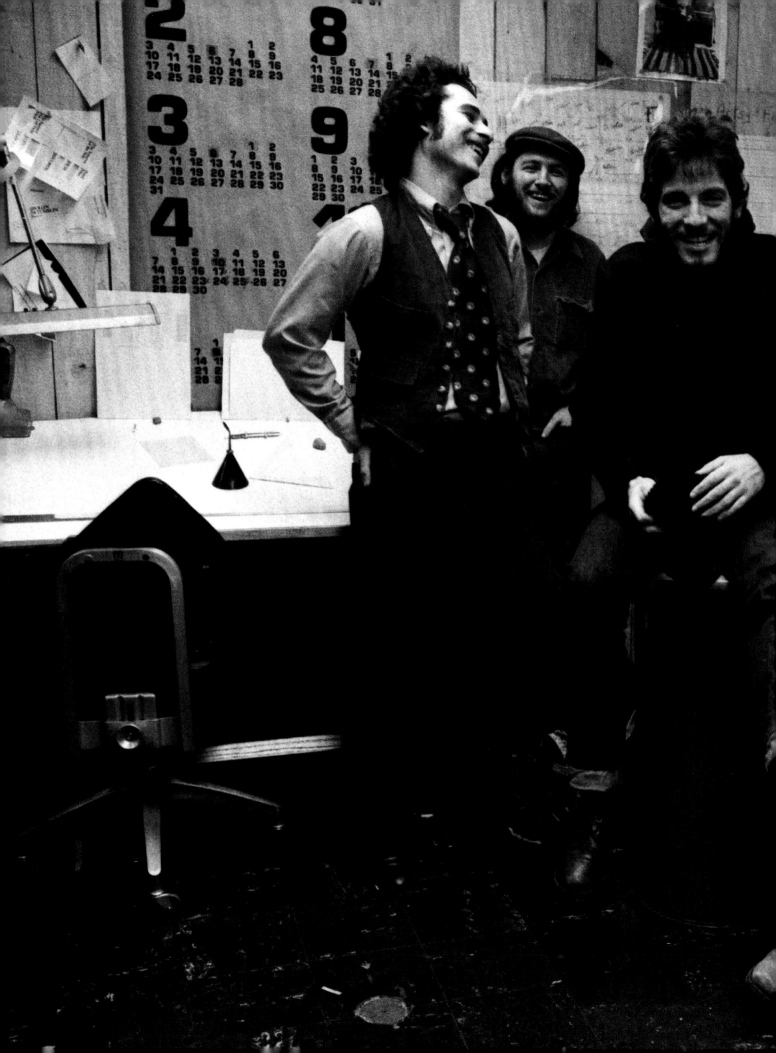

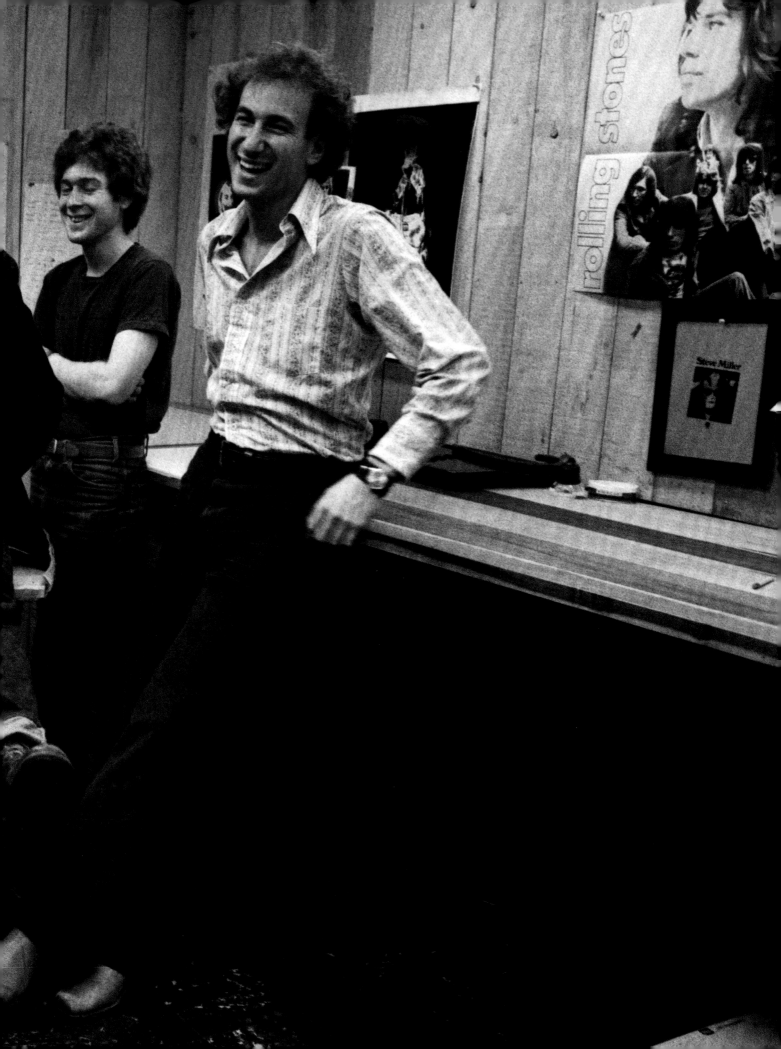

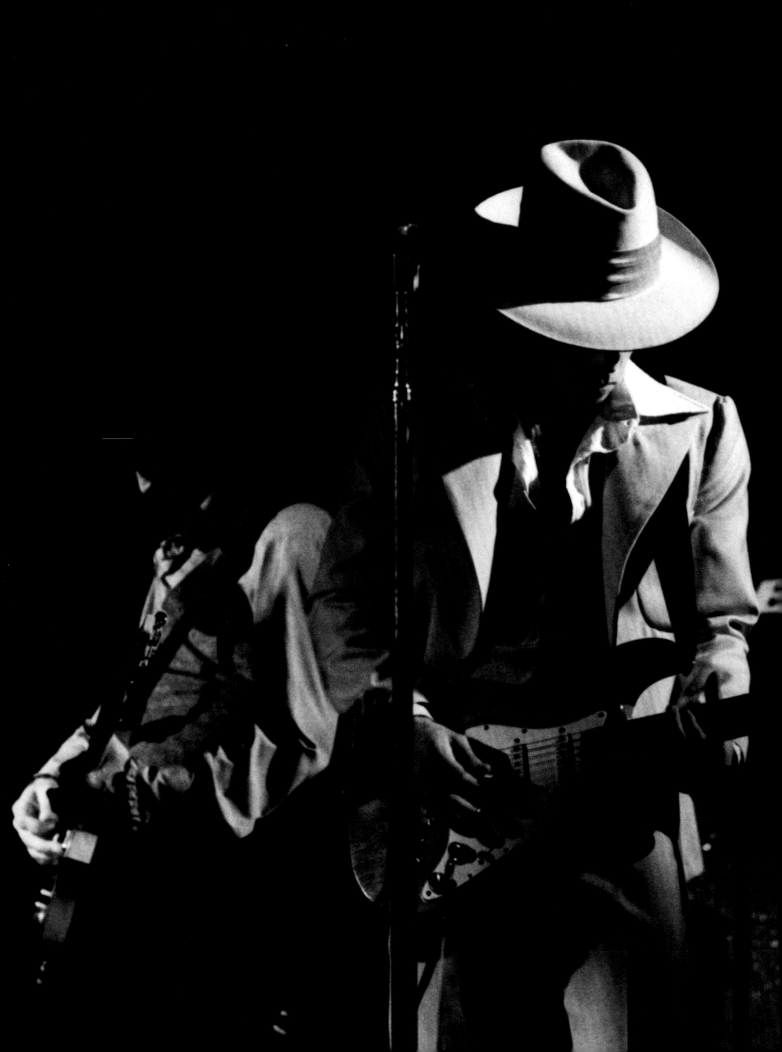

1975

THE BOTTOM LINE, NYC

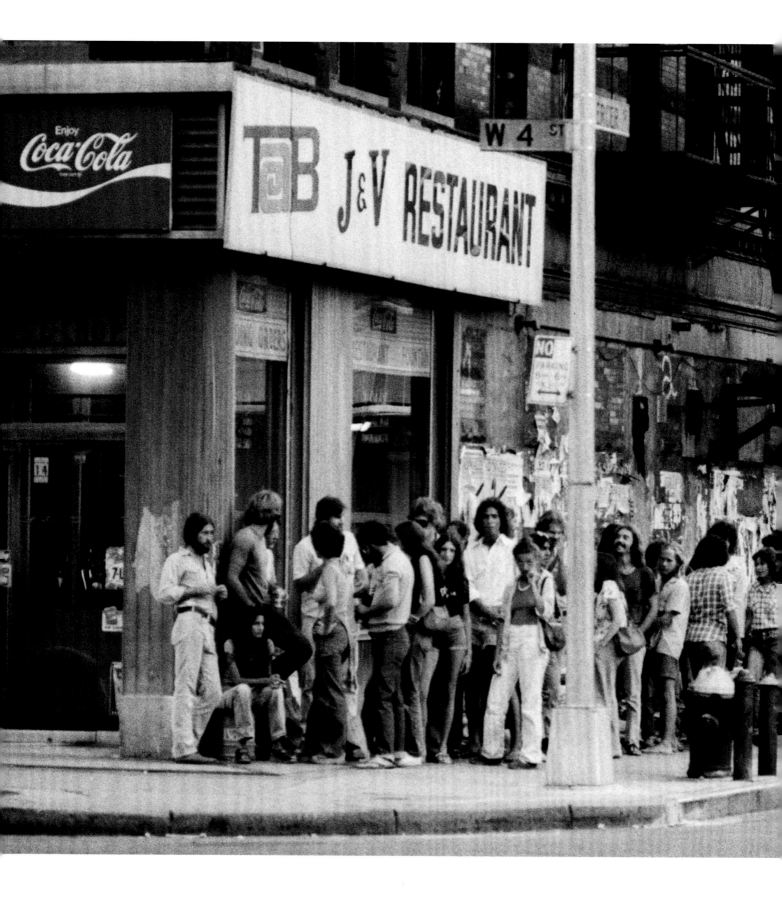

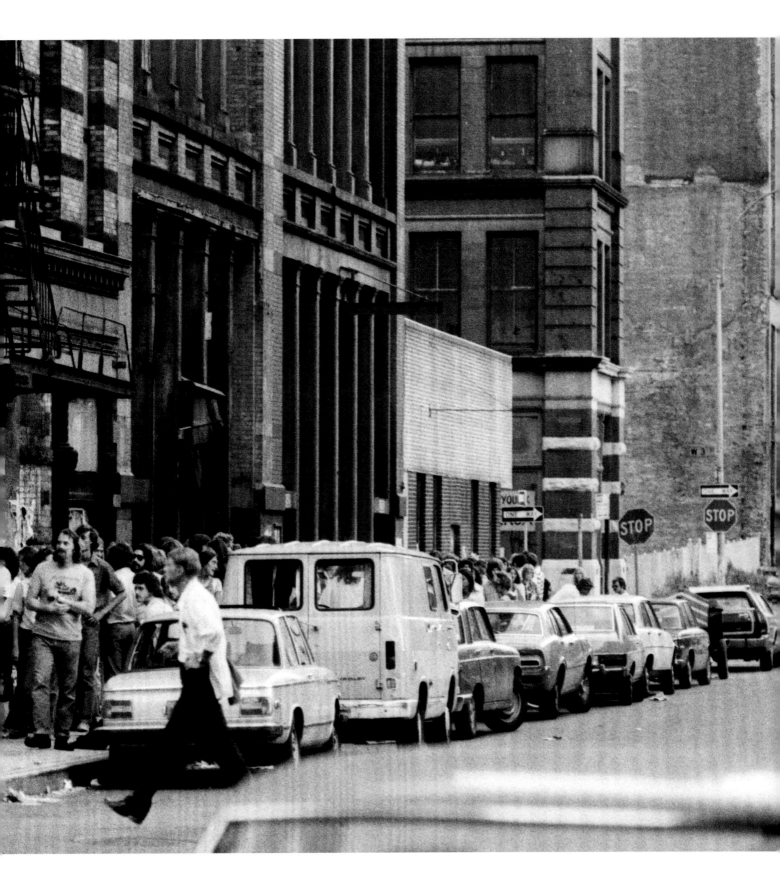

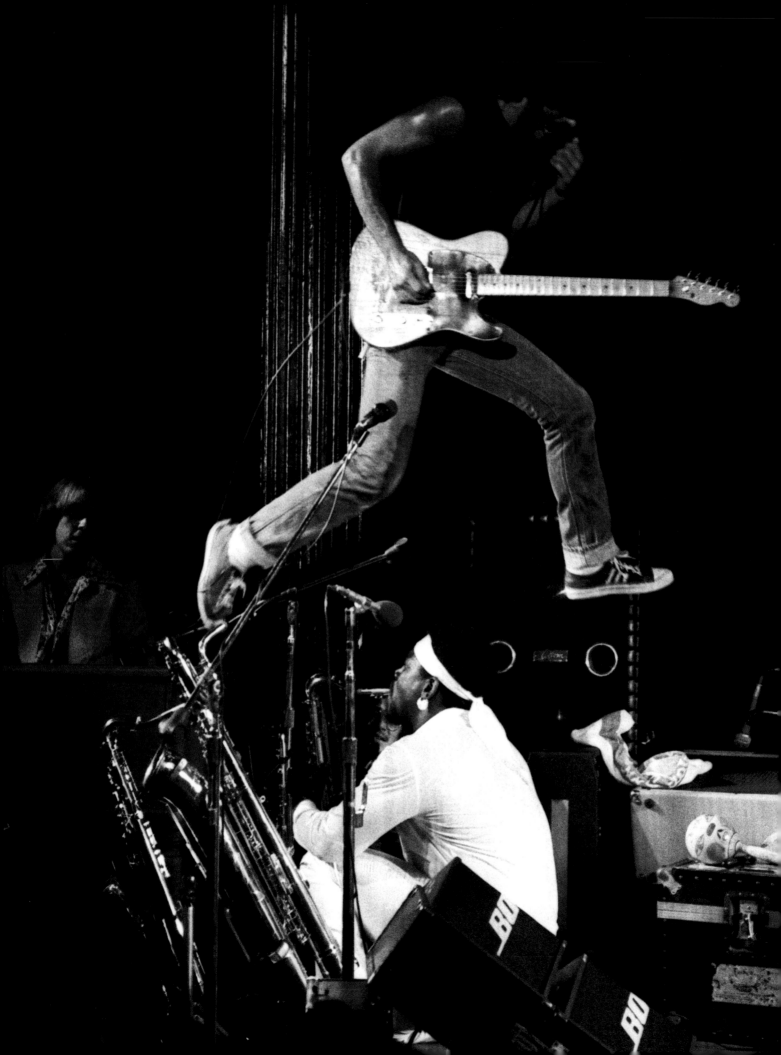

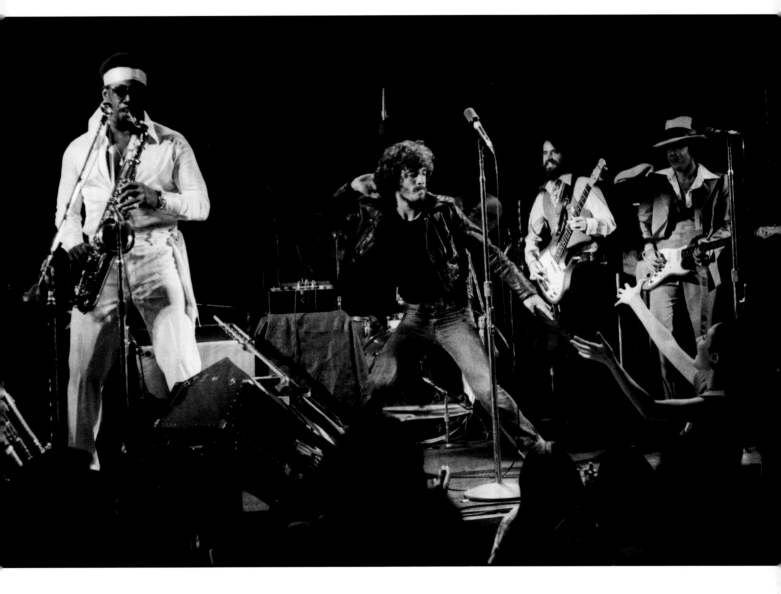

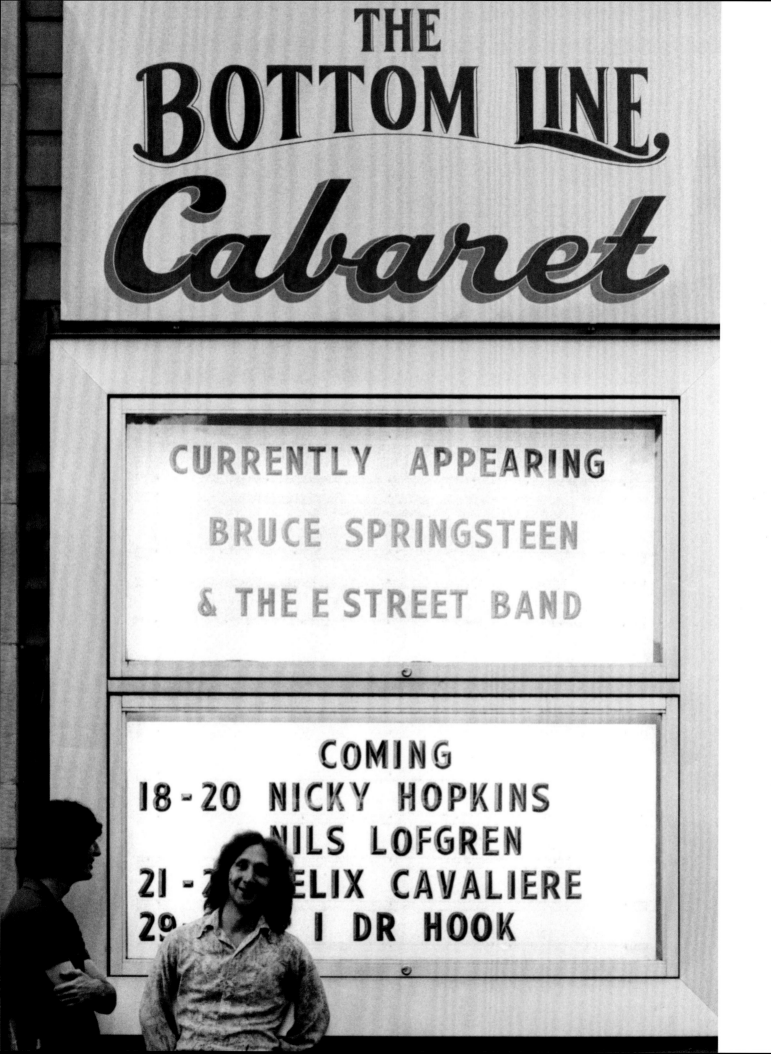

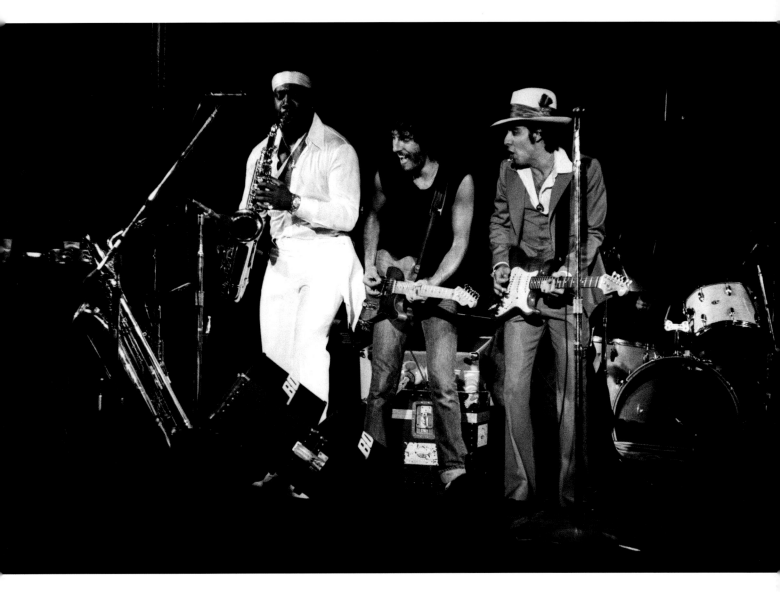

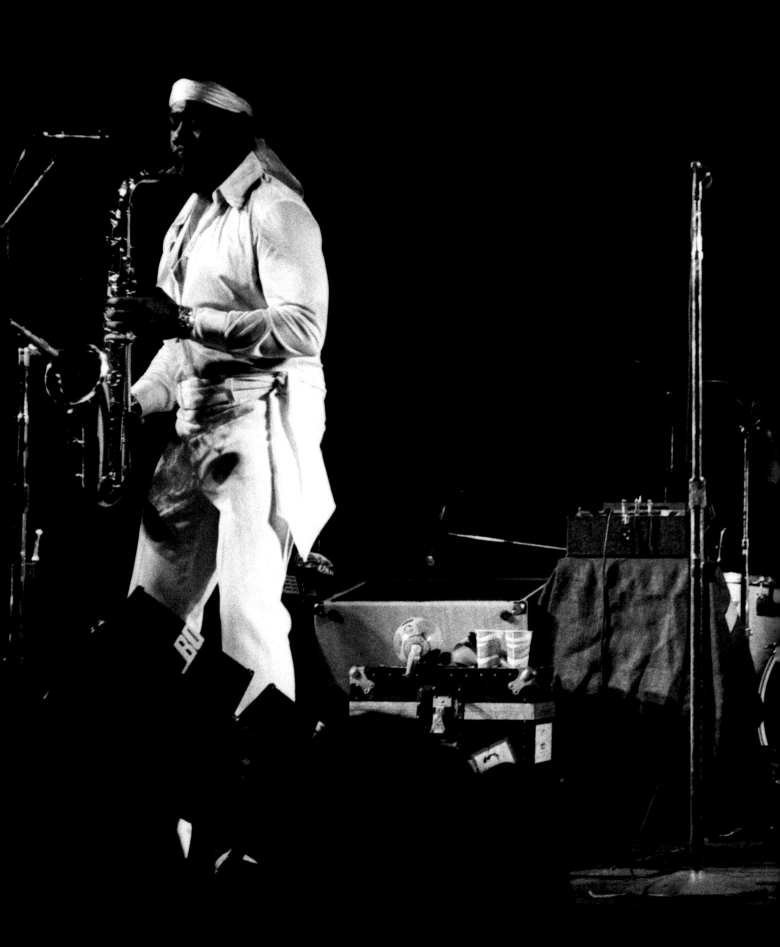

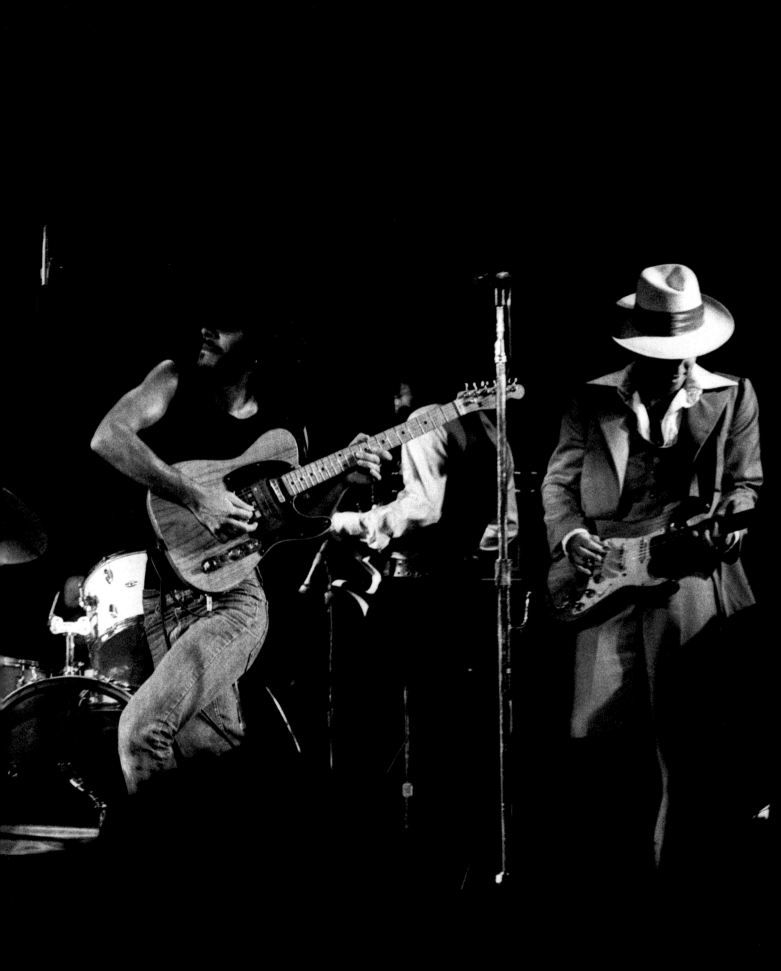

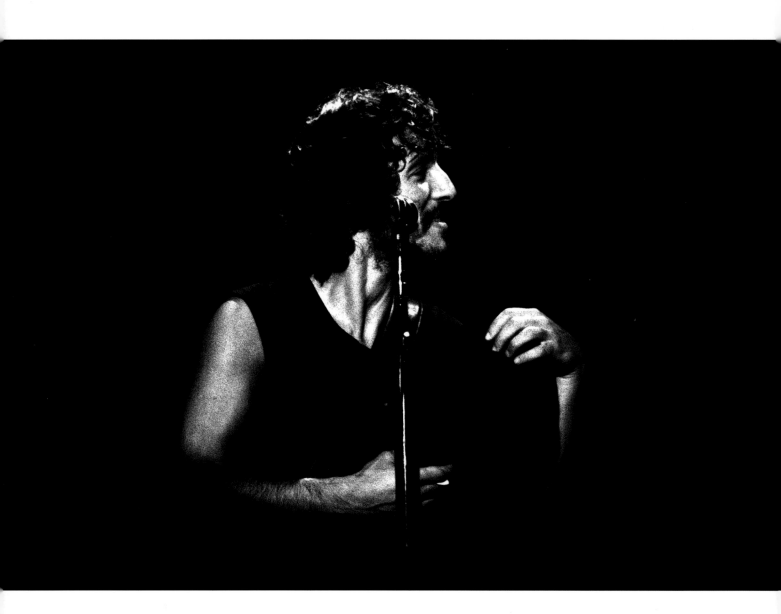

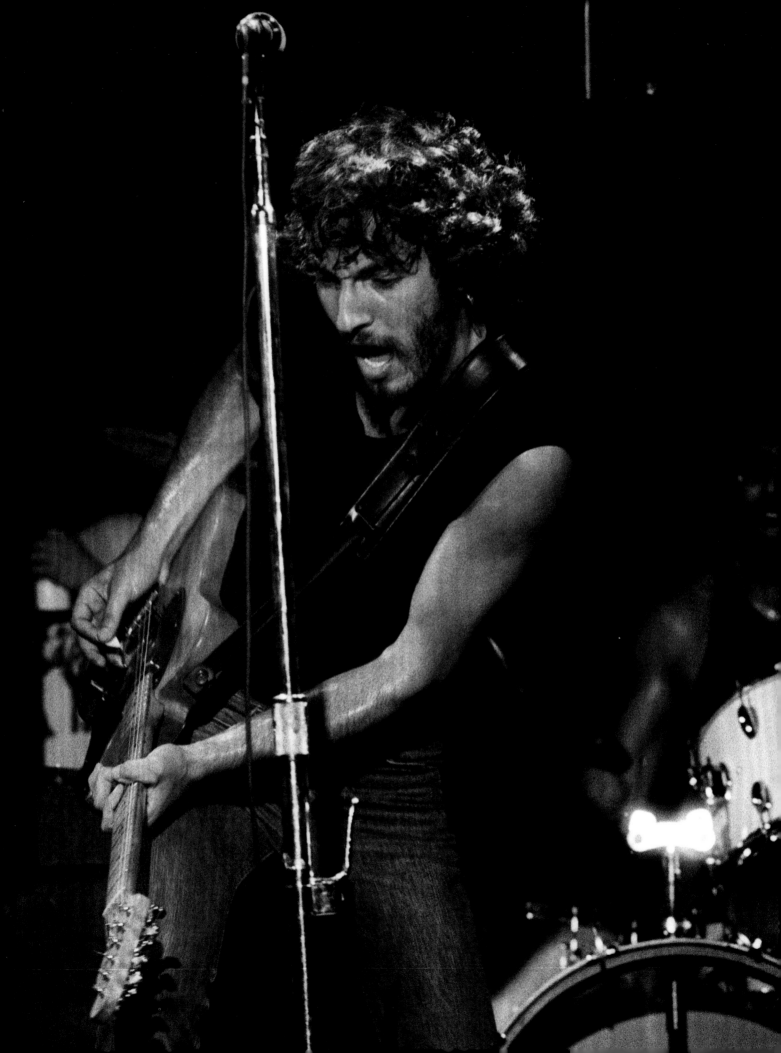

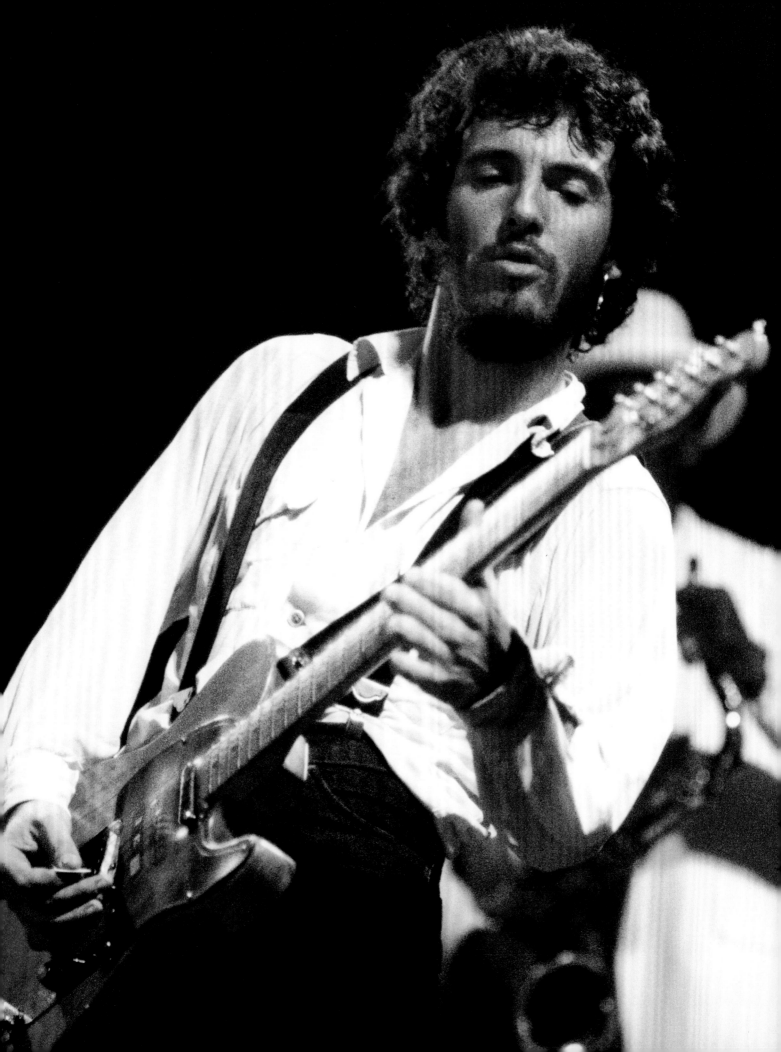

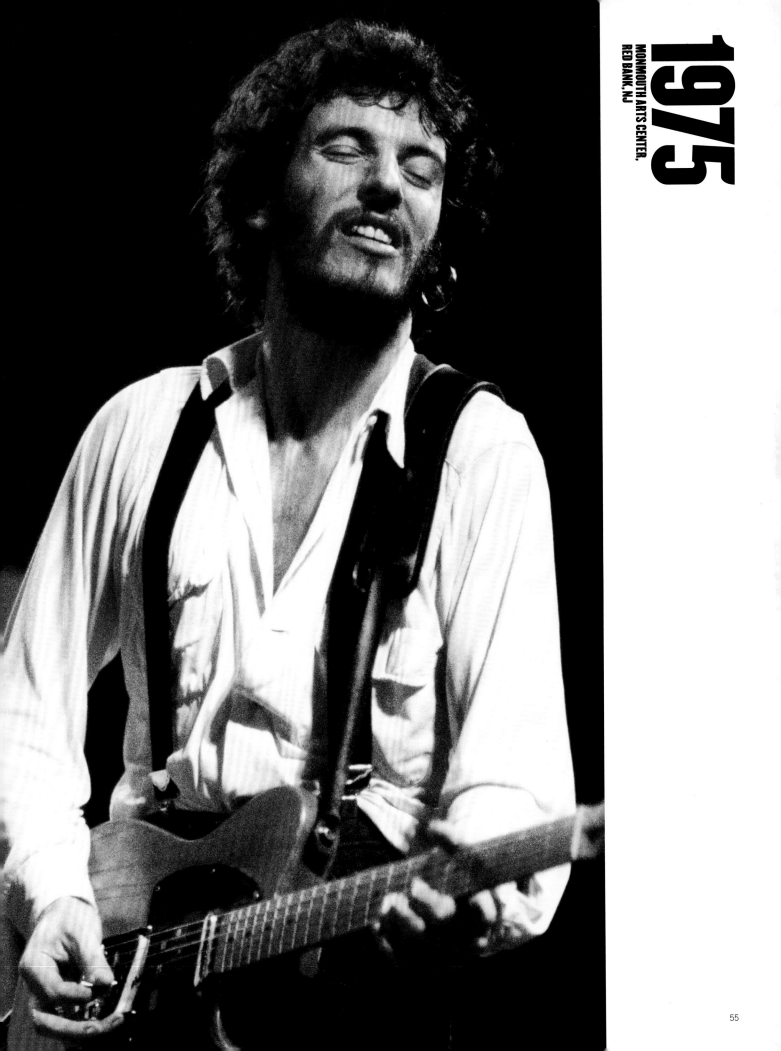

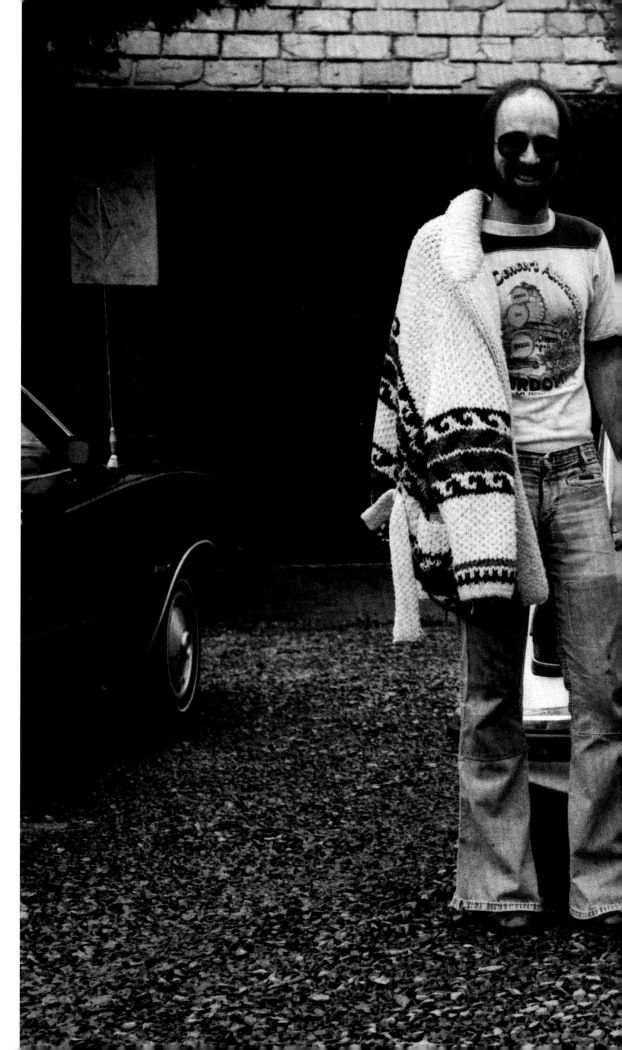

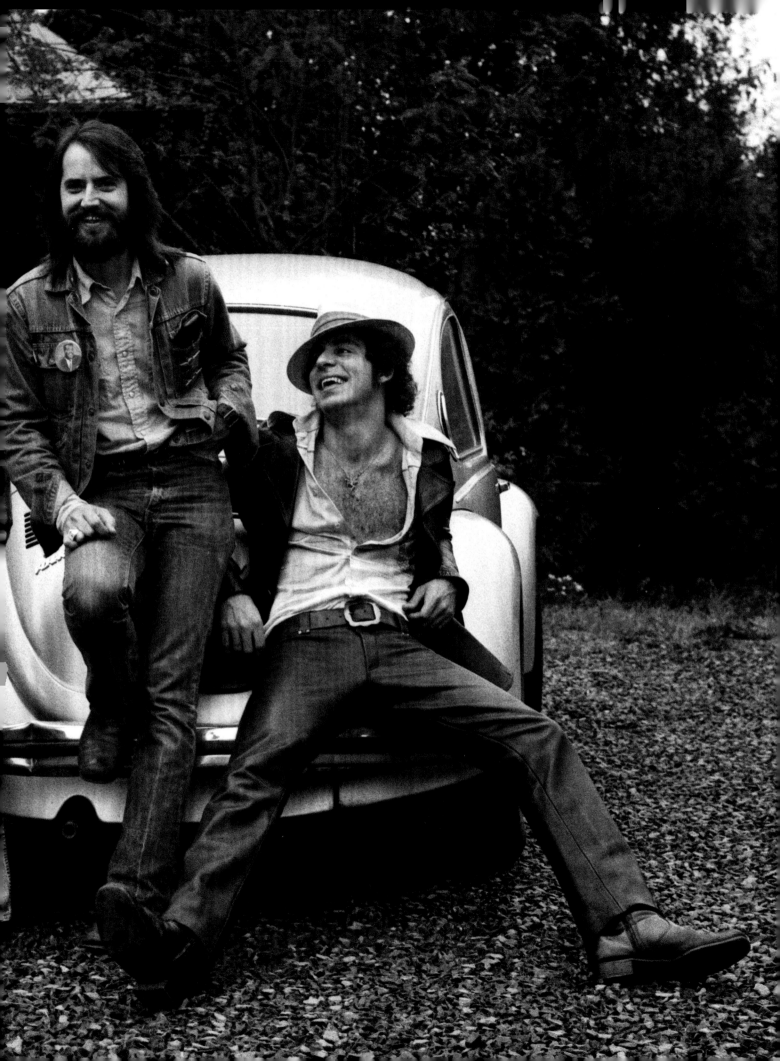

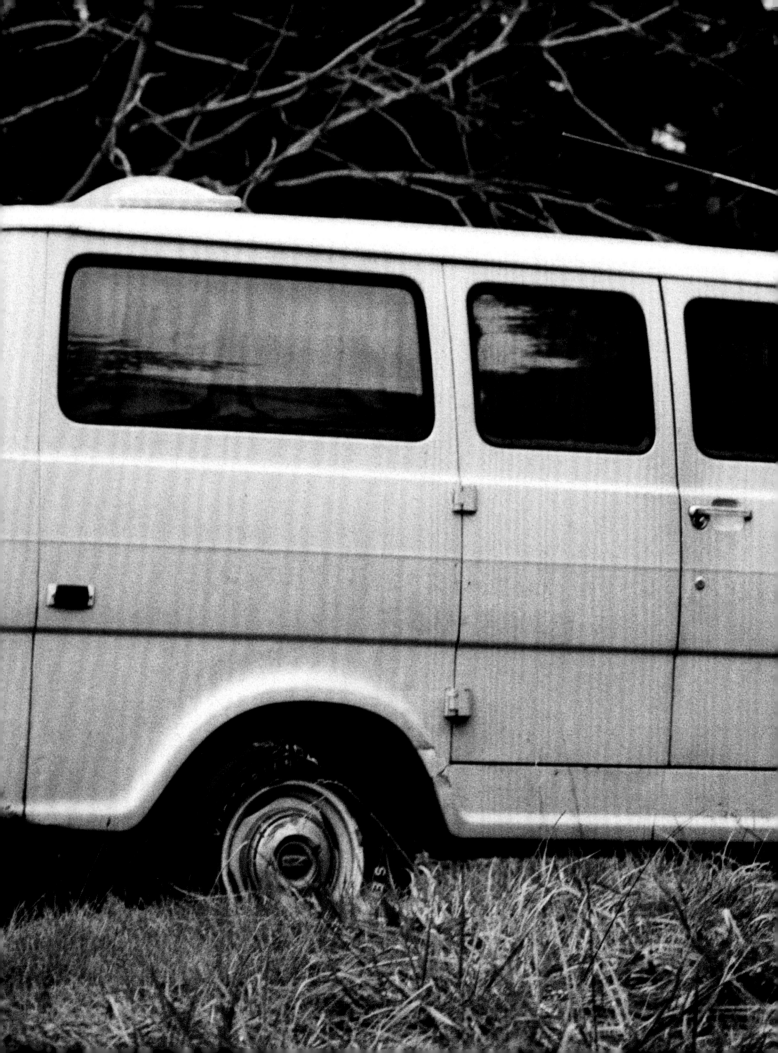

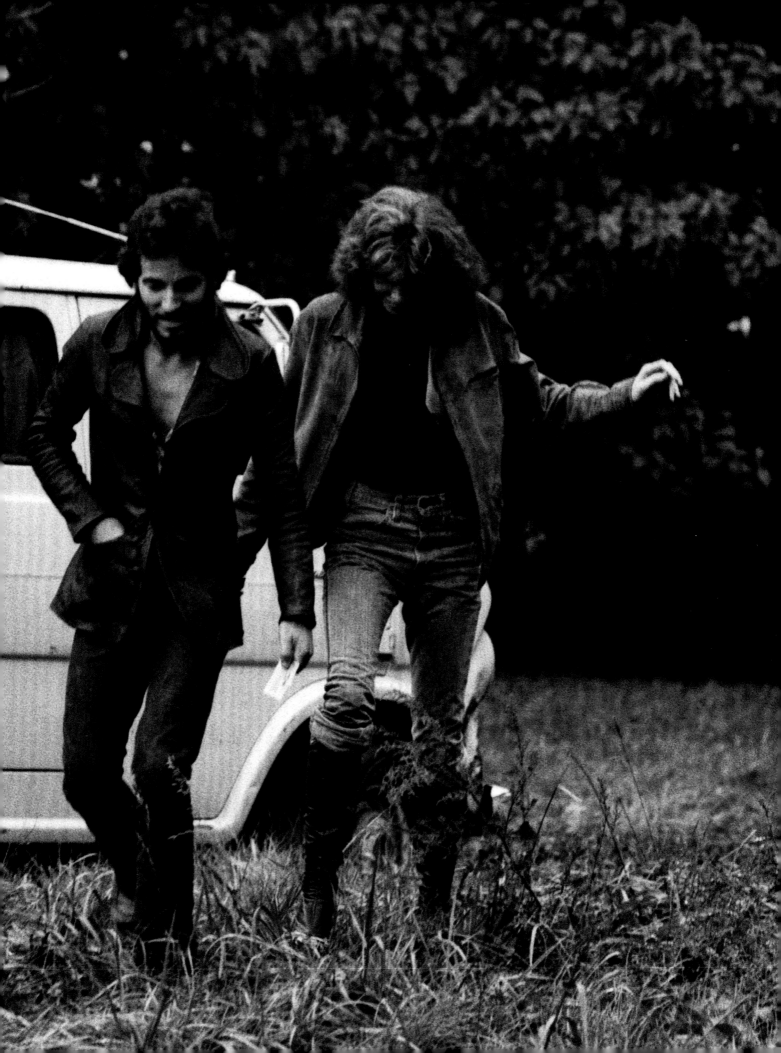

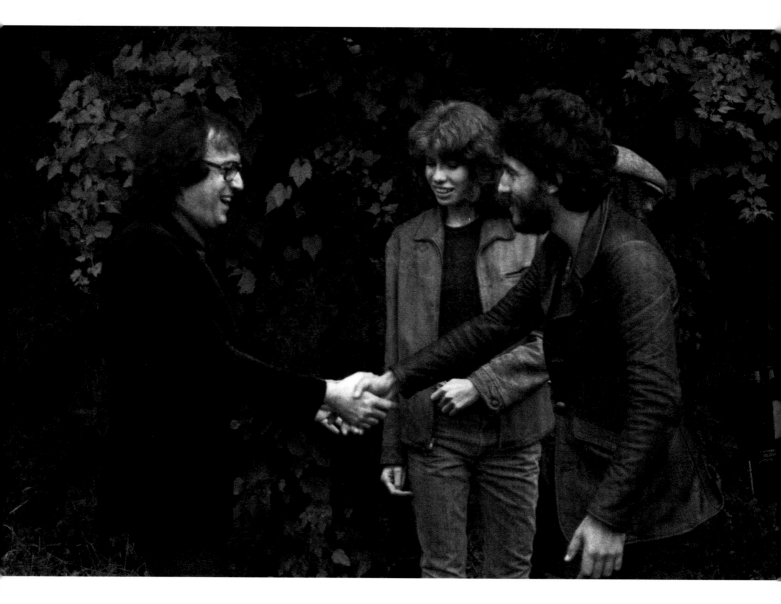

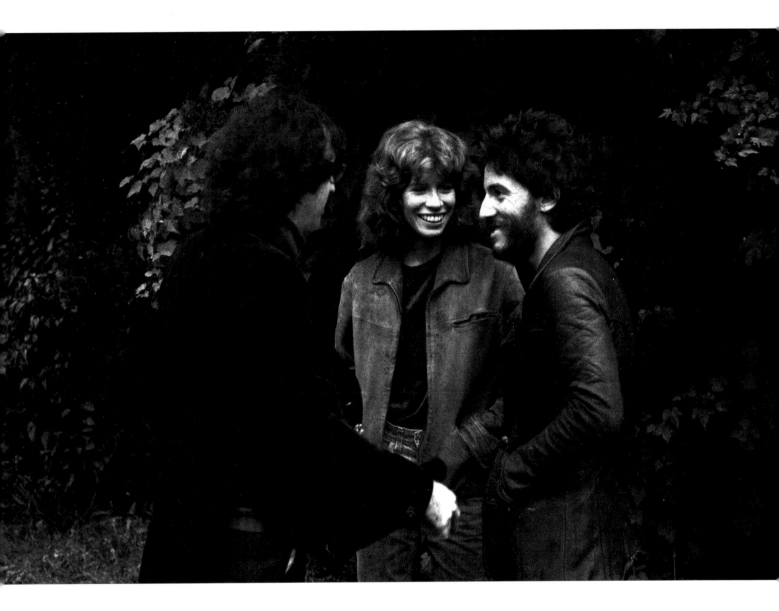

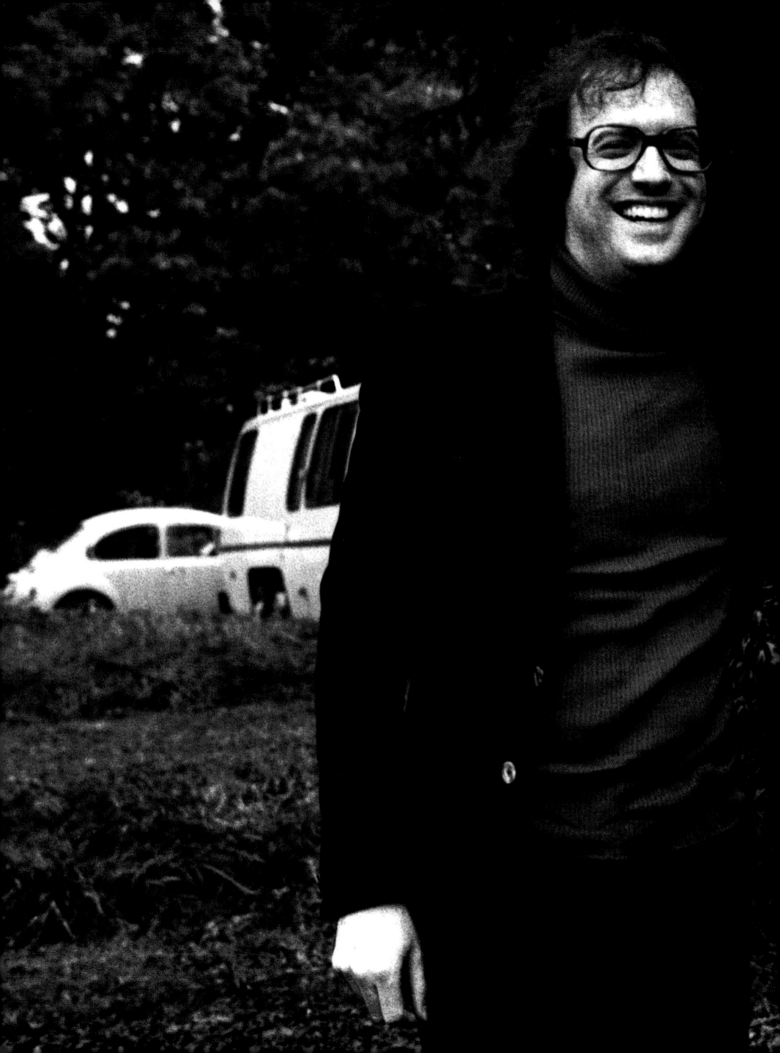

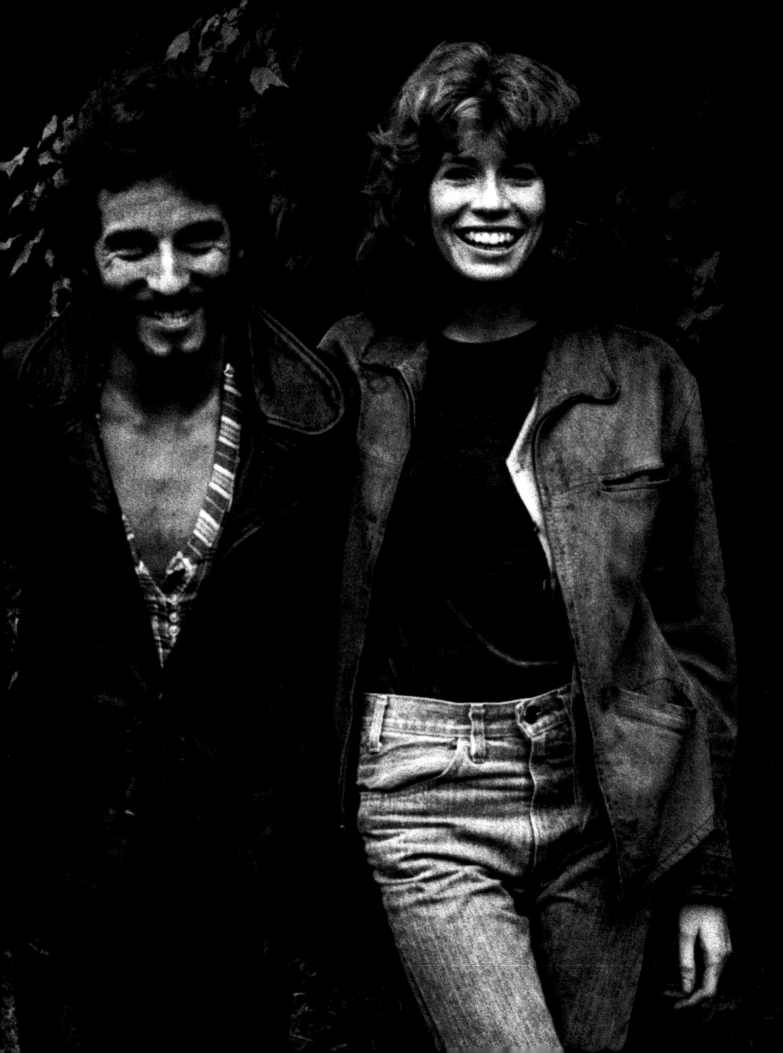

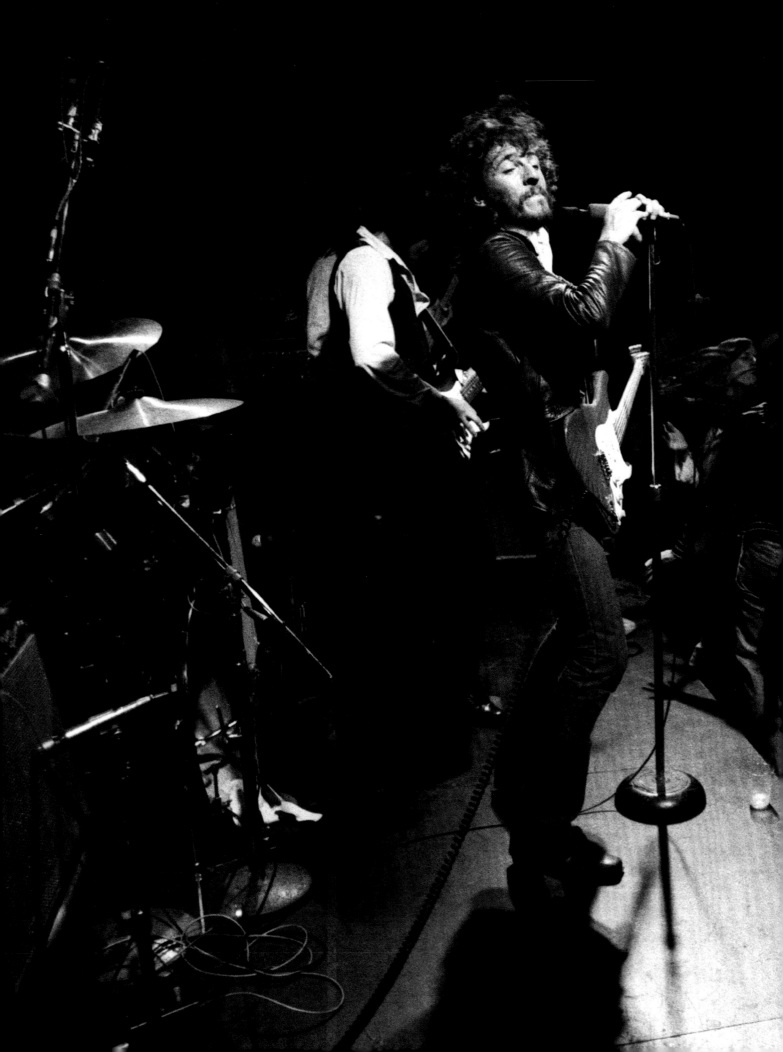

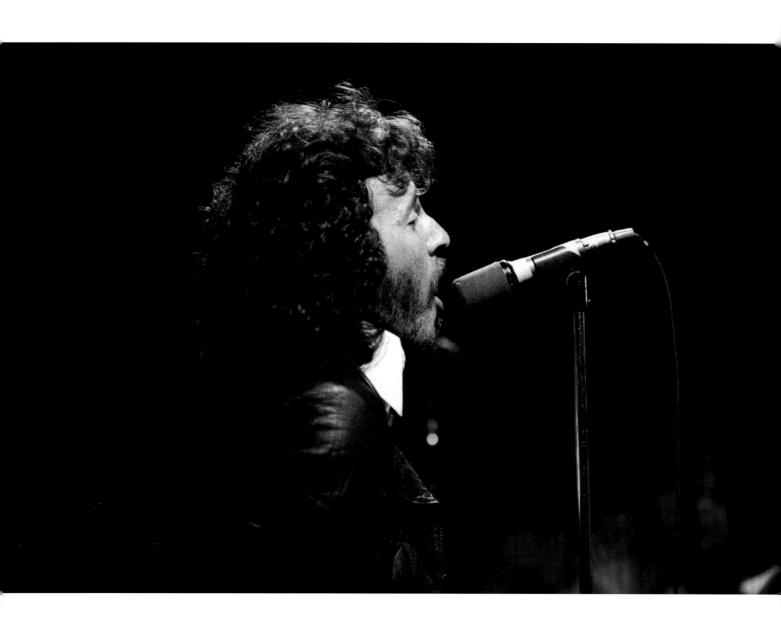

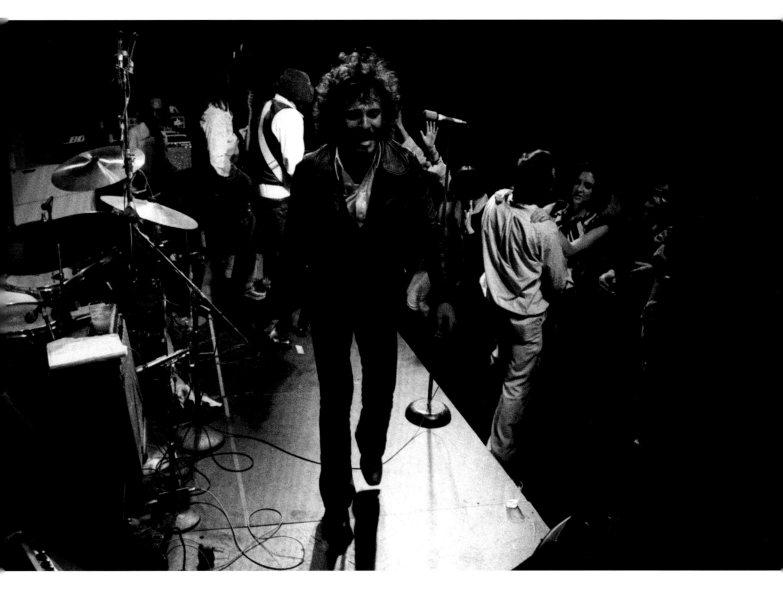

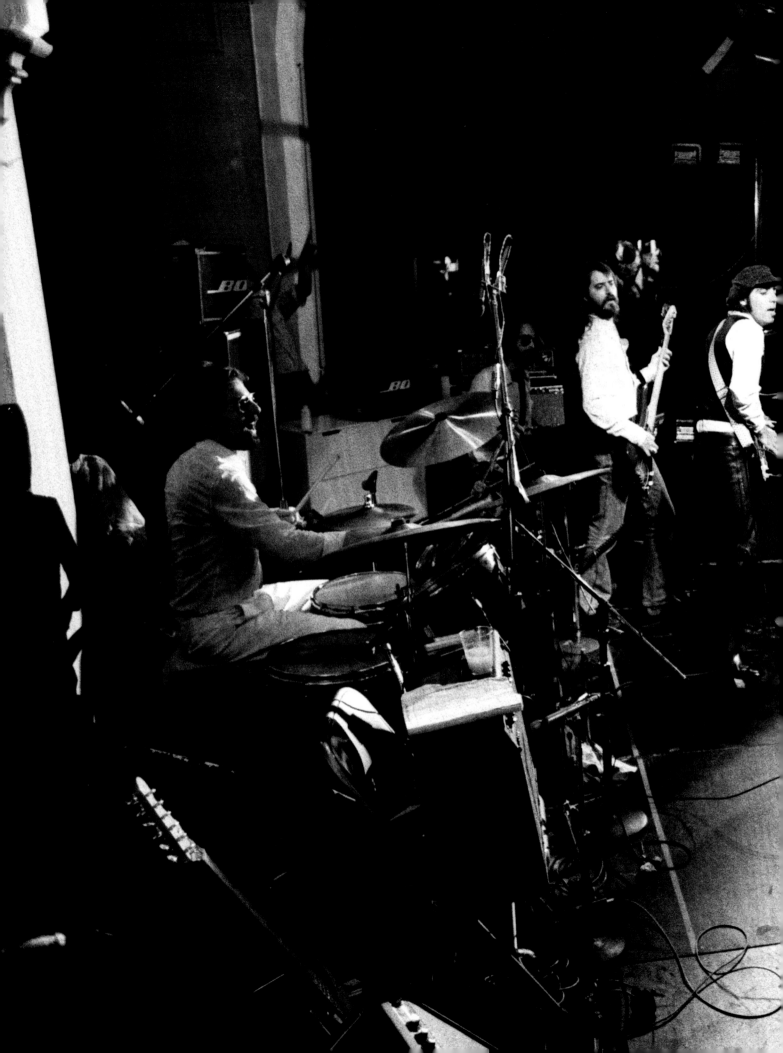

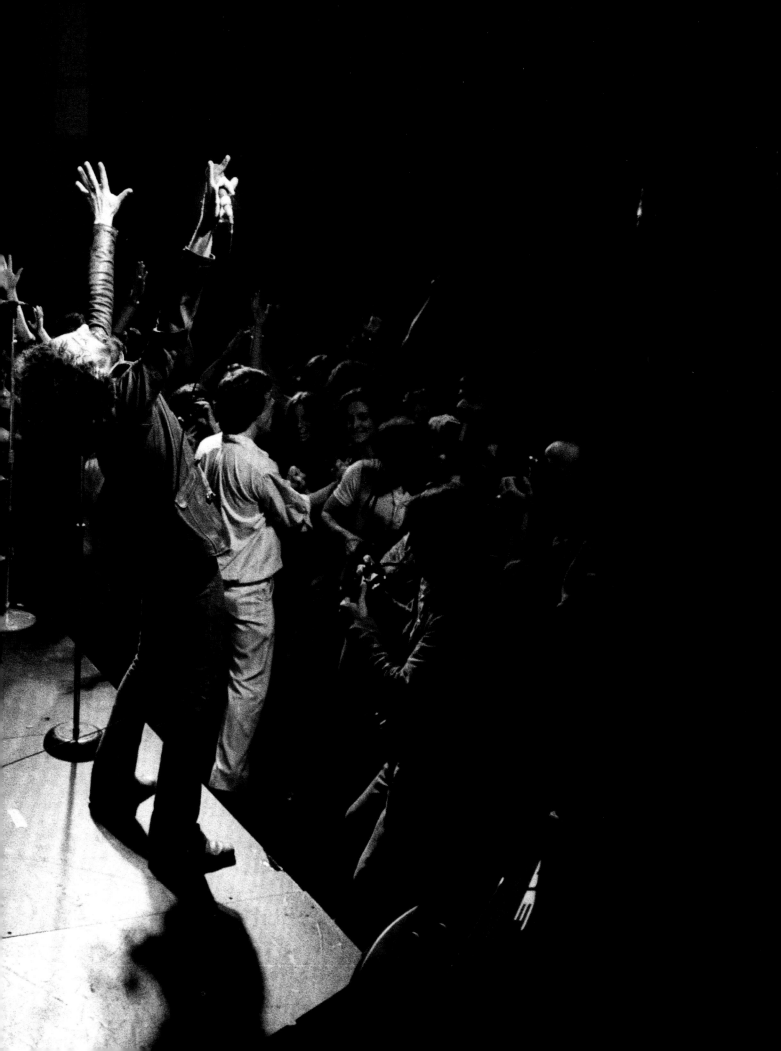

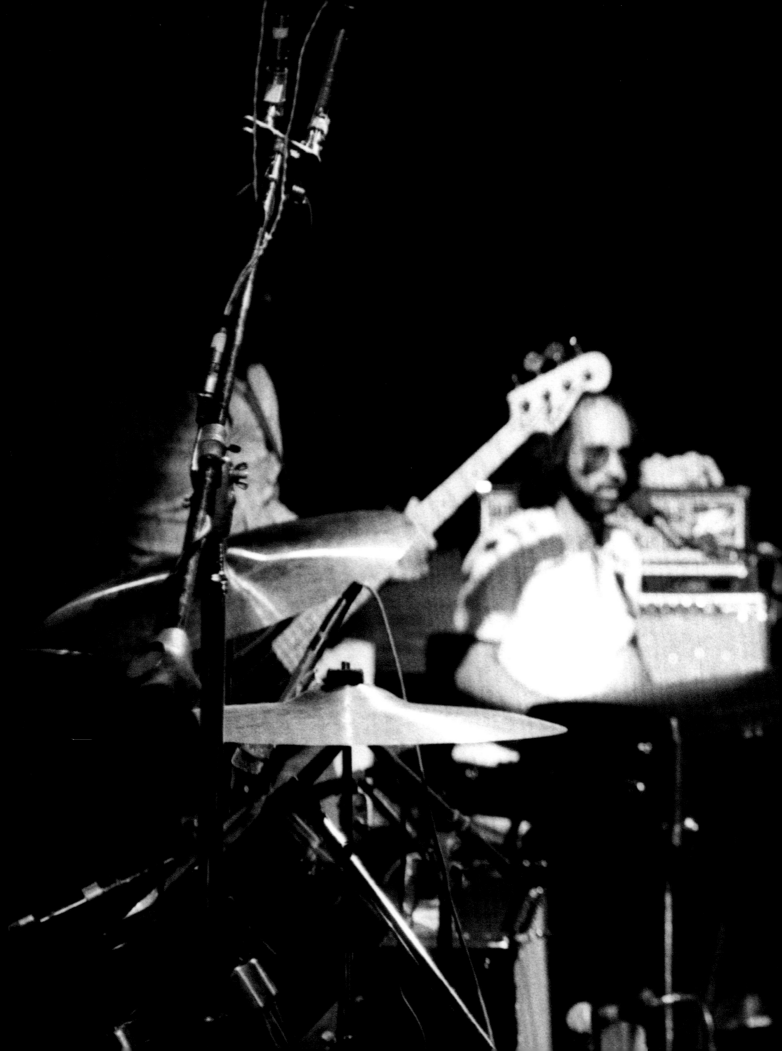

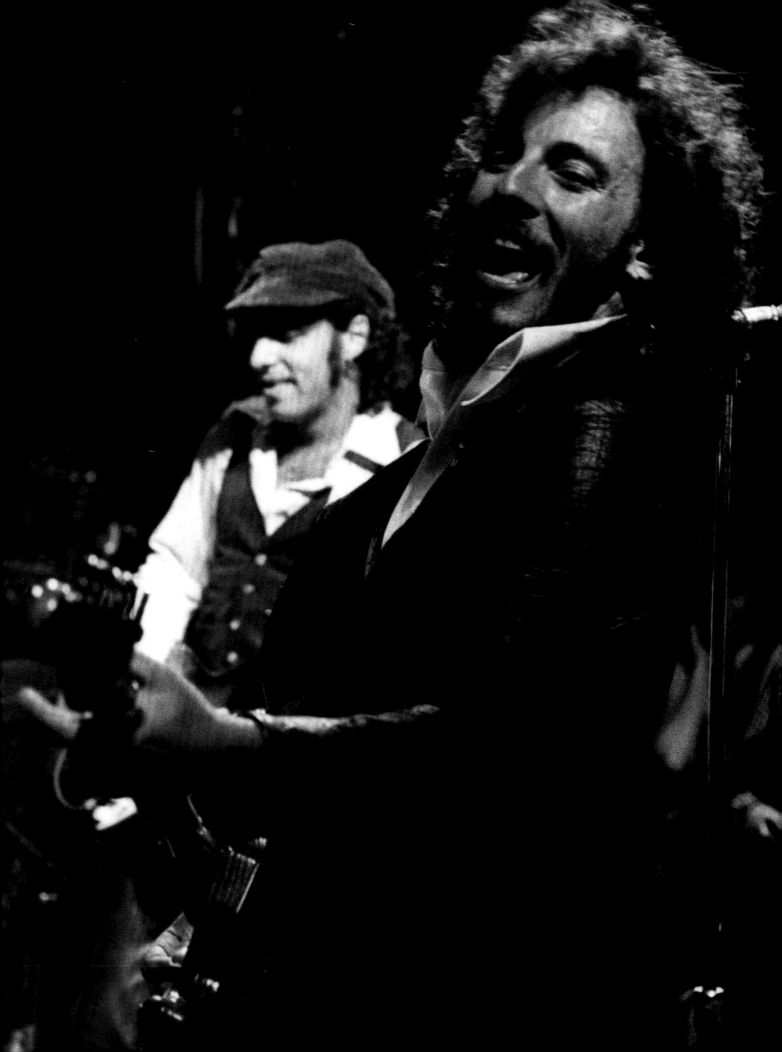

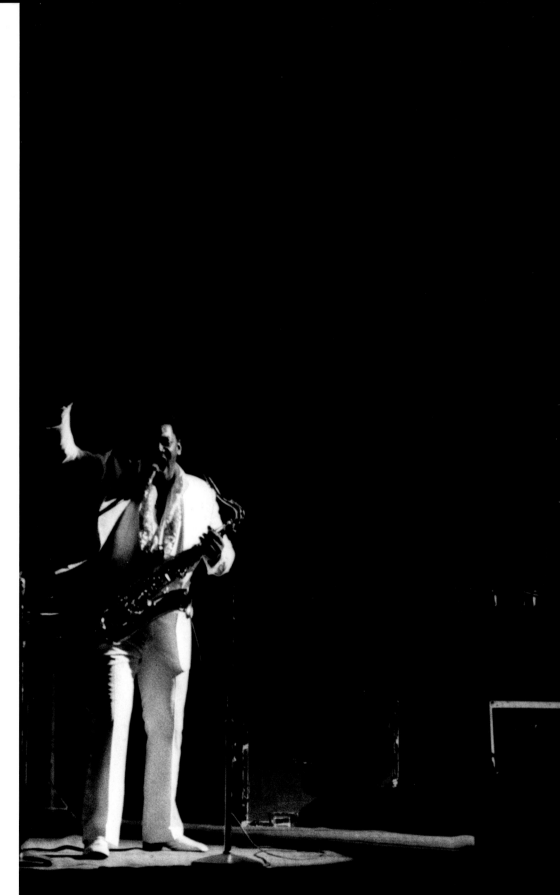

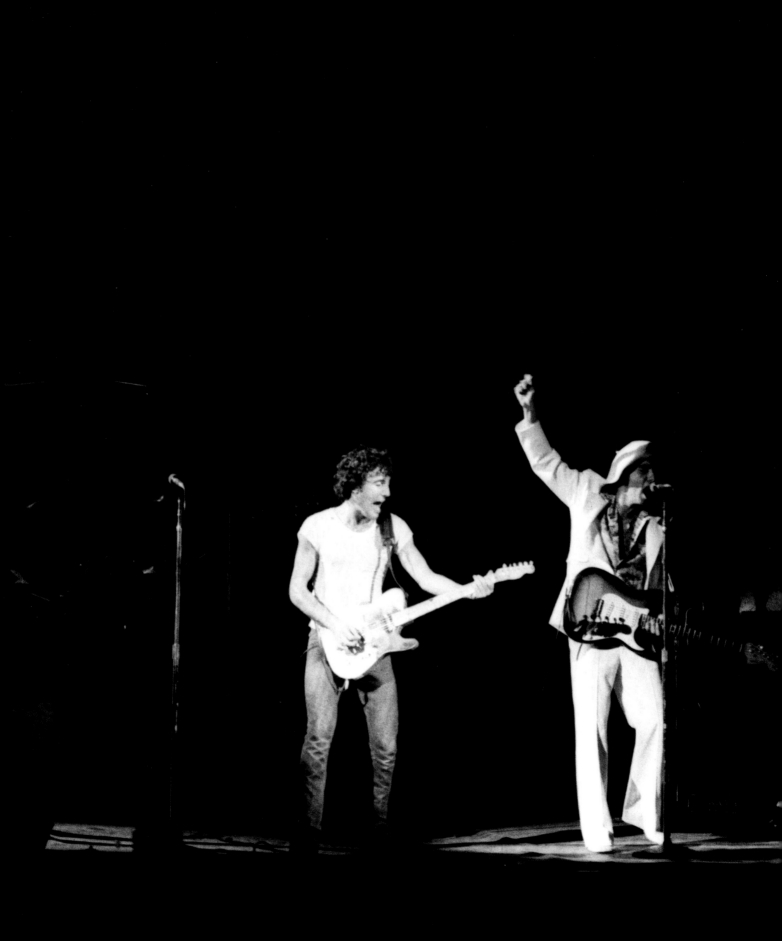

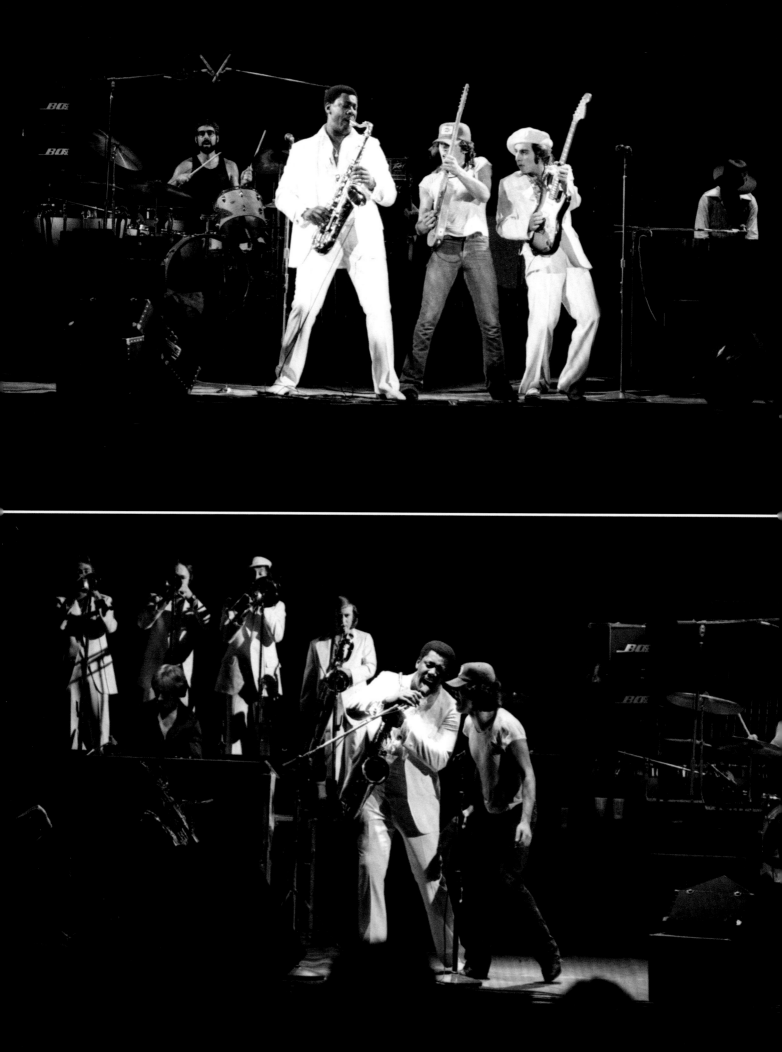

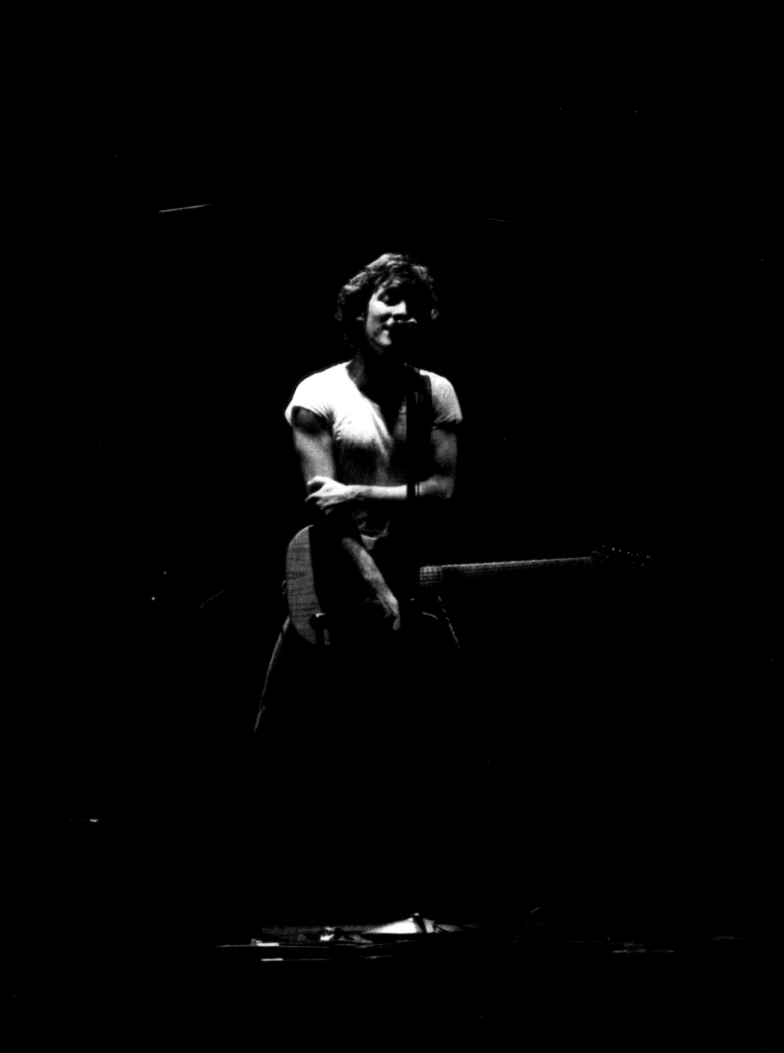

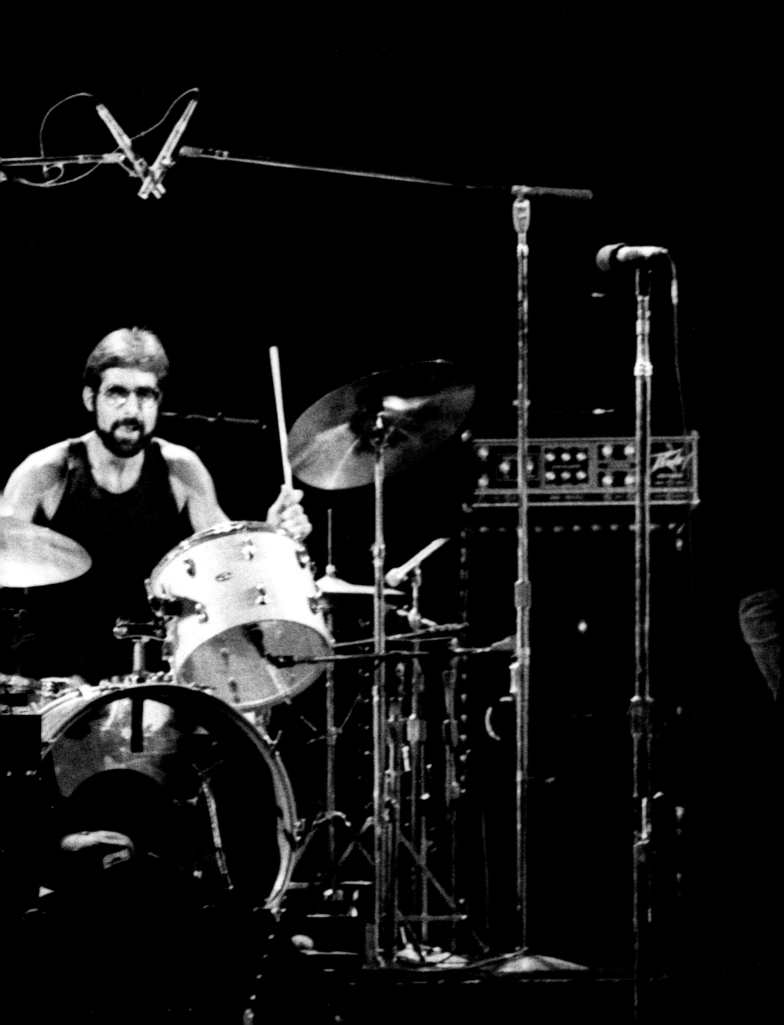

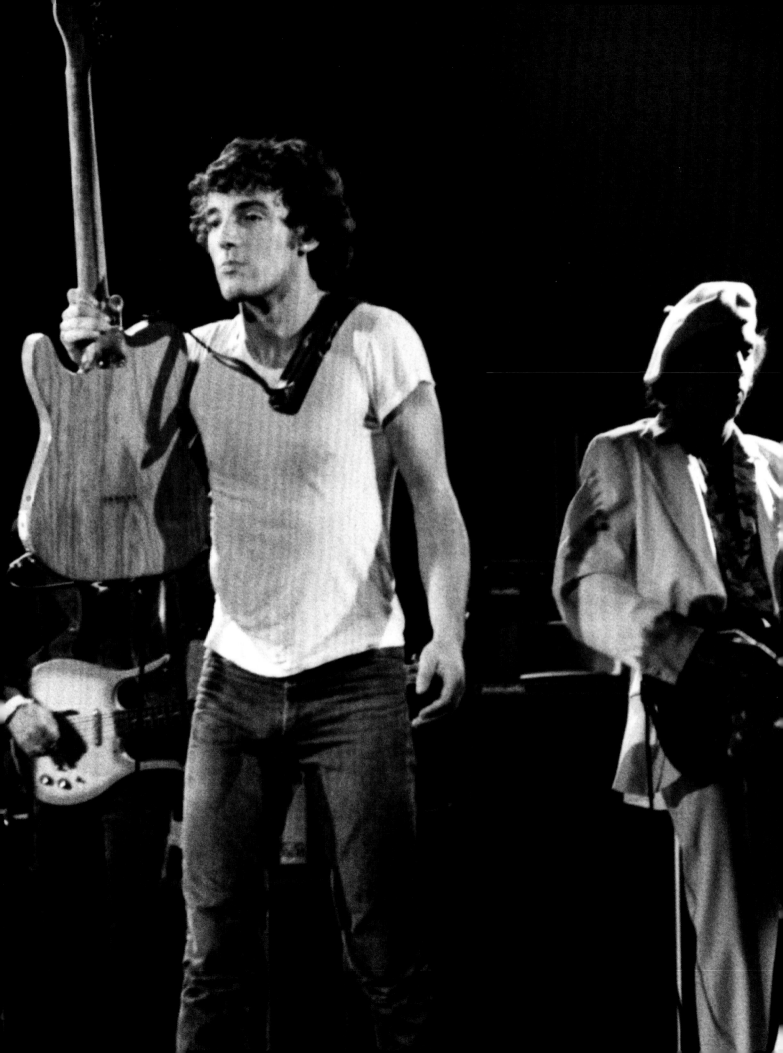

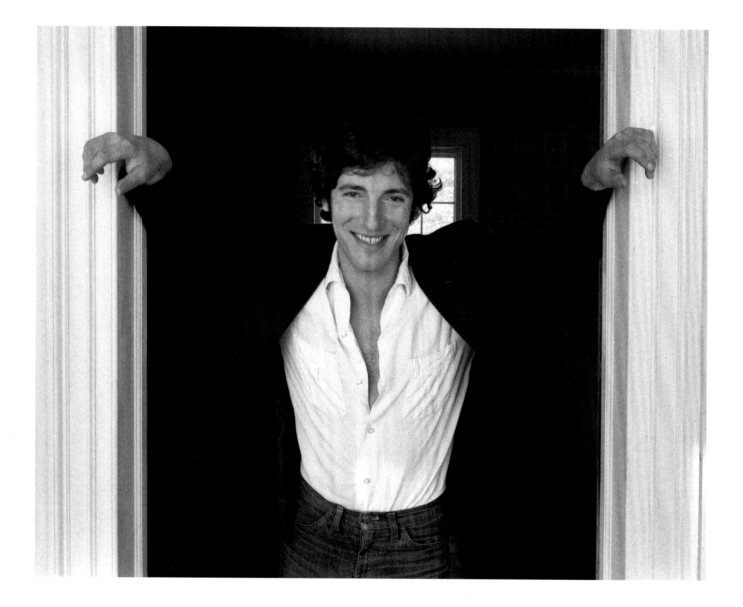

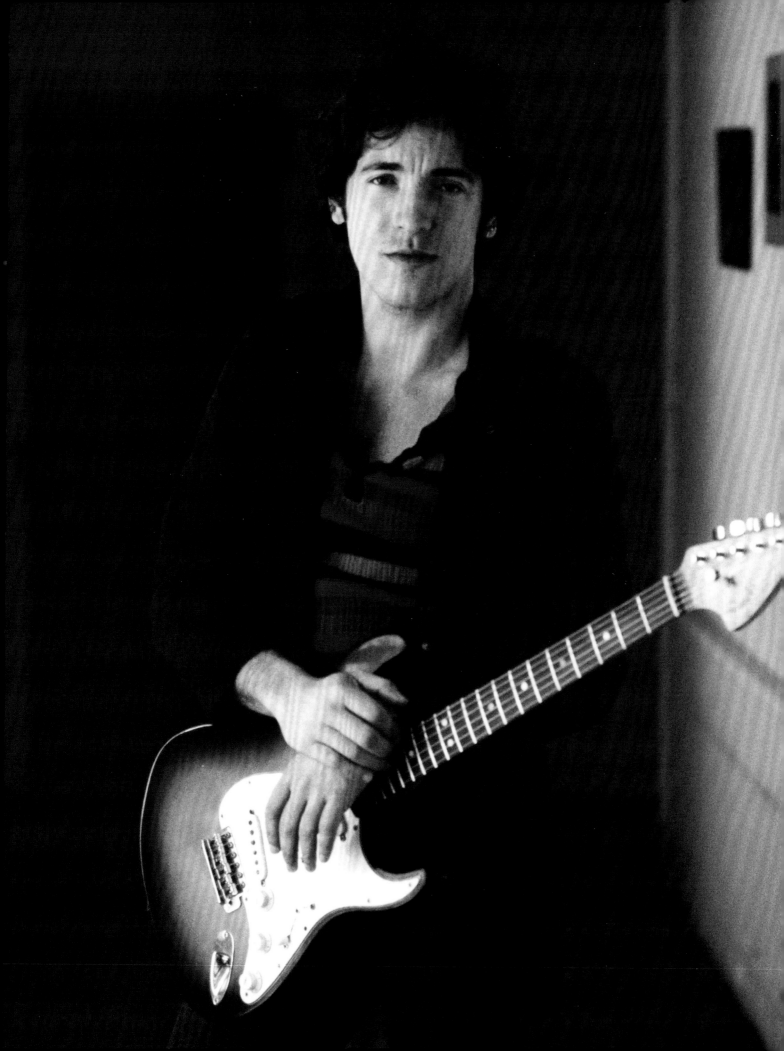

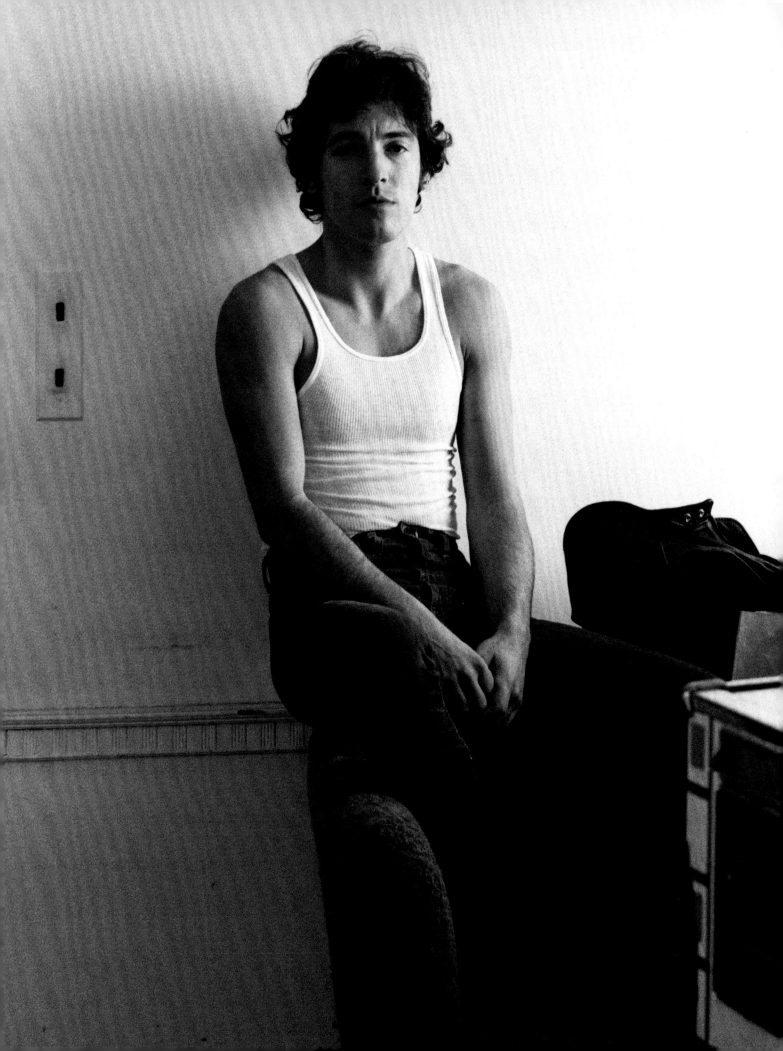

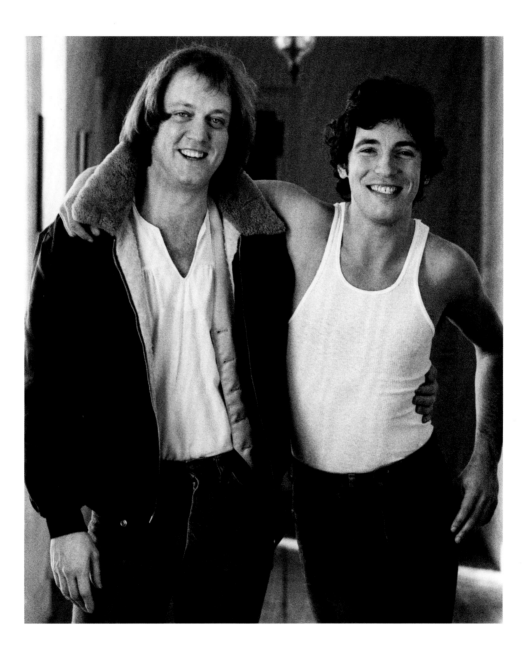

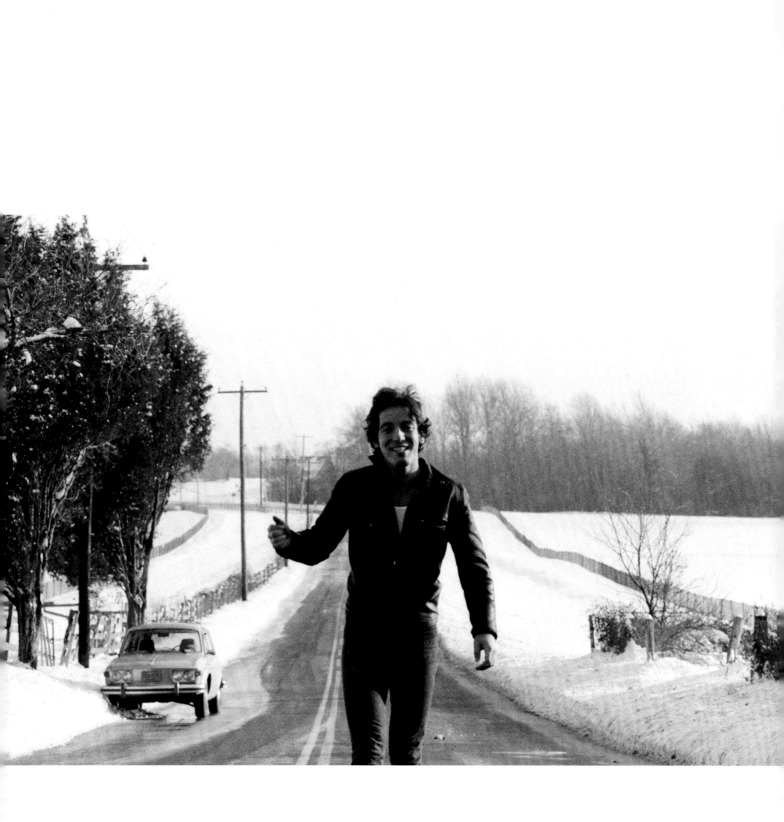

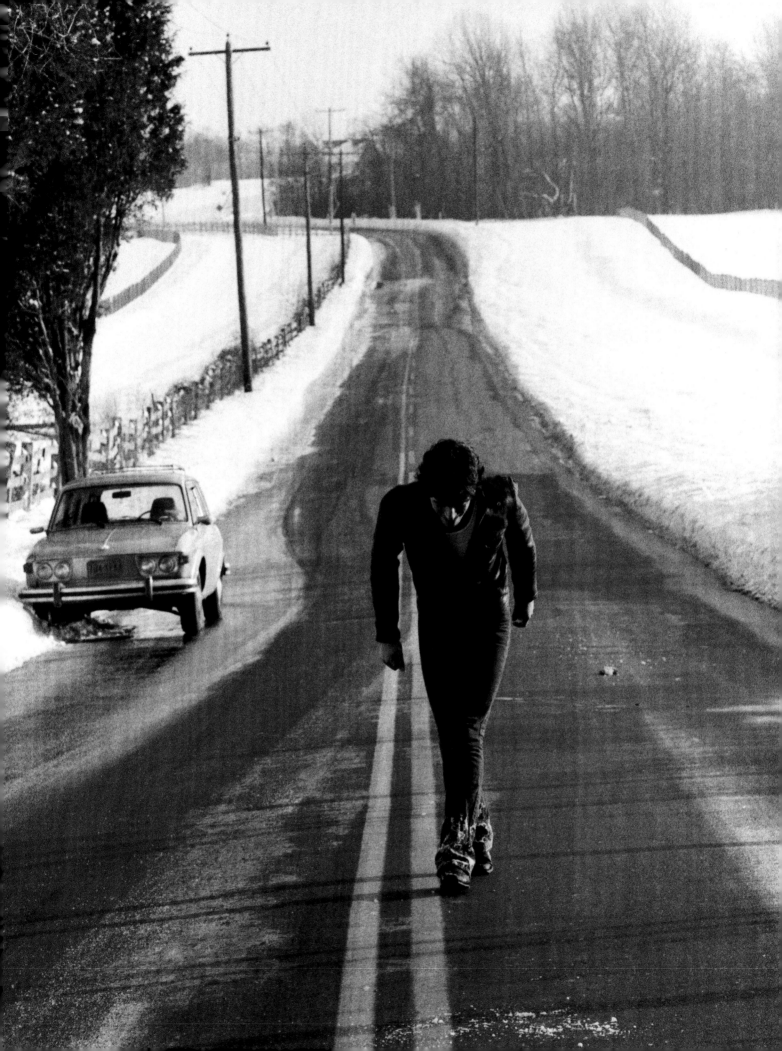

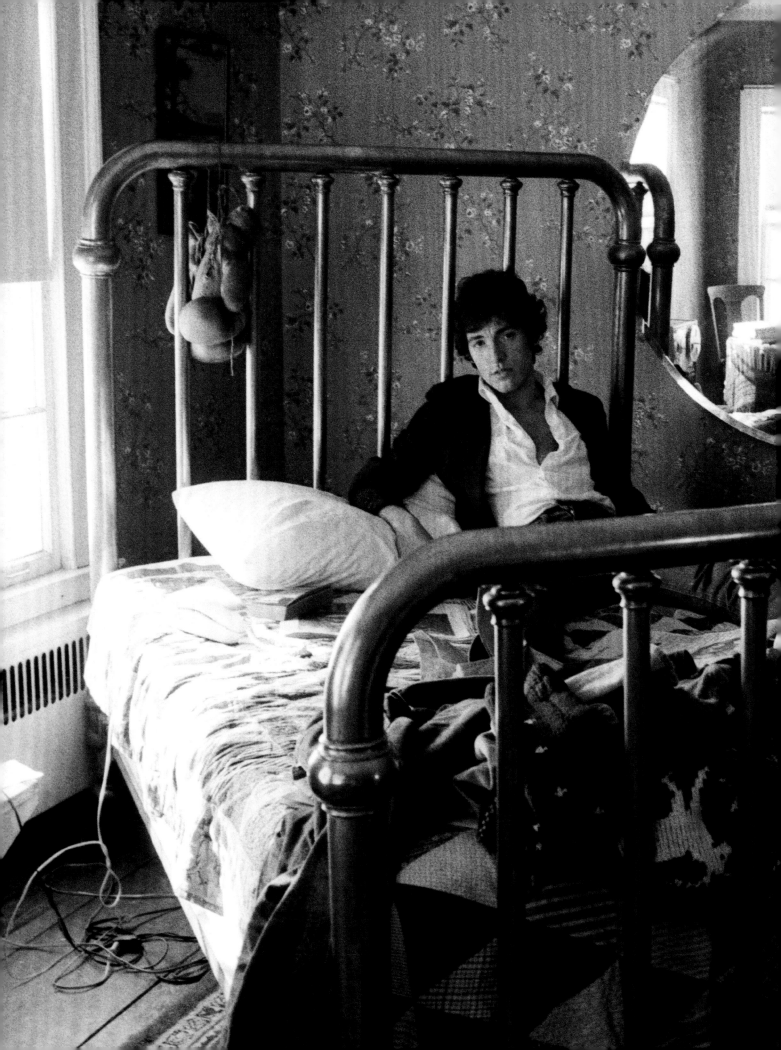

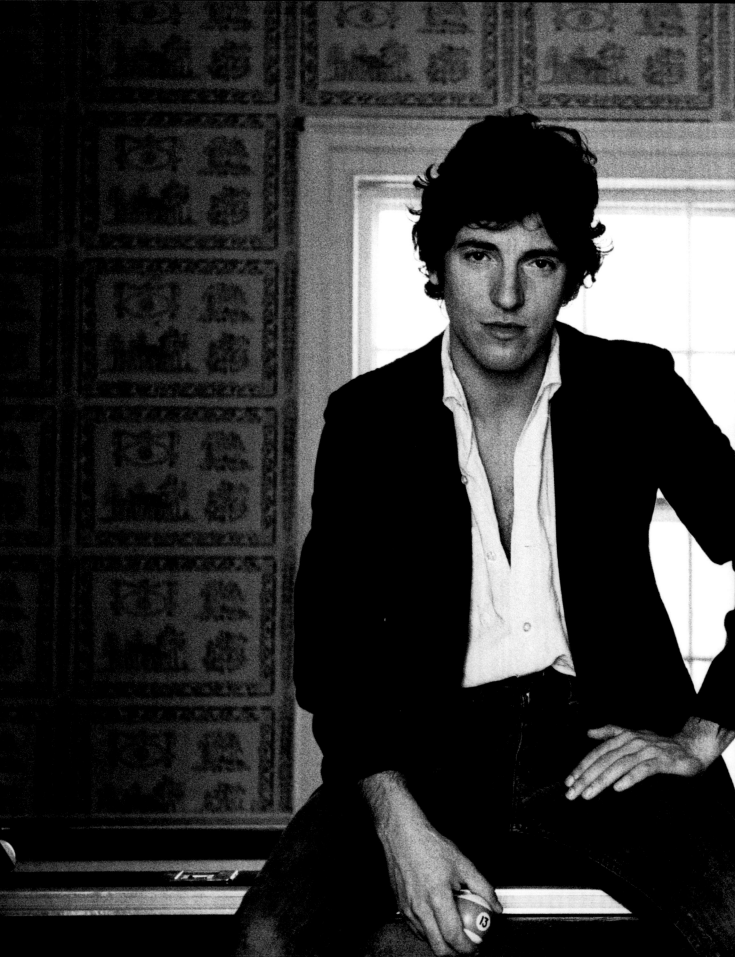

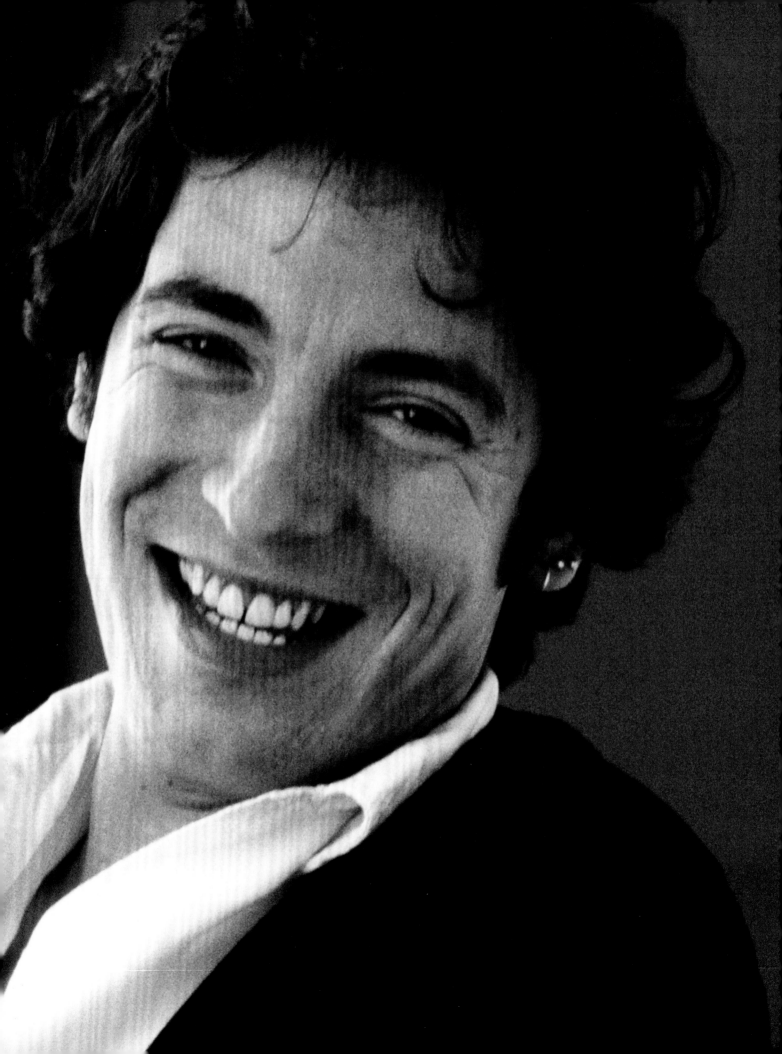

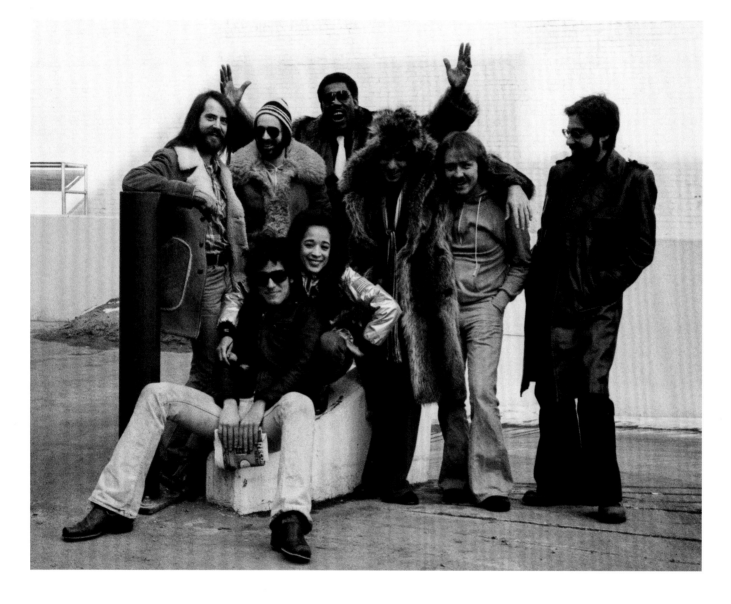

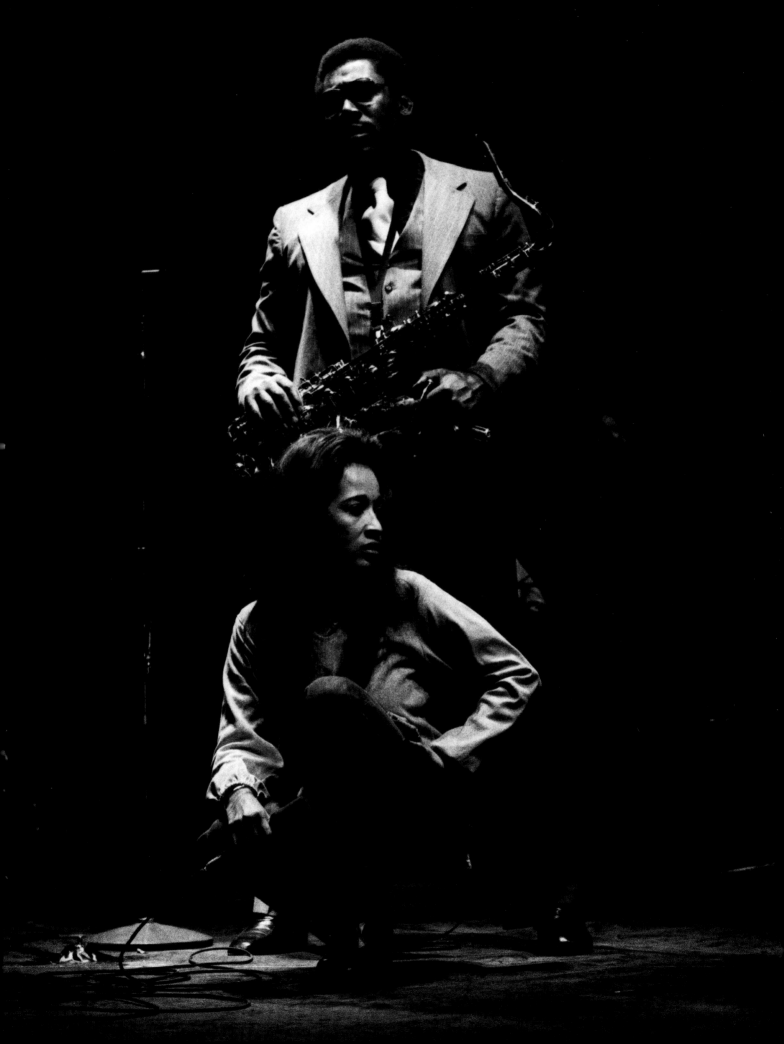

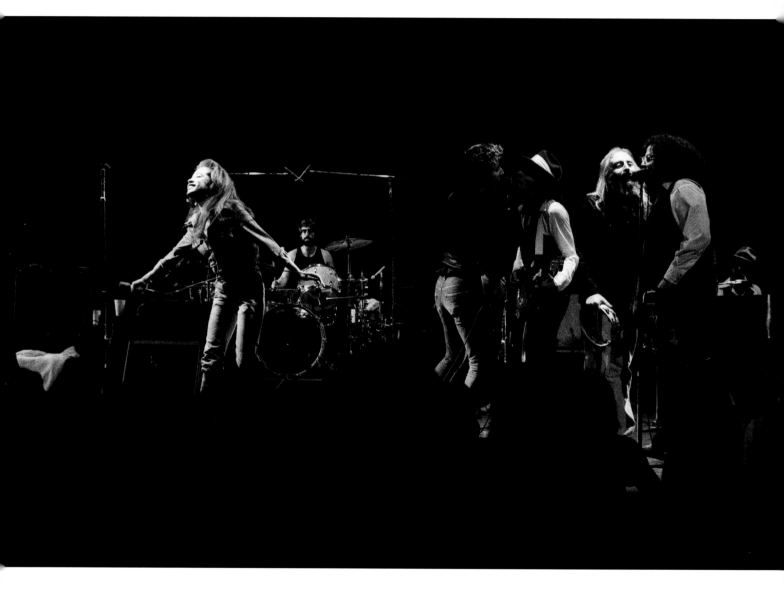

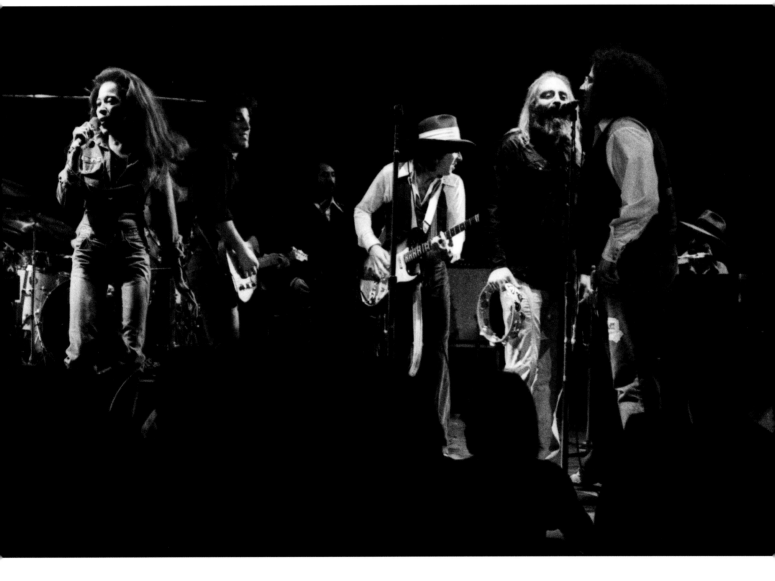

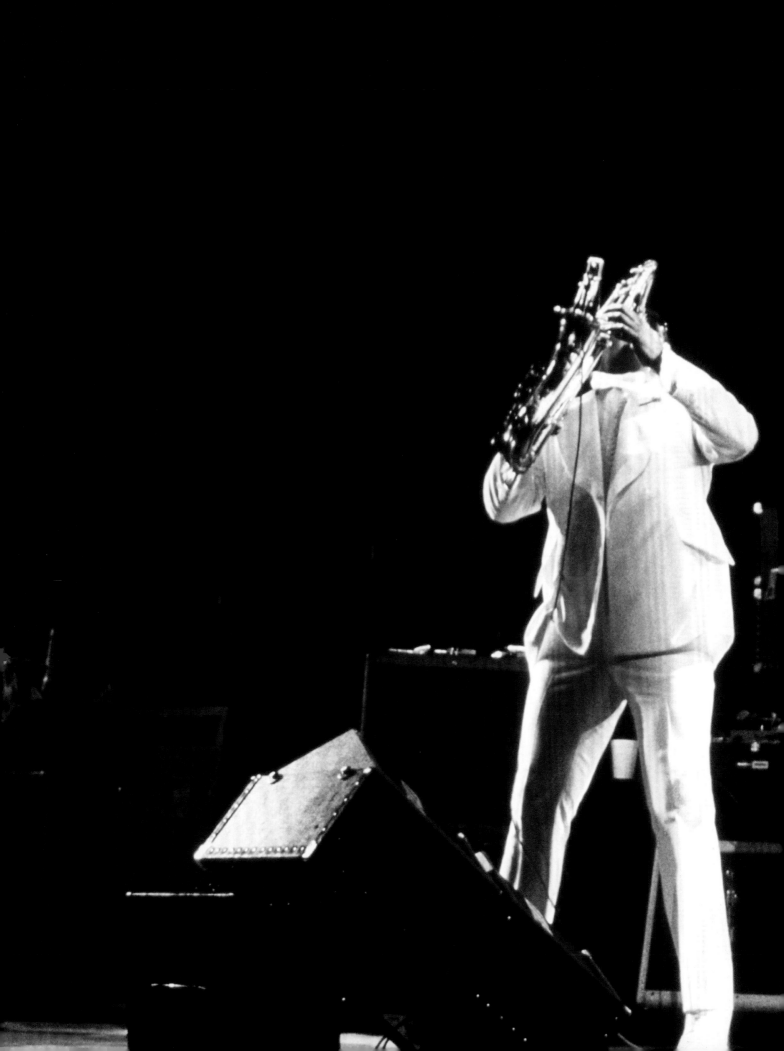

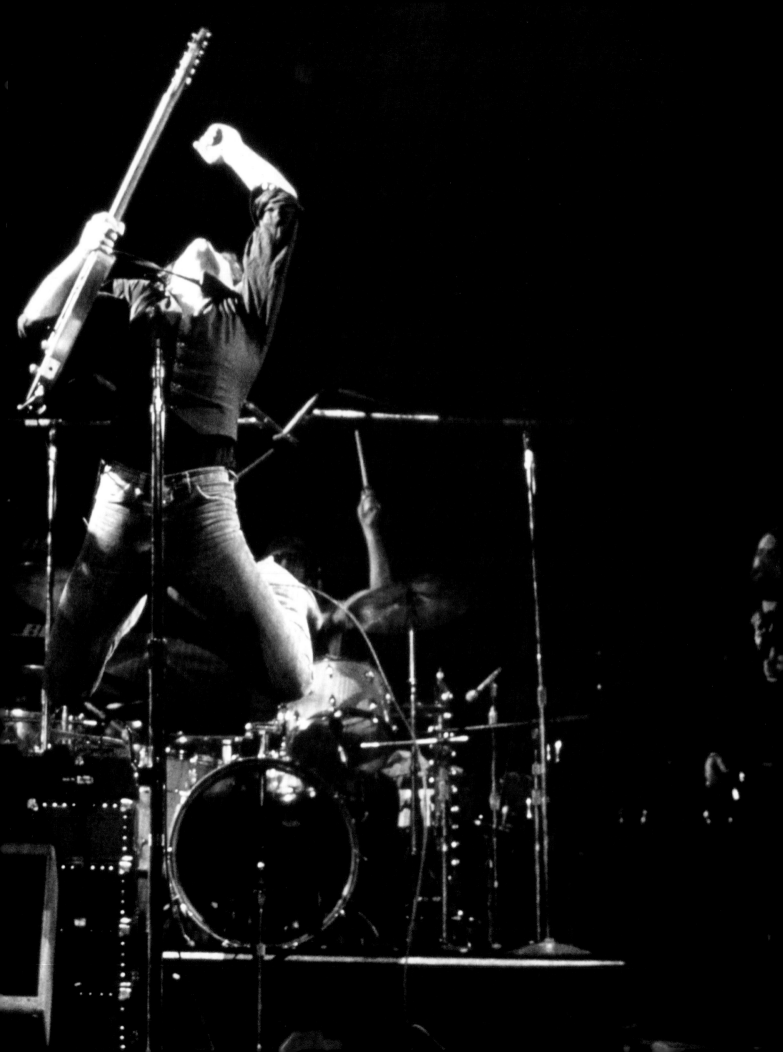

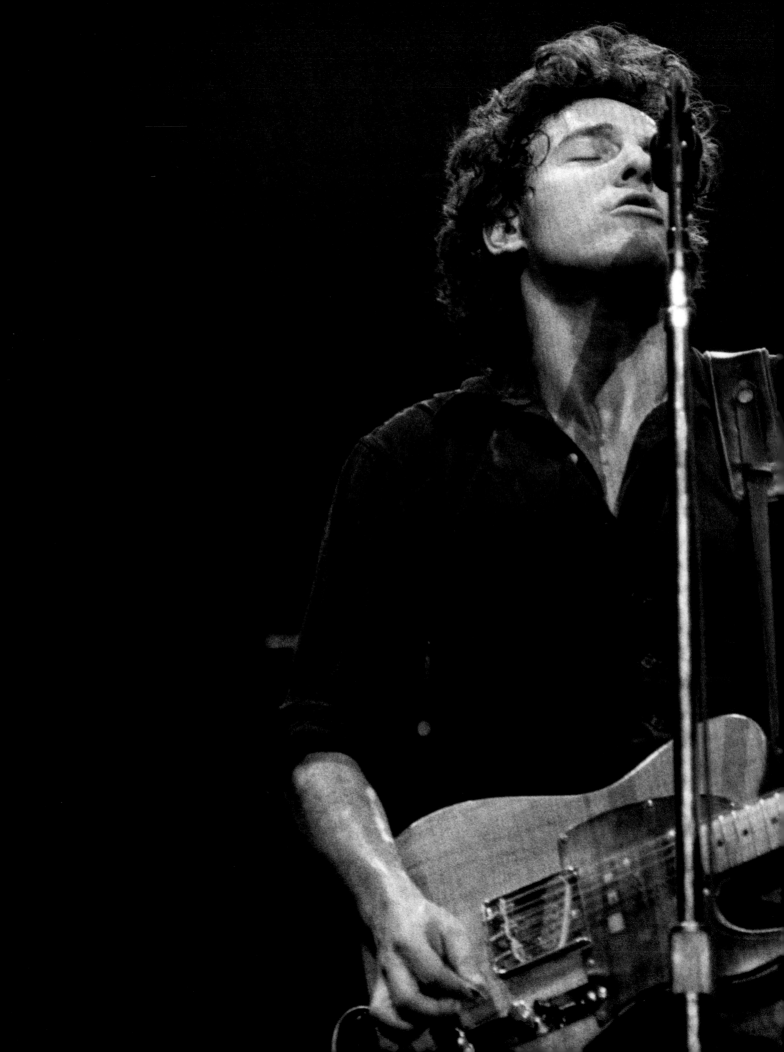

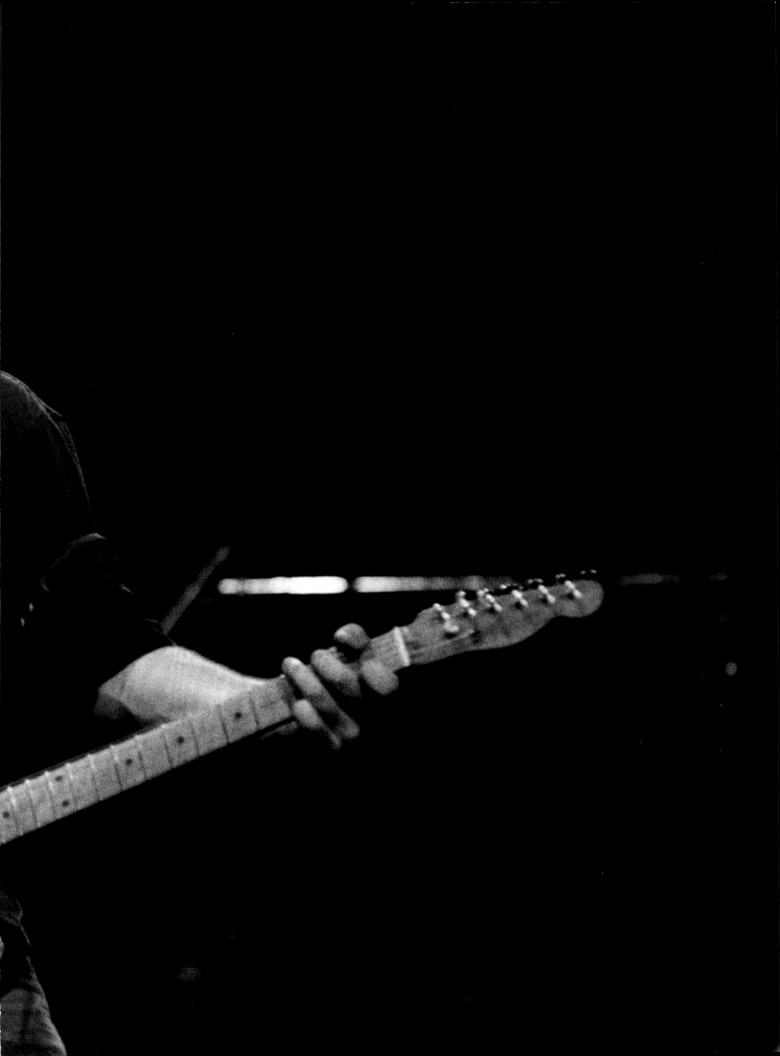

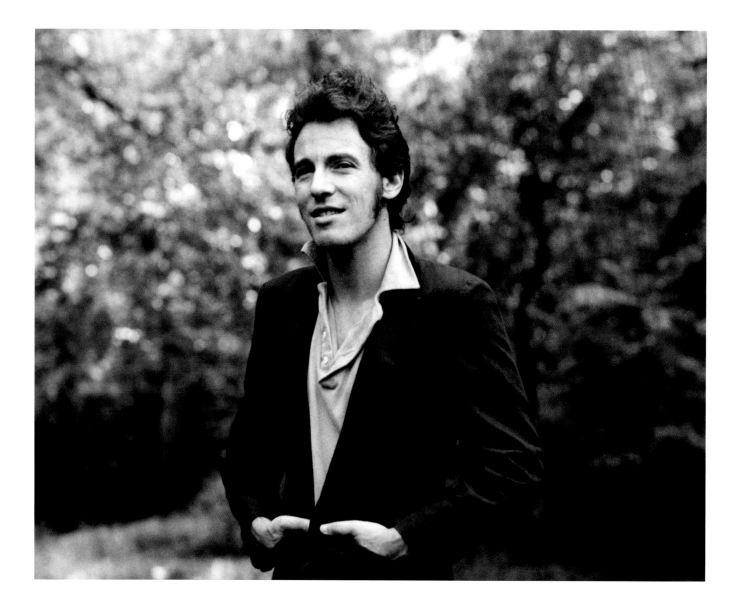

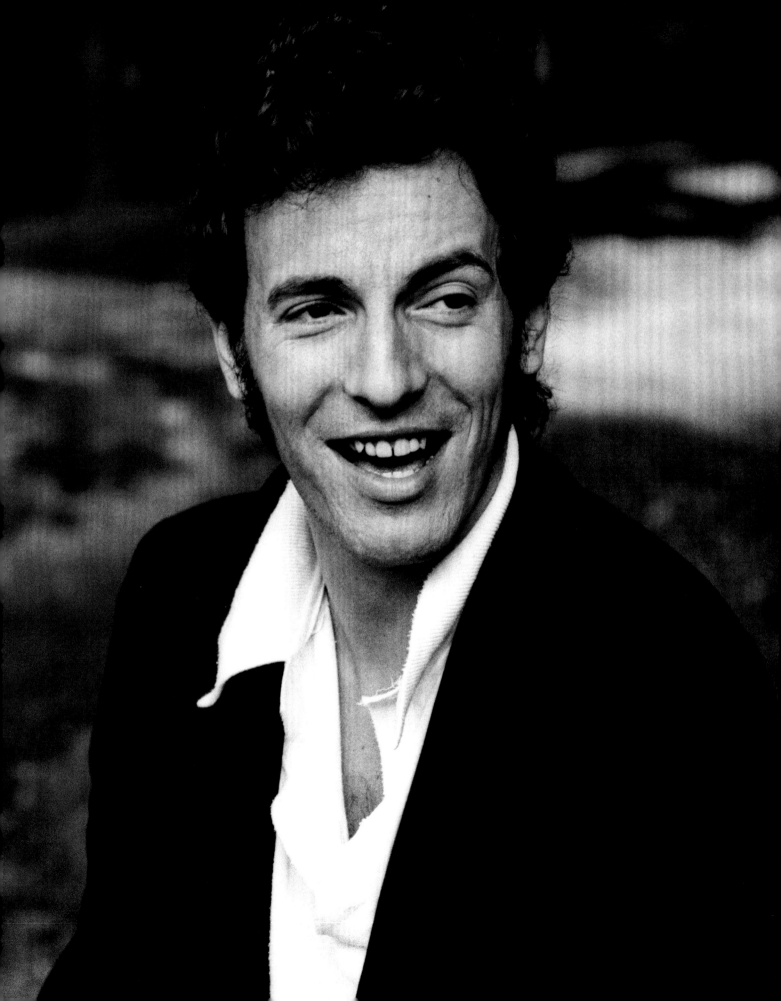

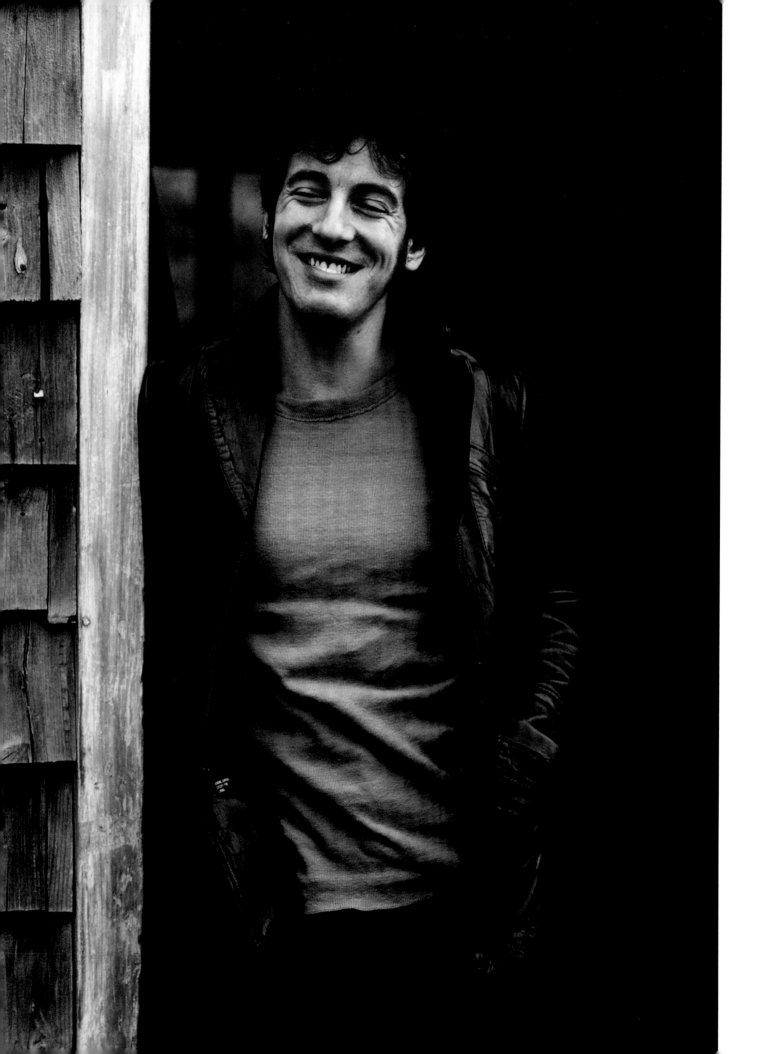

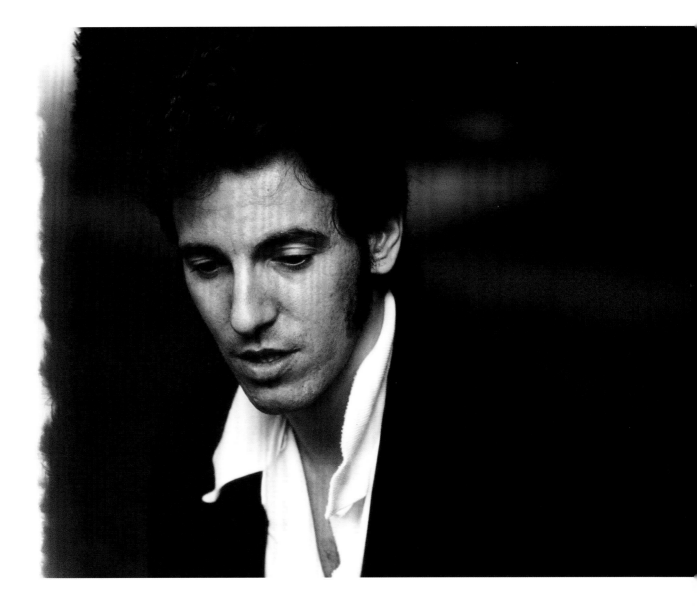

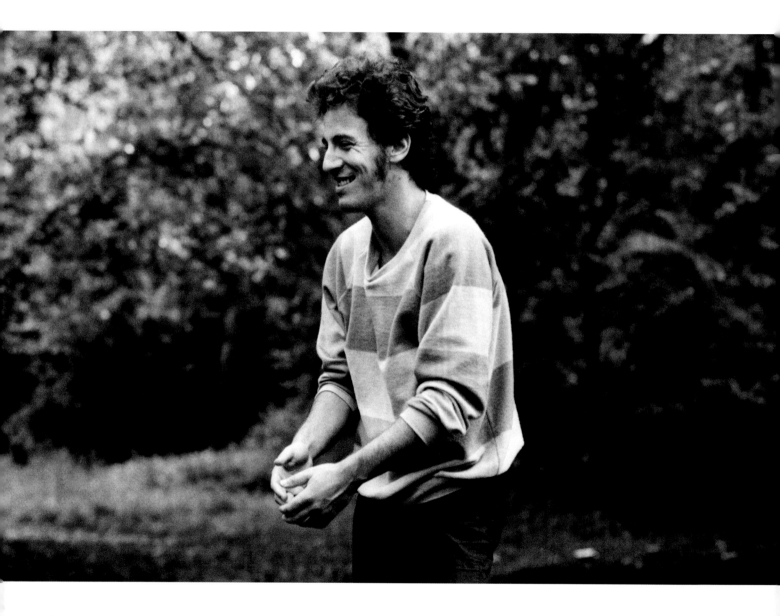

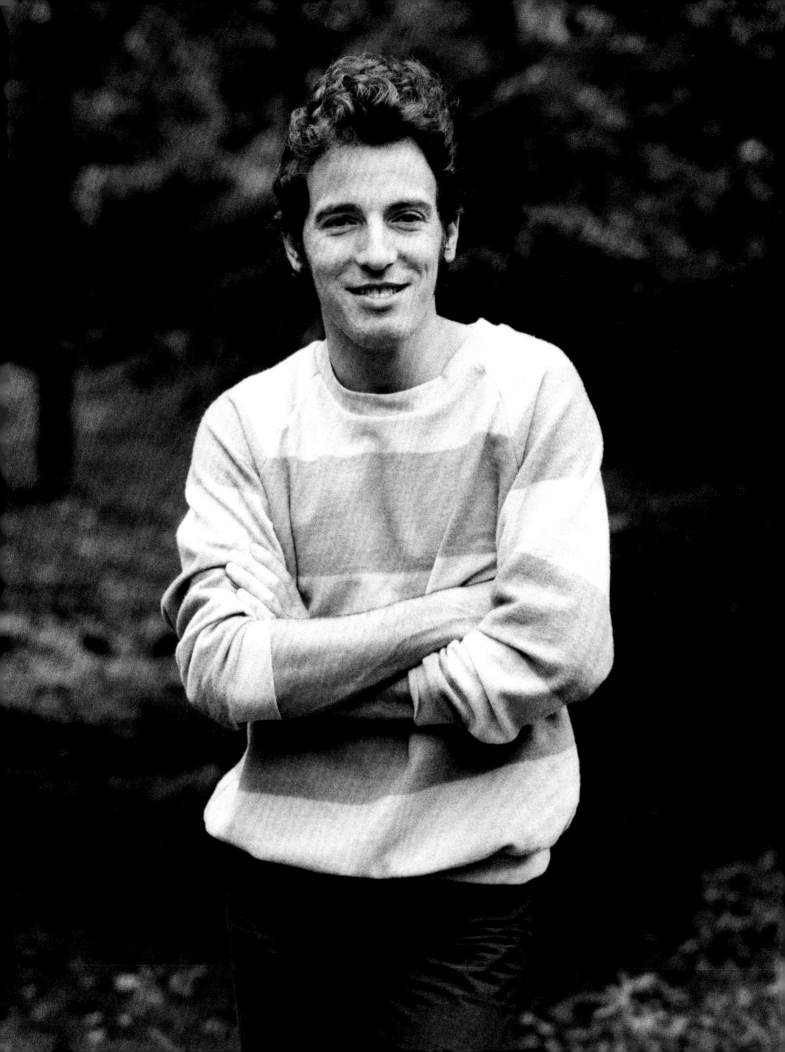

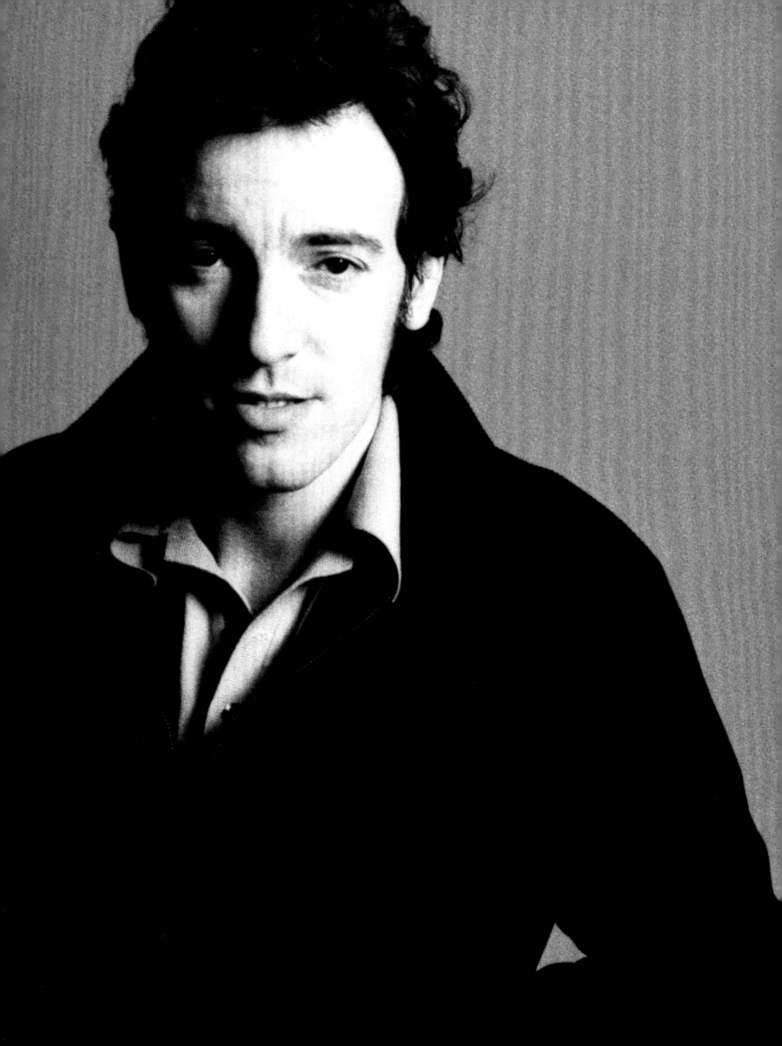

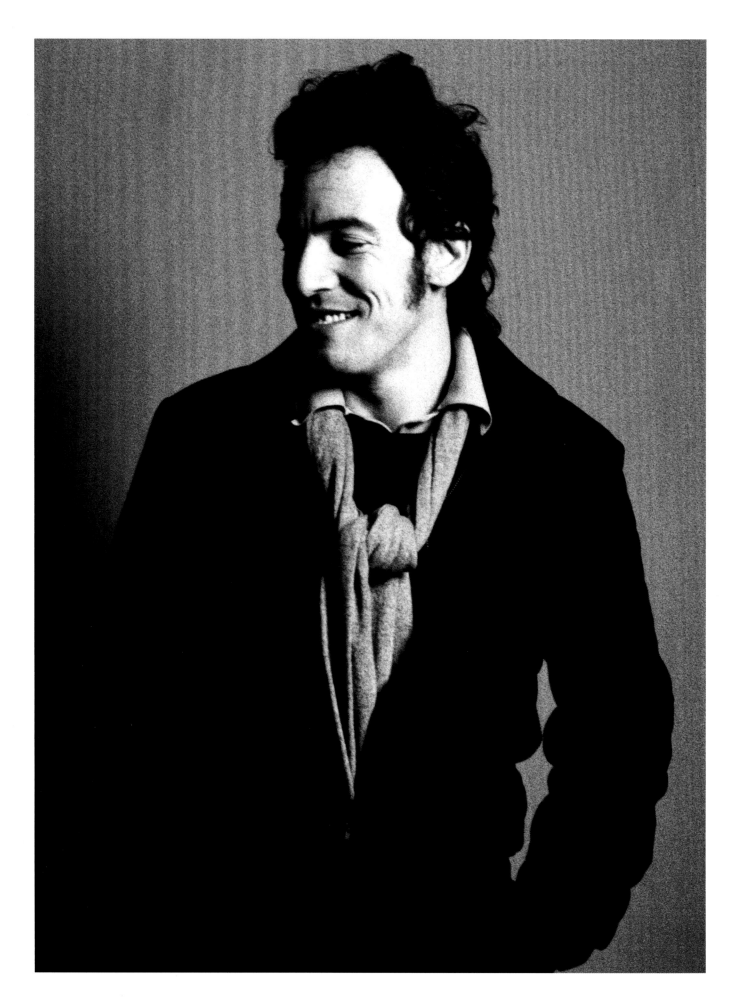

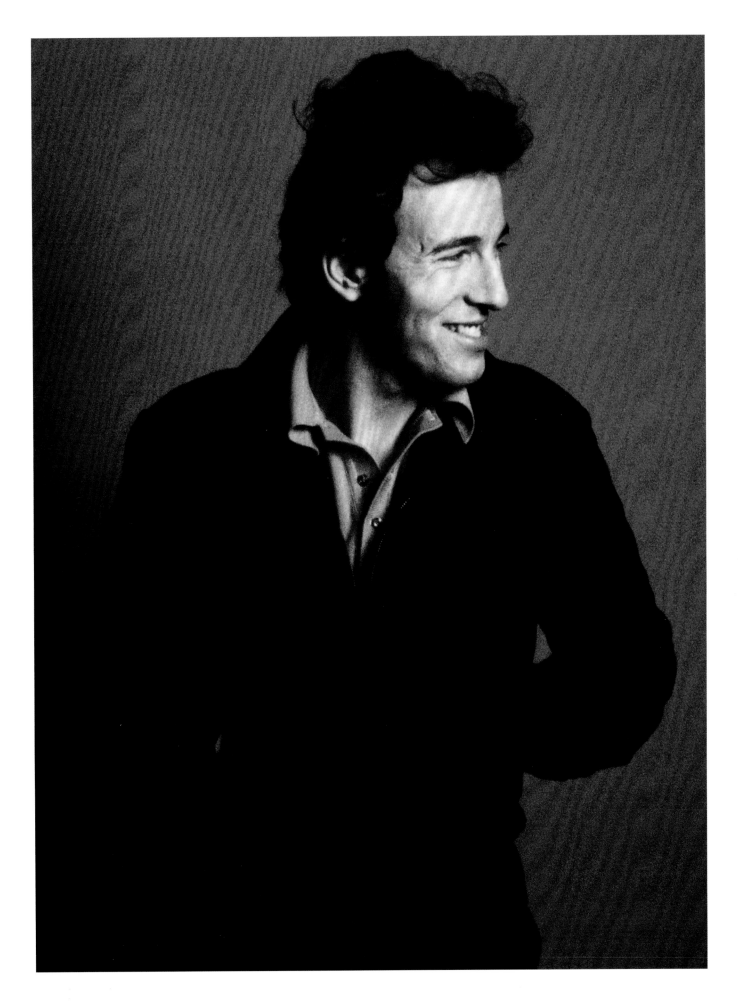

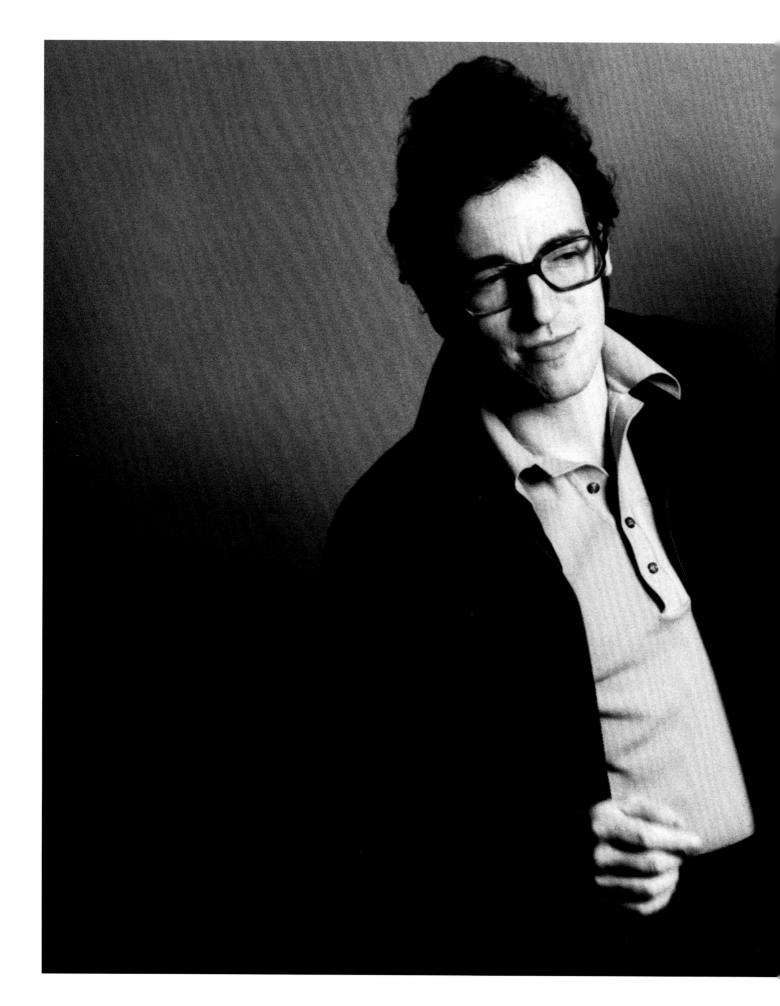

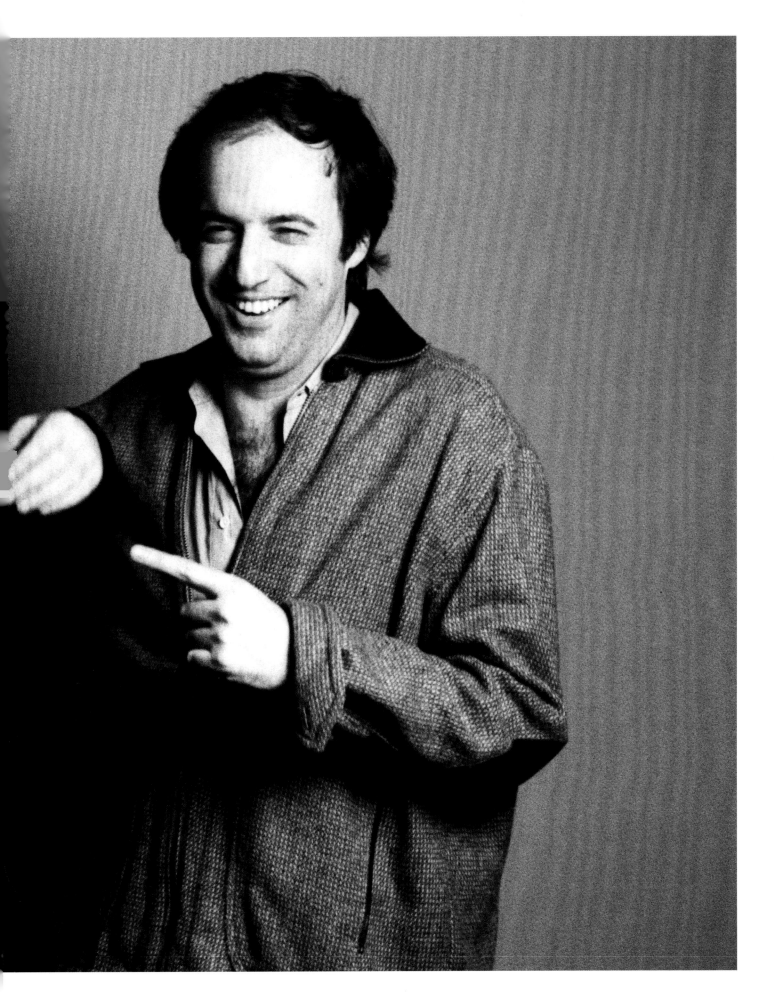

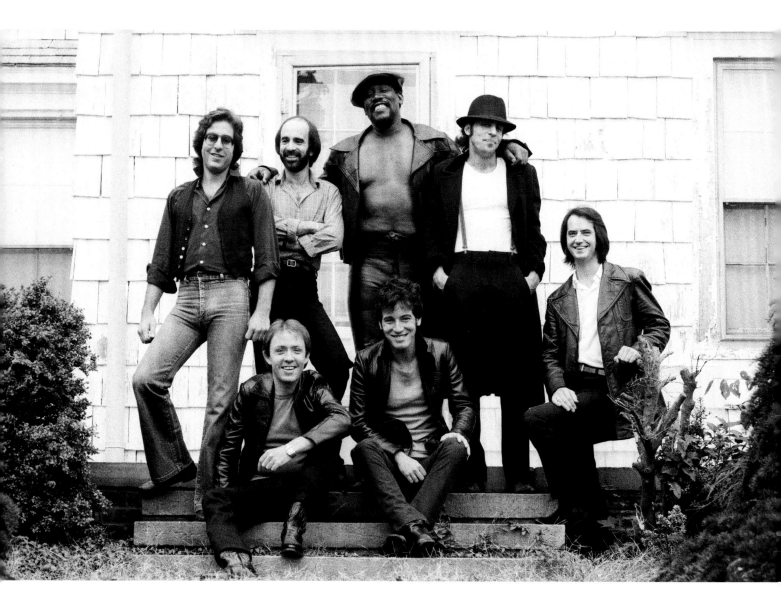

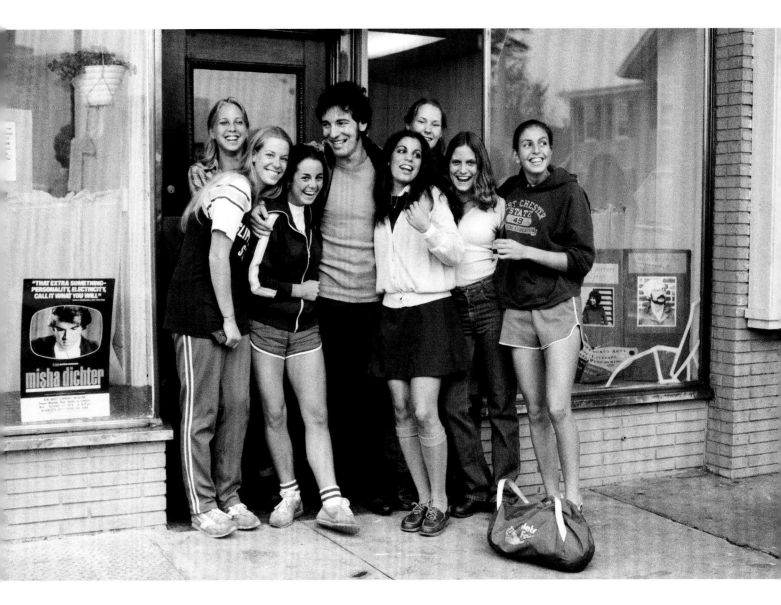

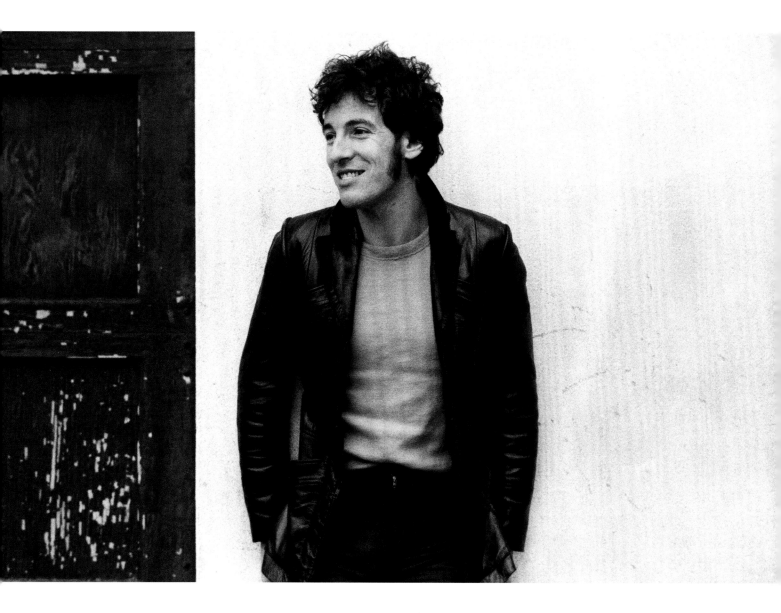

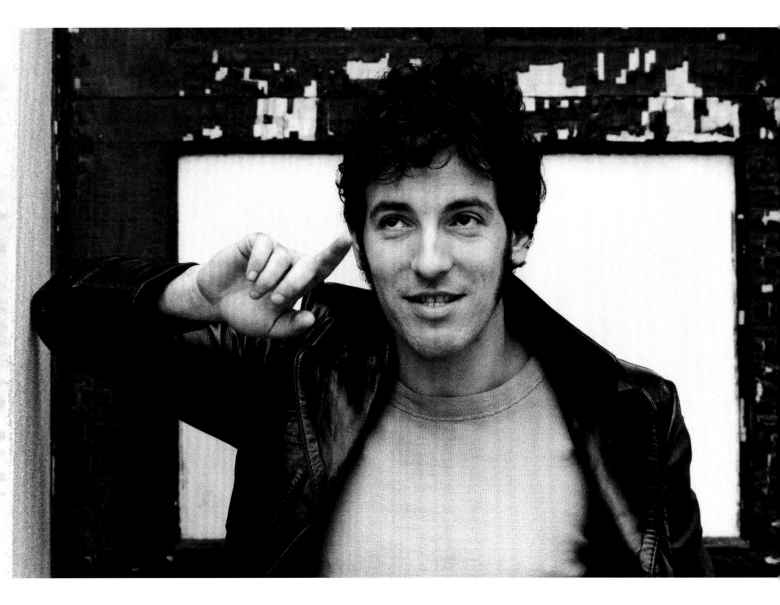

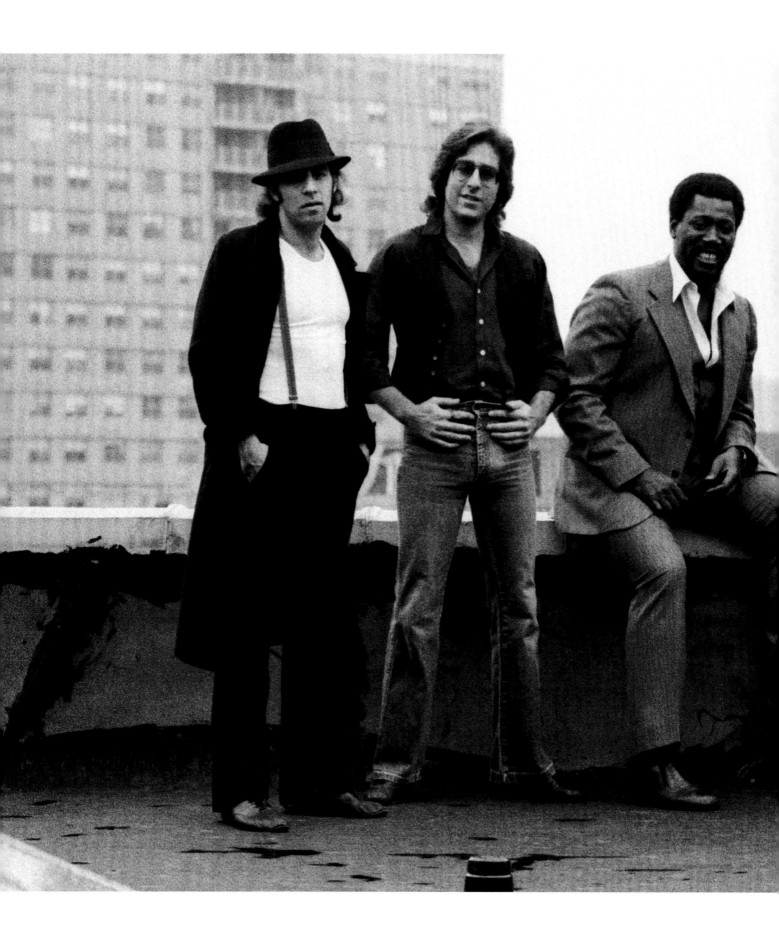

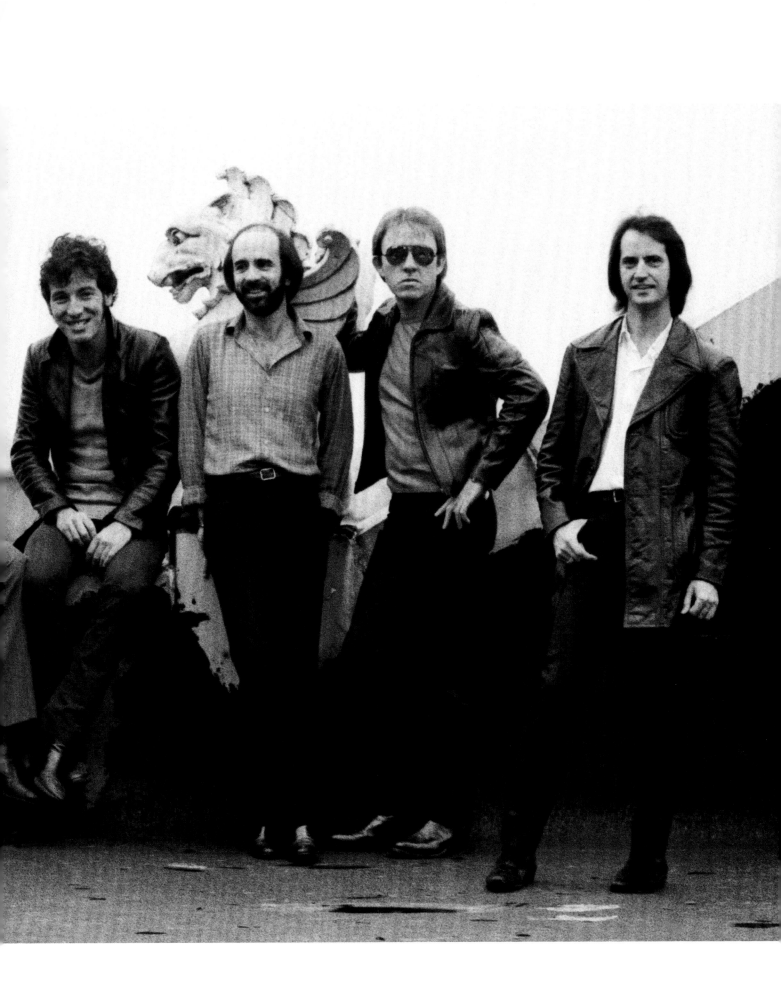

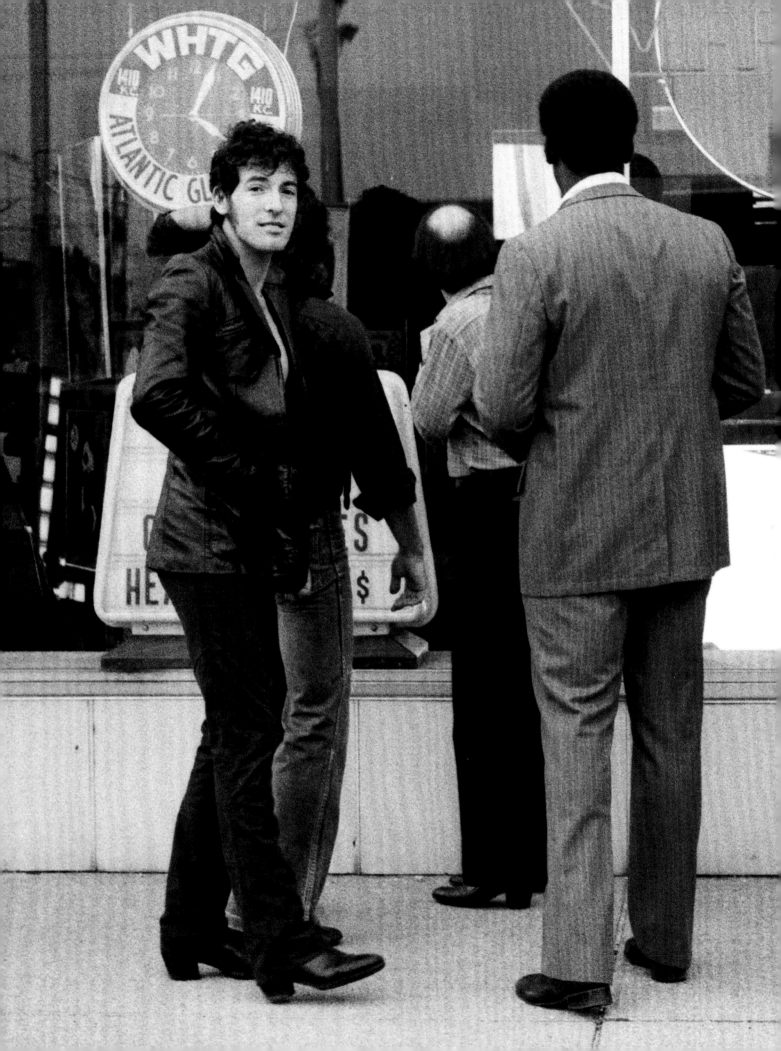

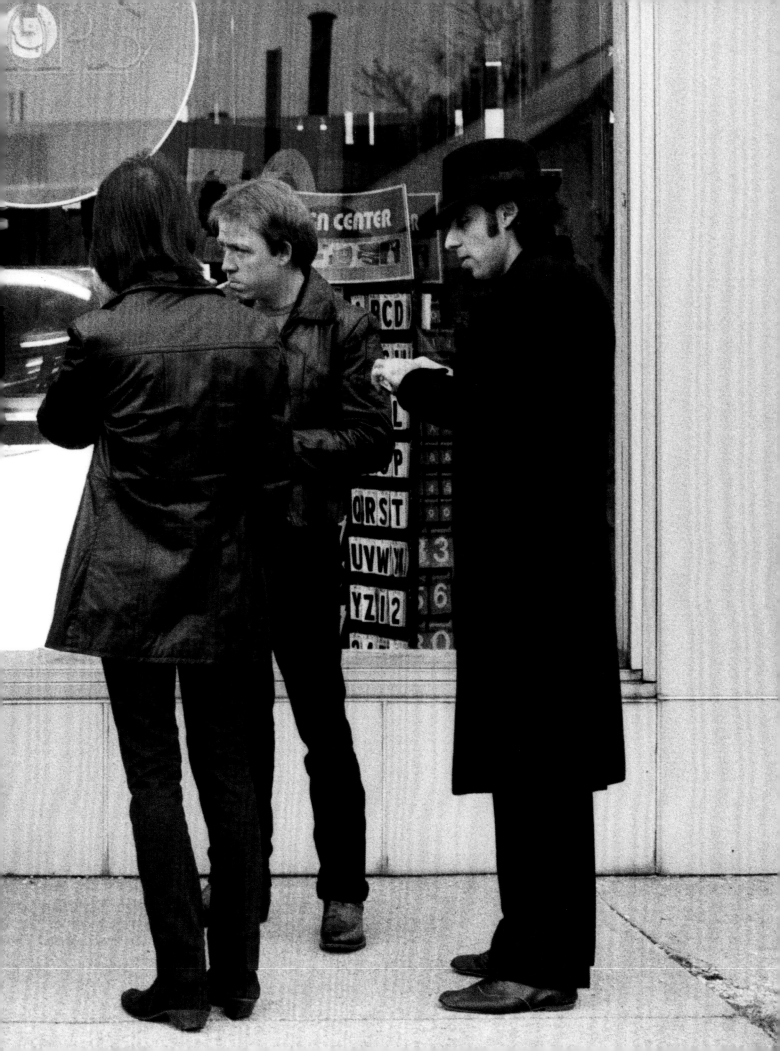

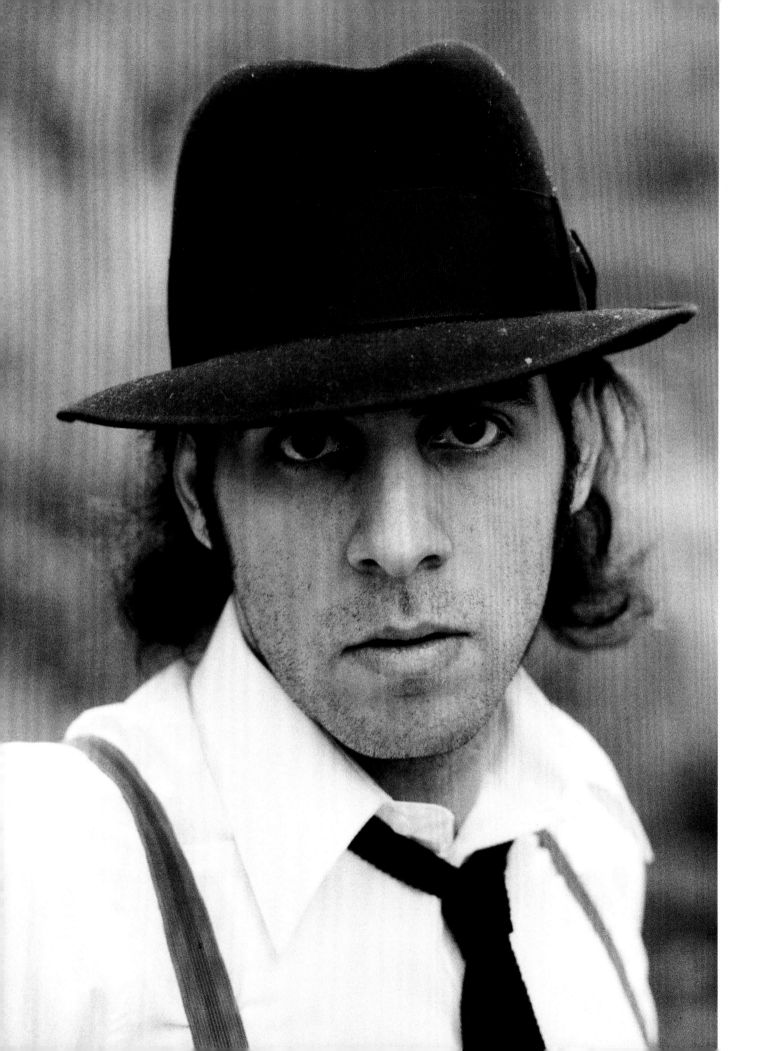

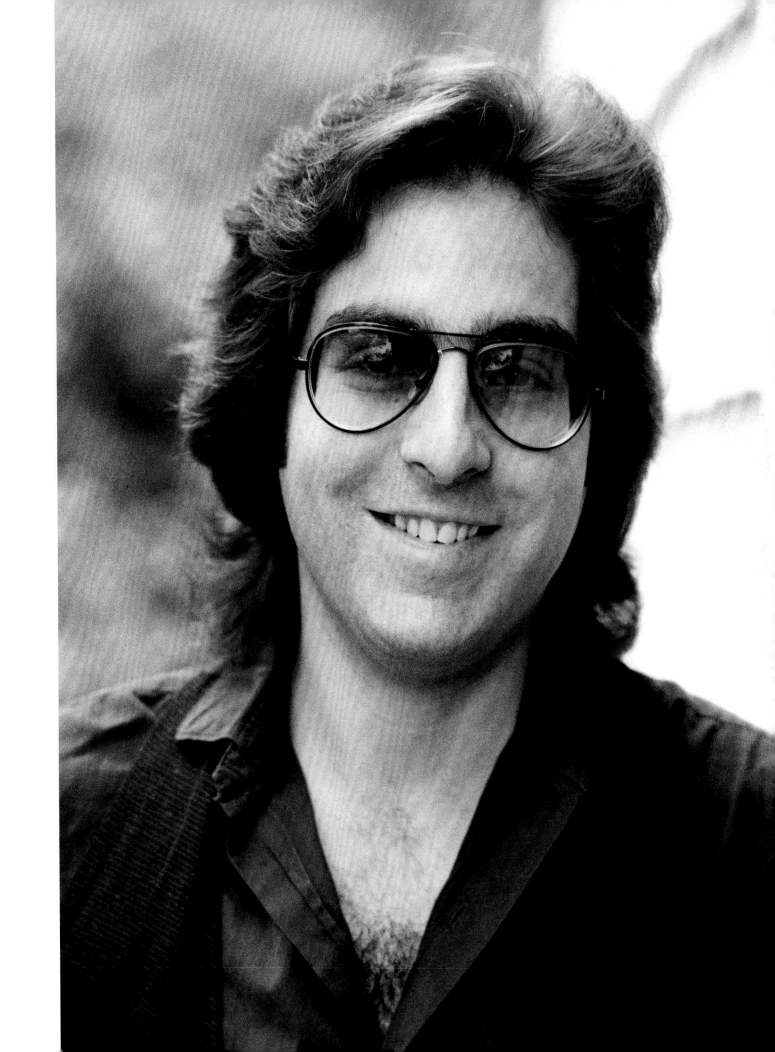

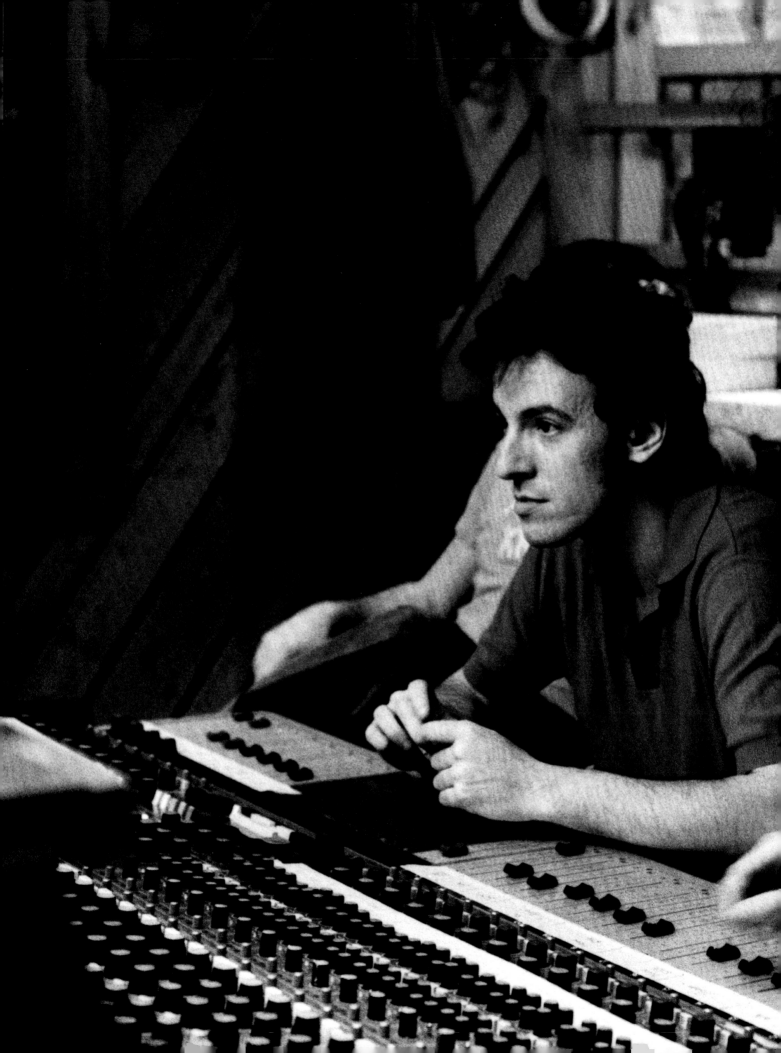

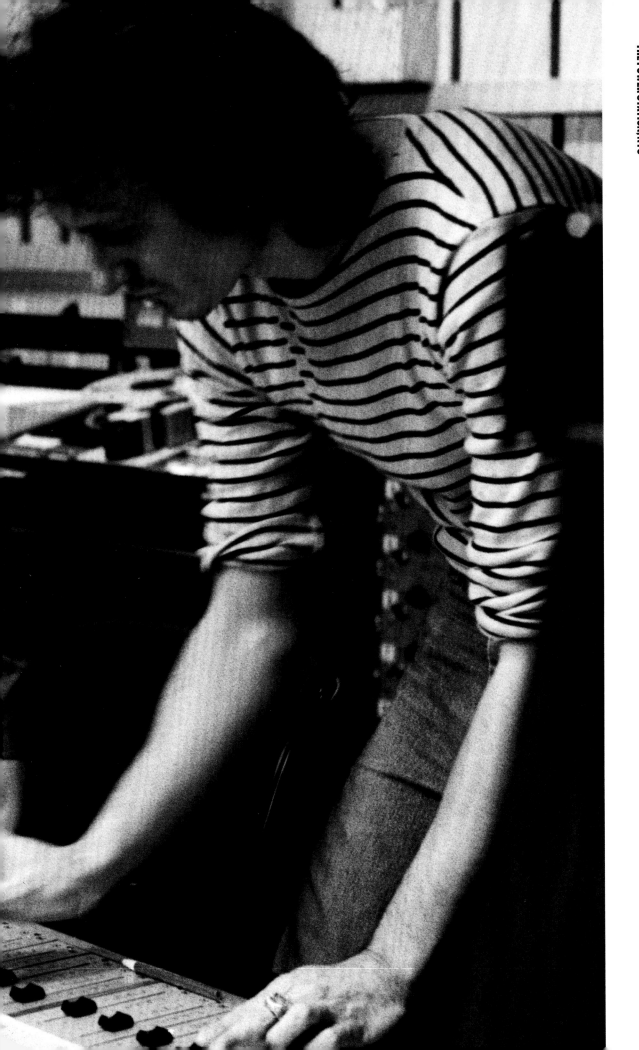

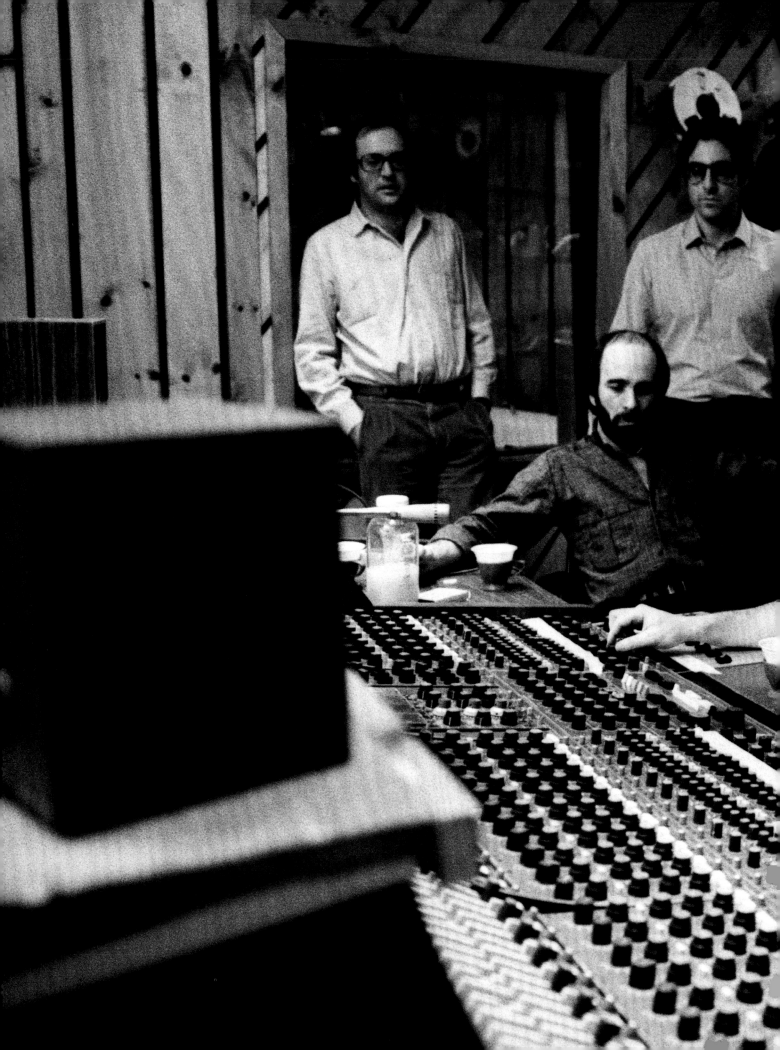

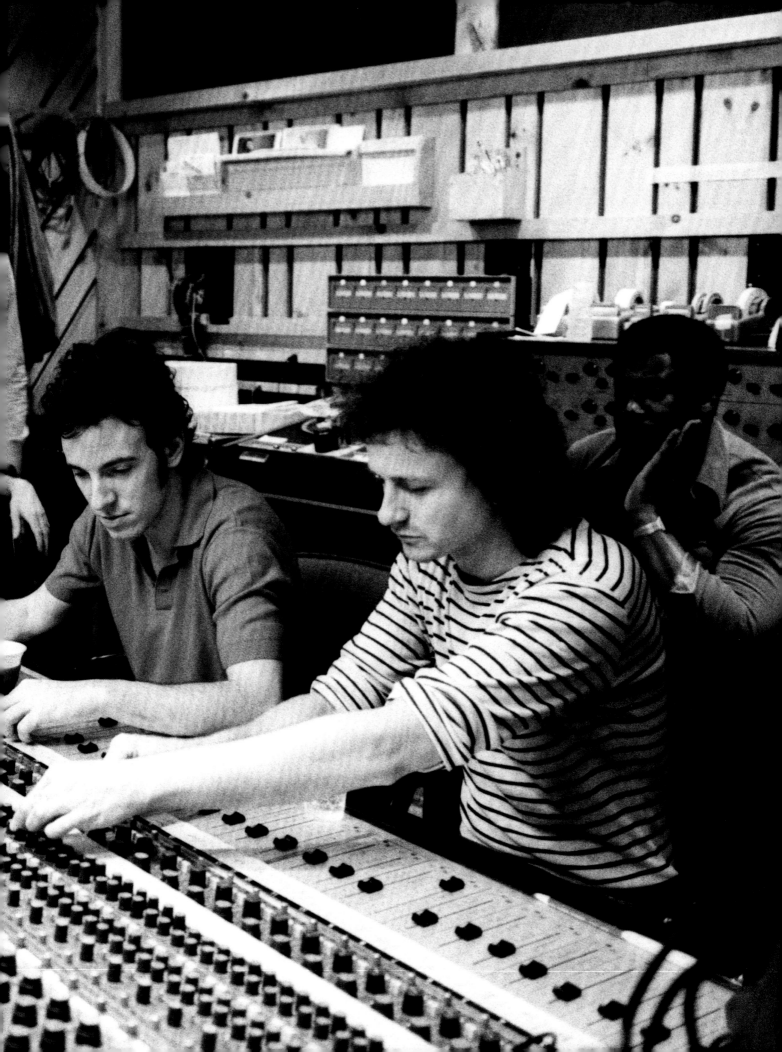

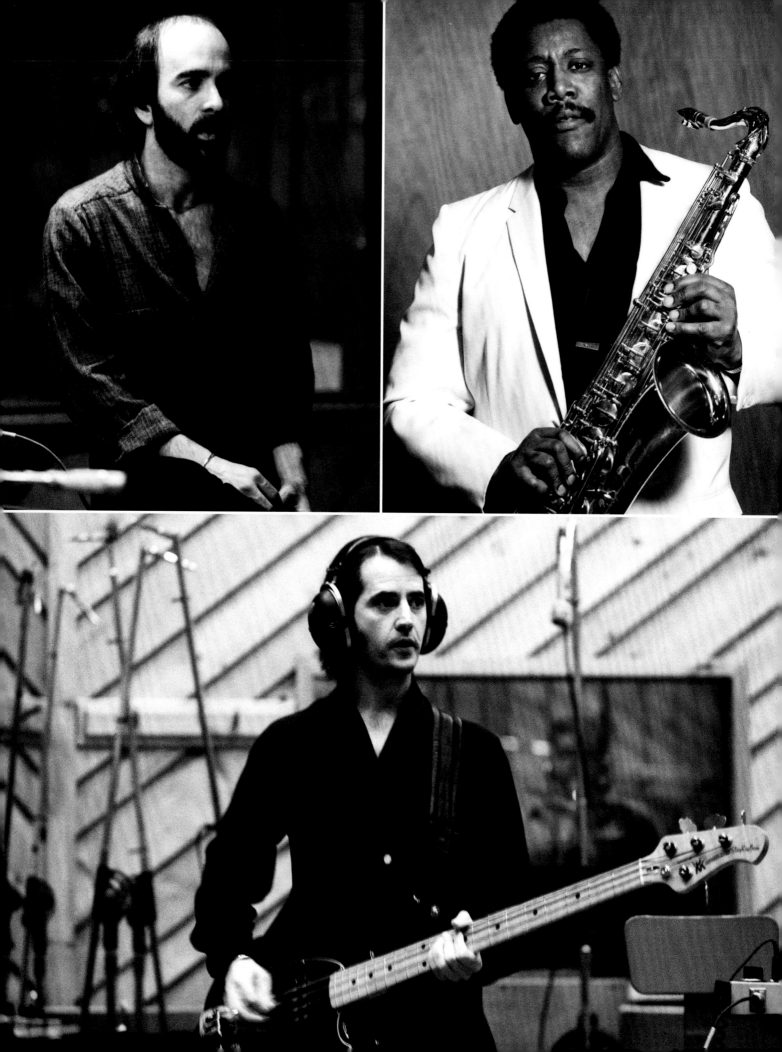

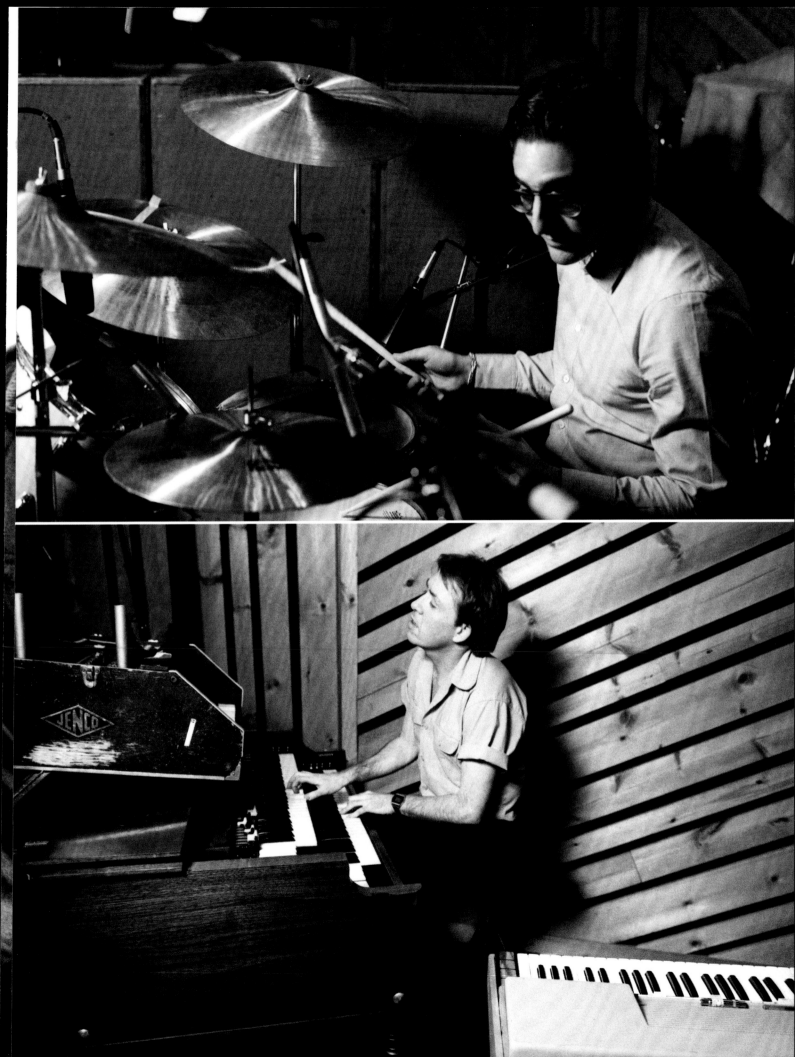

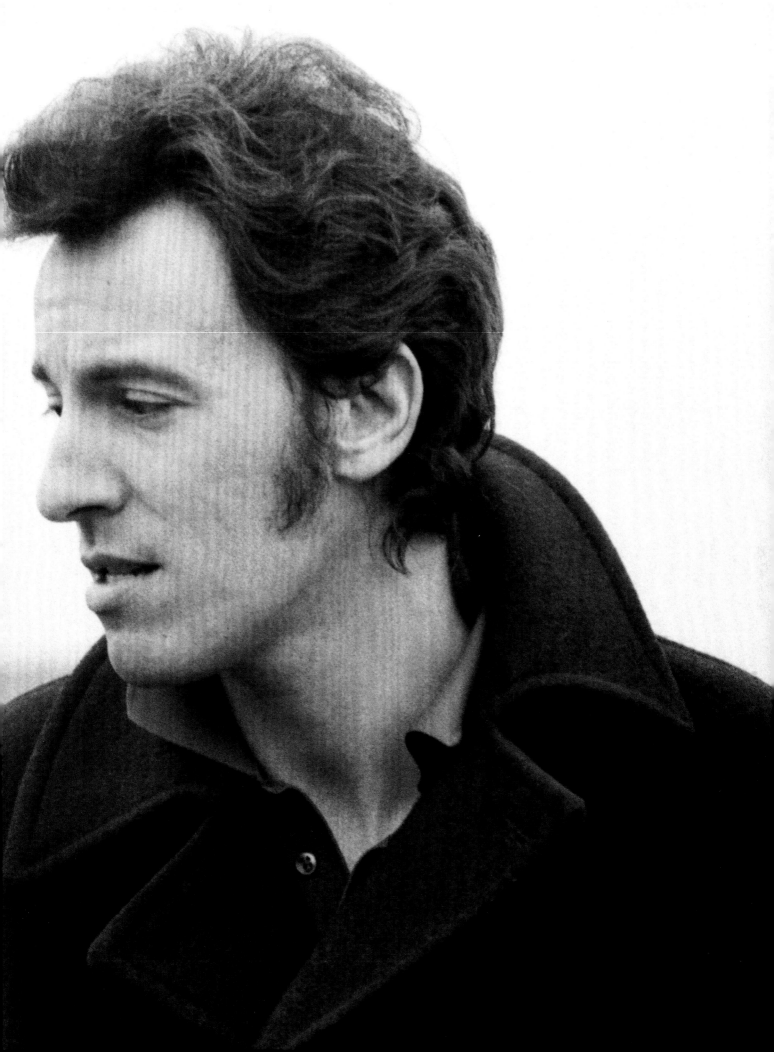

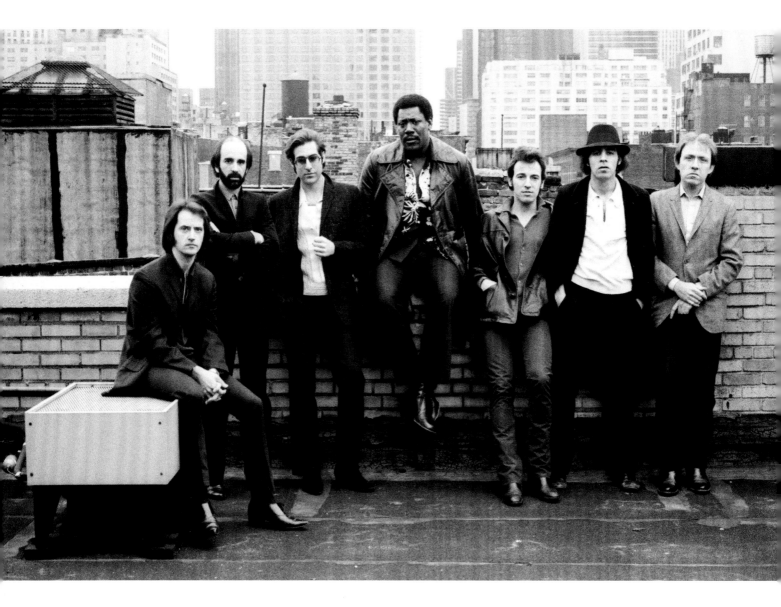

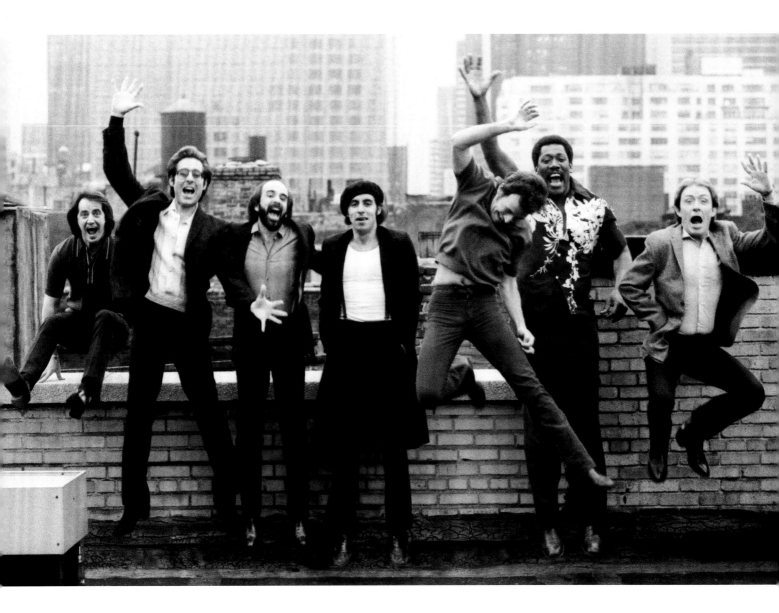

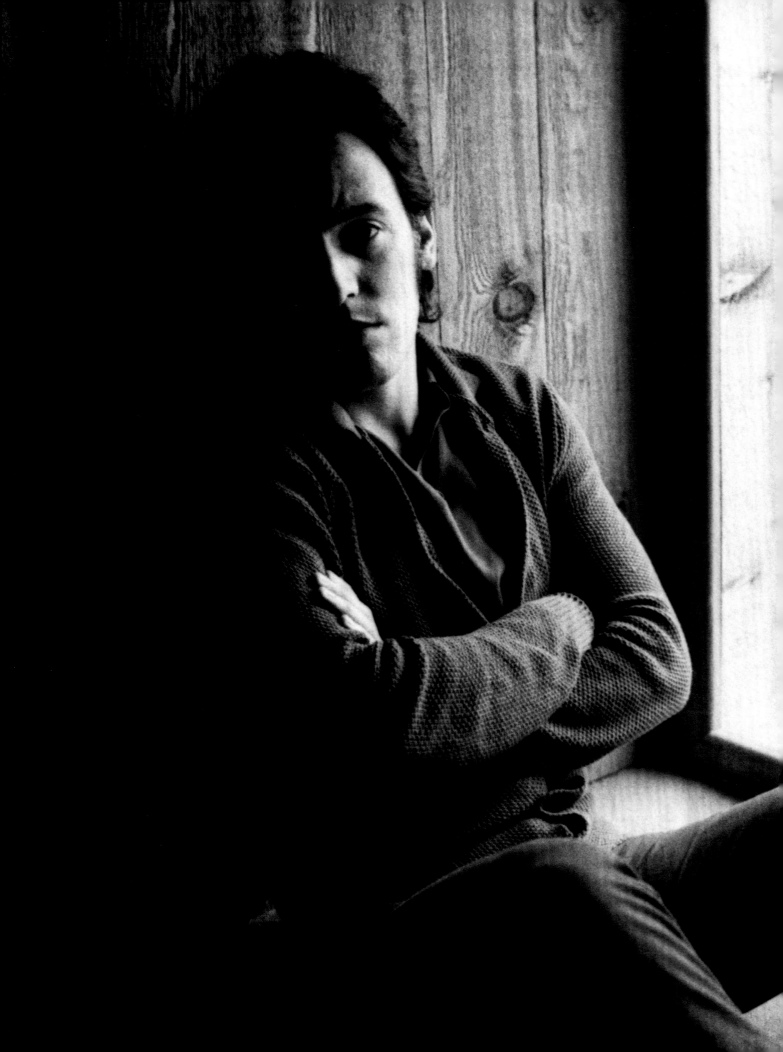

1980

MADISON SQUARE GARDEN, NYC

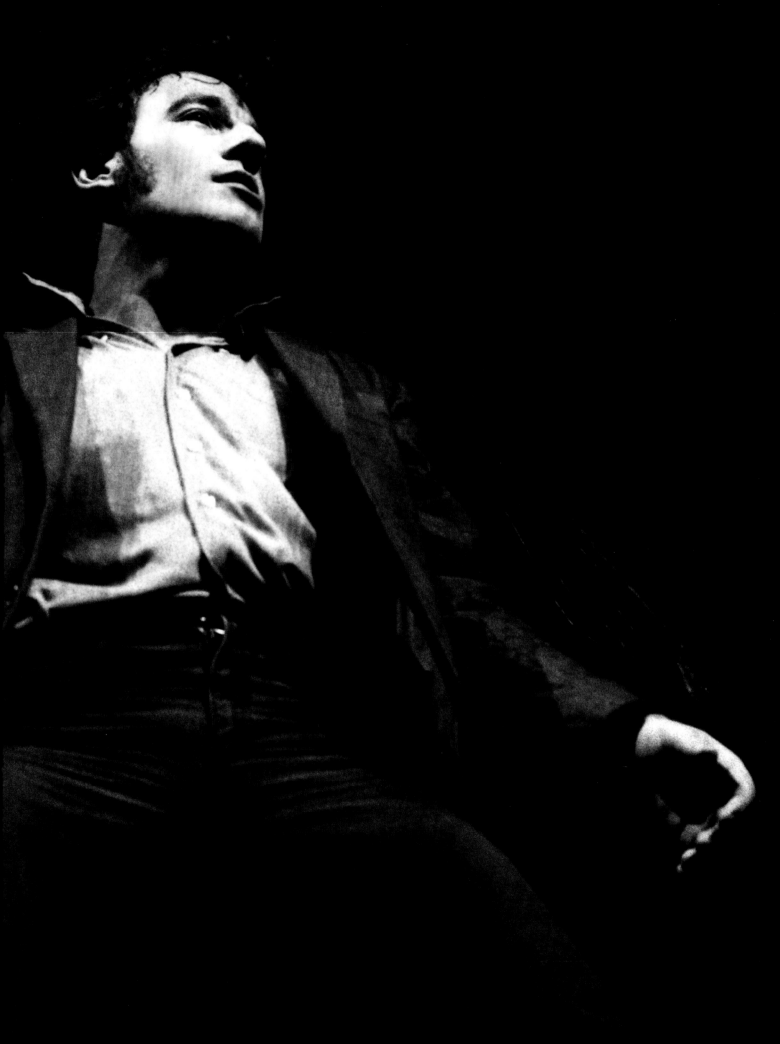

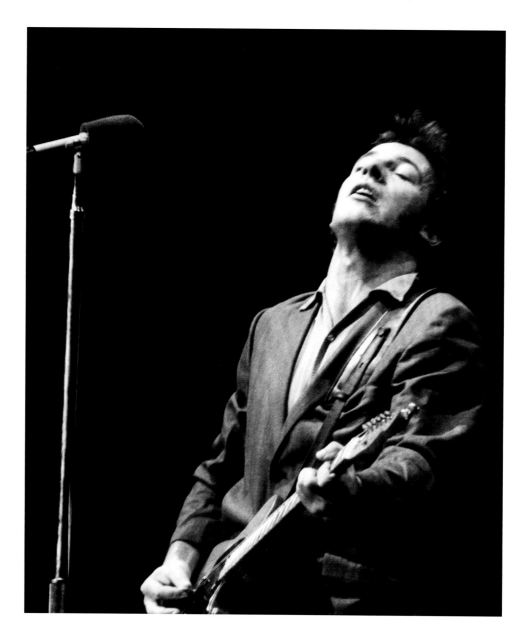

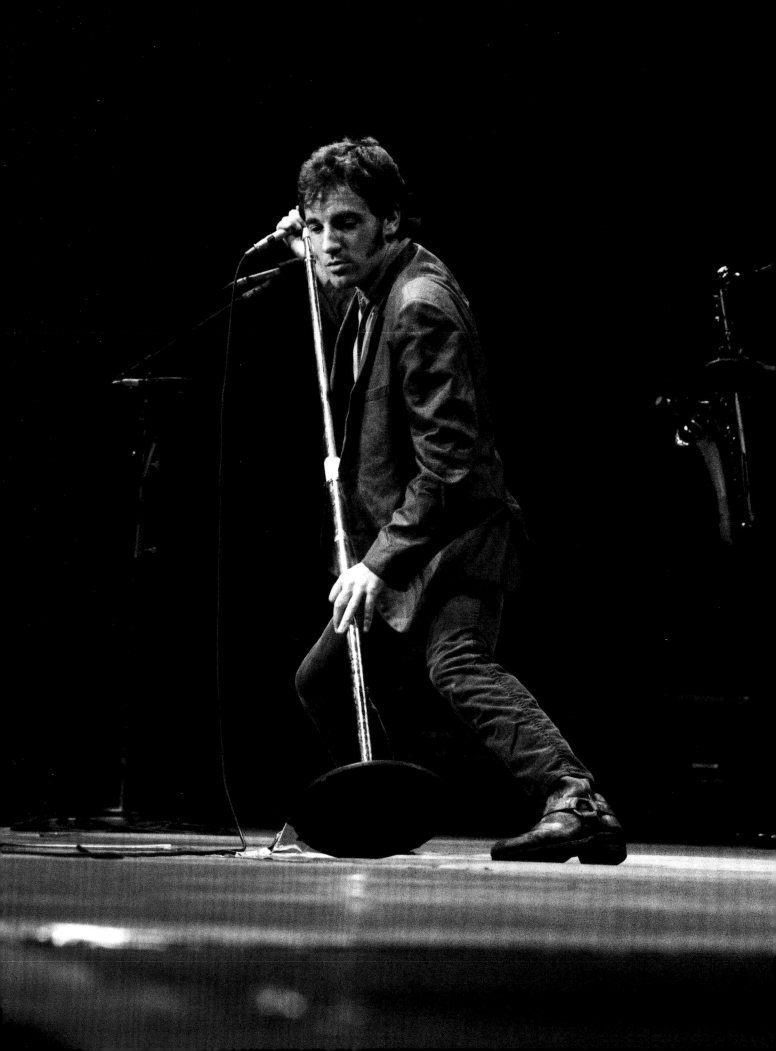

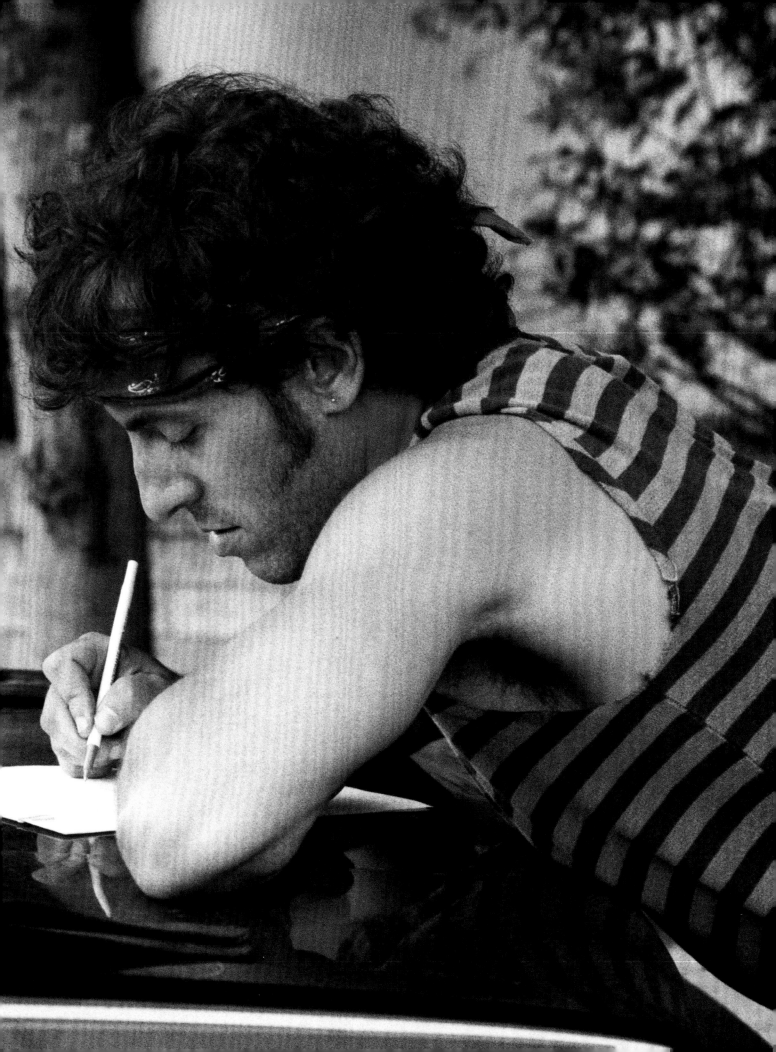

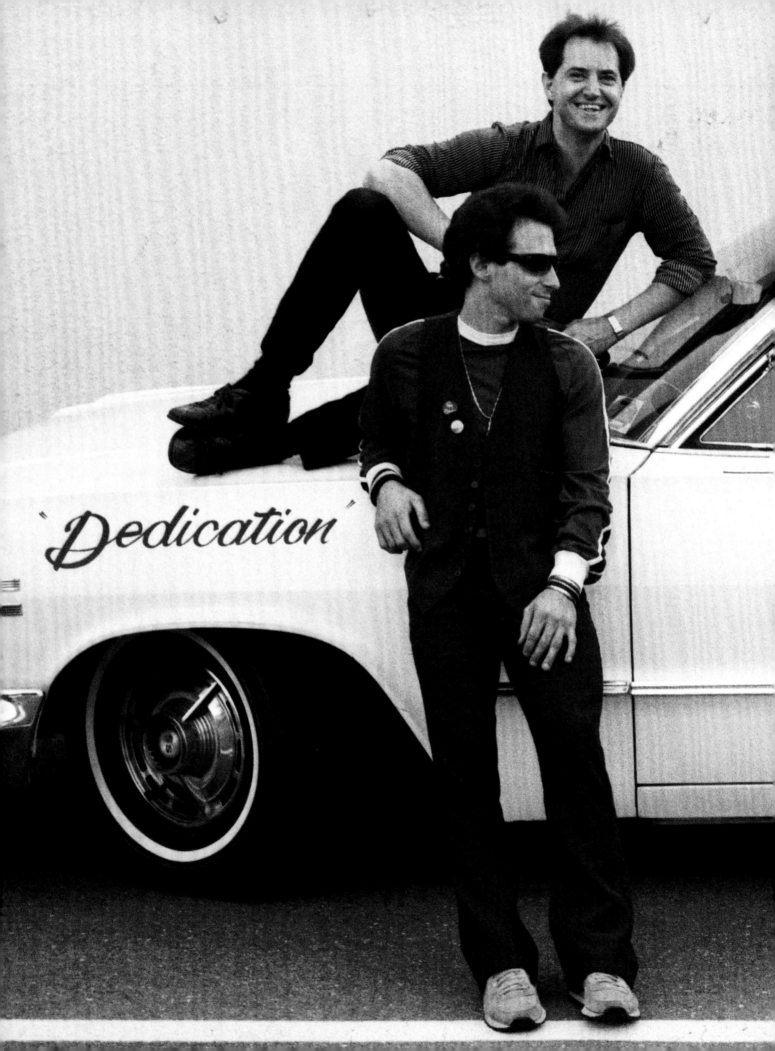

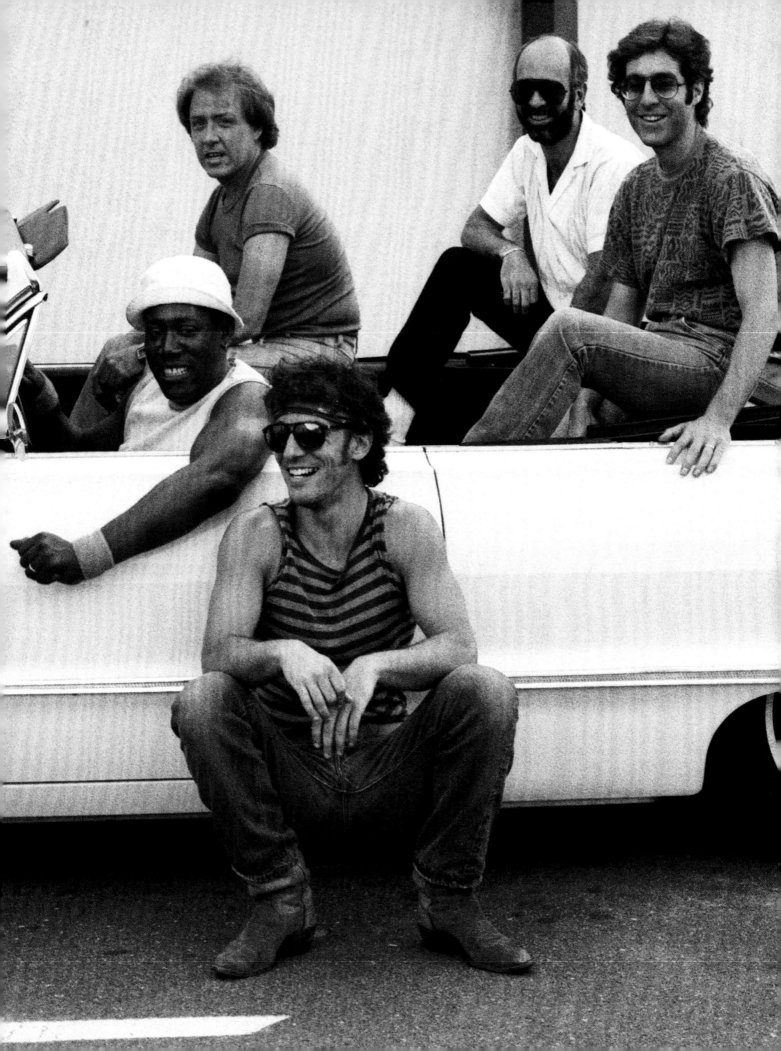

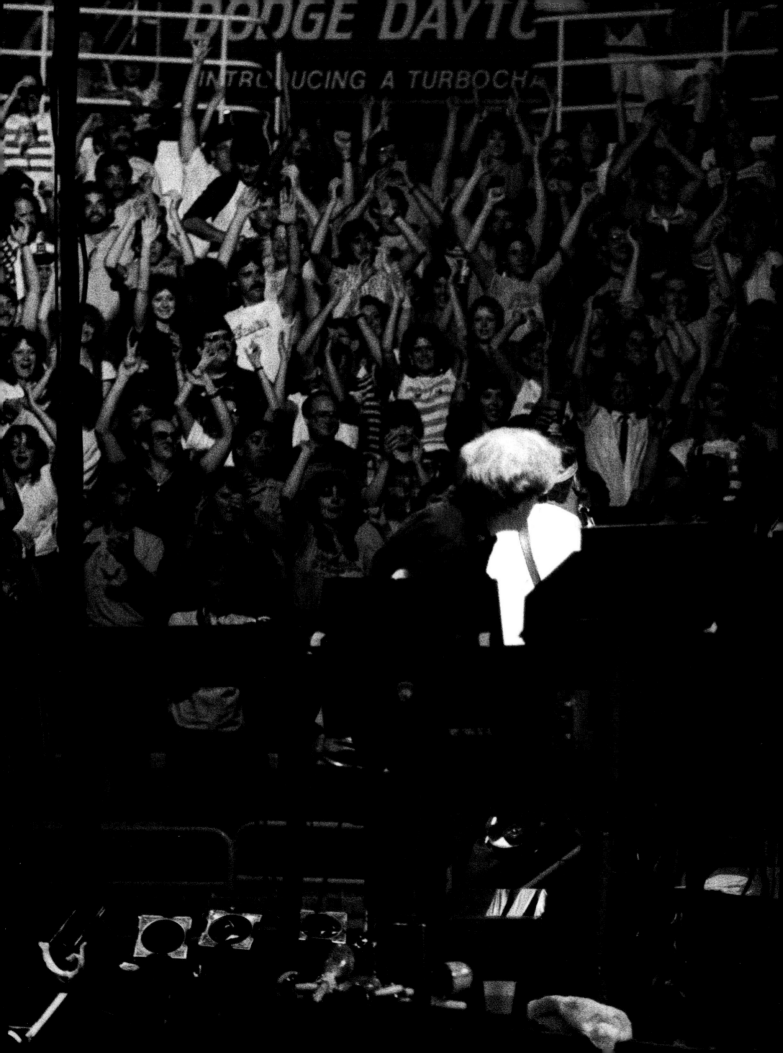

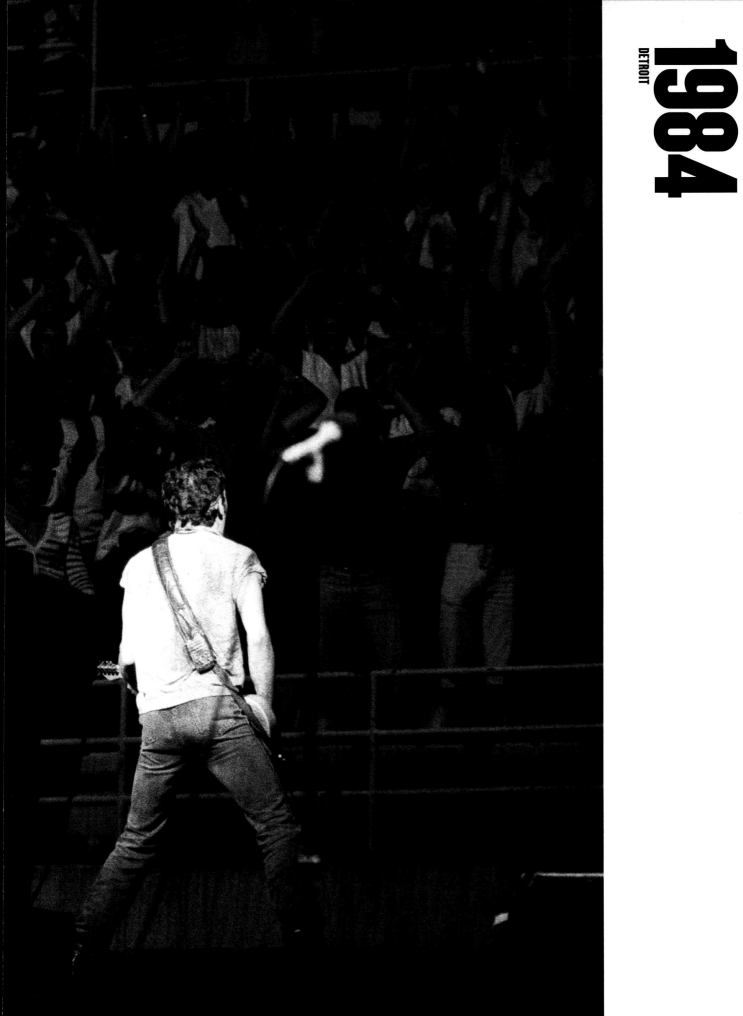

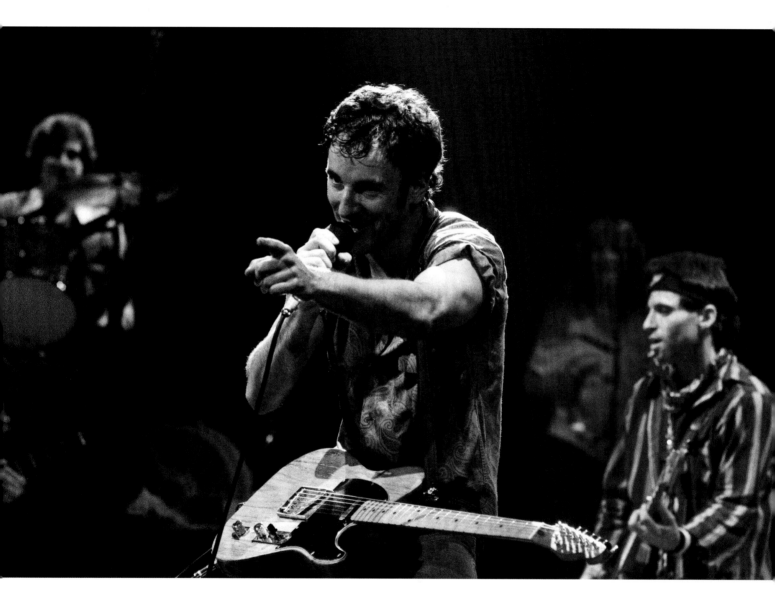

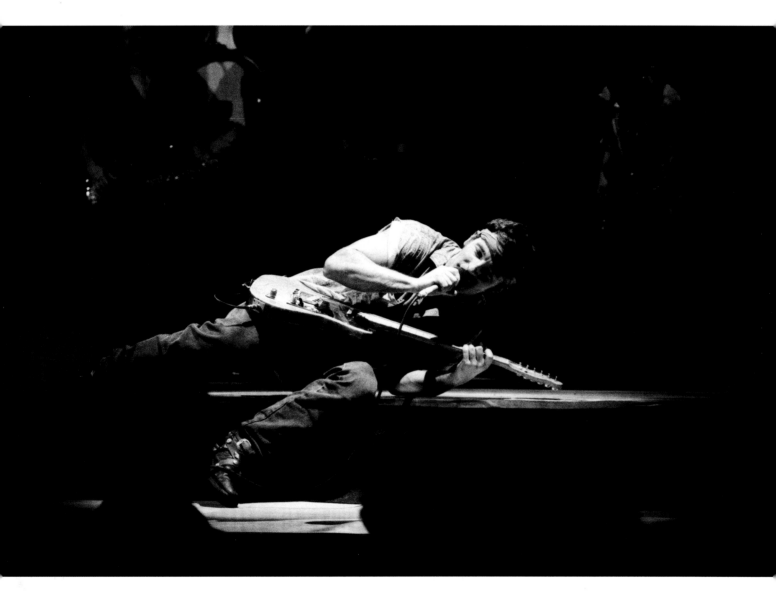

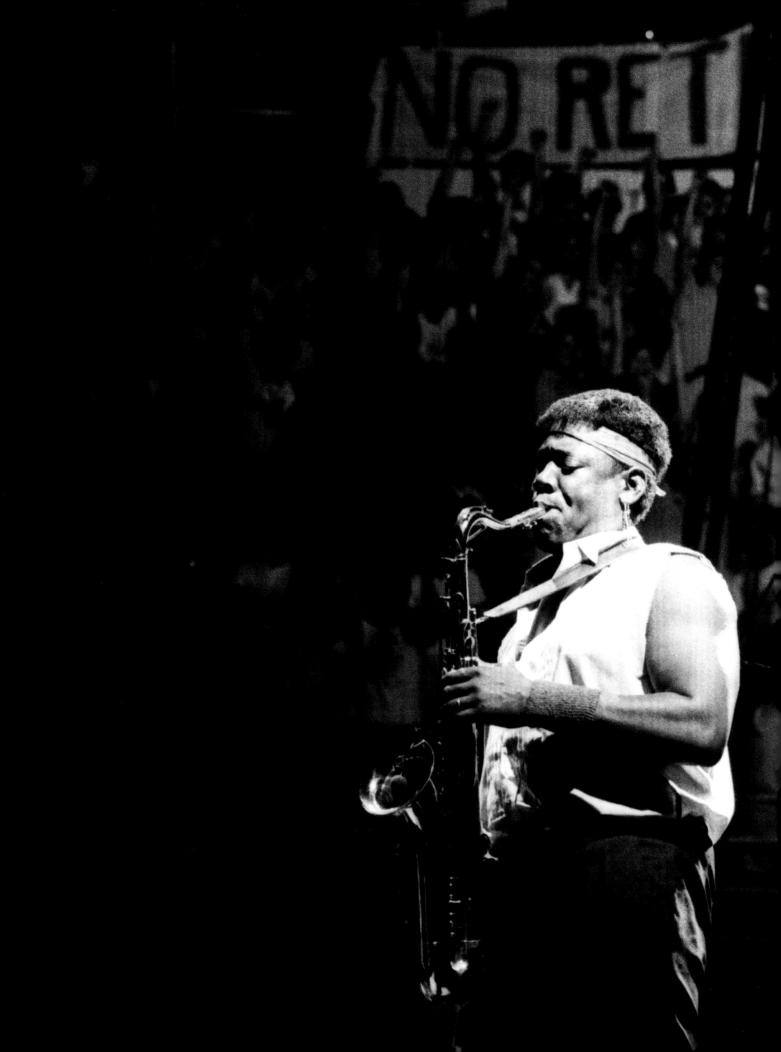

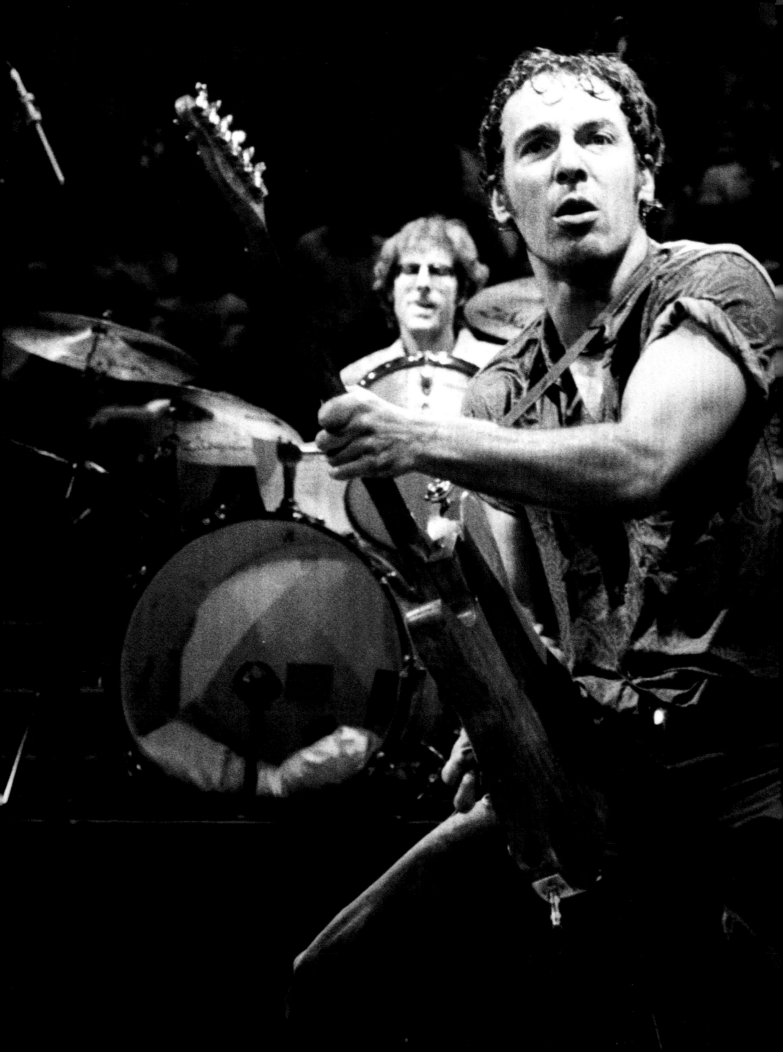

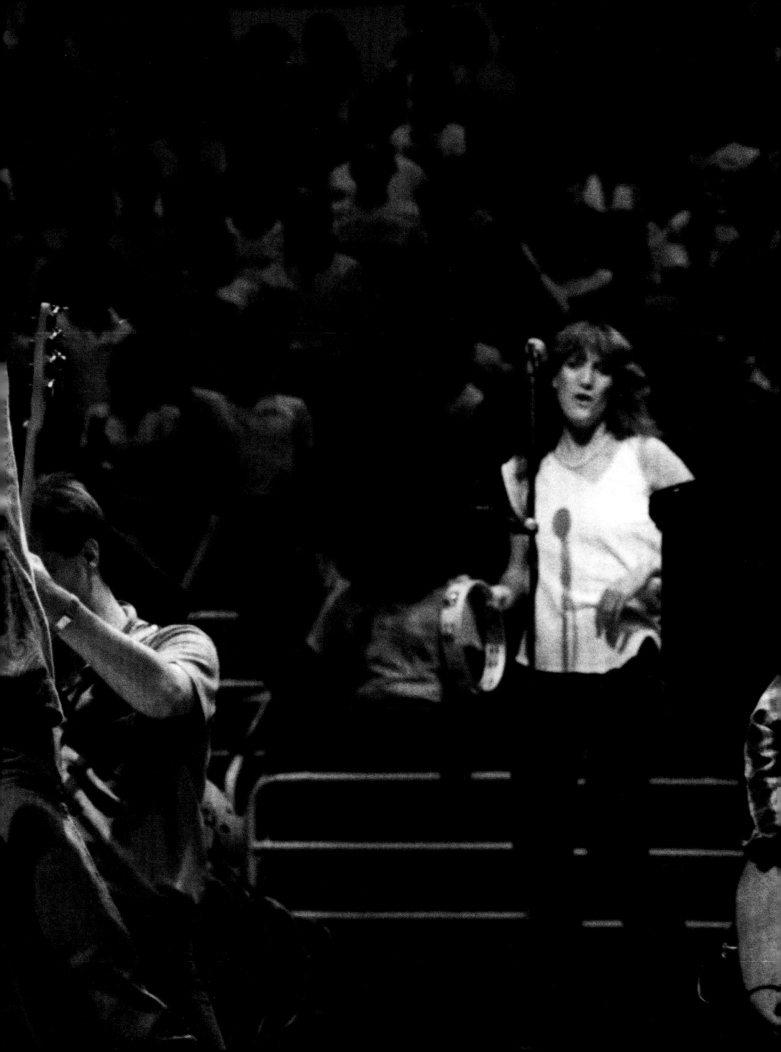

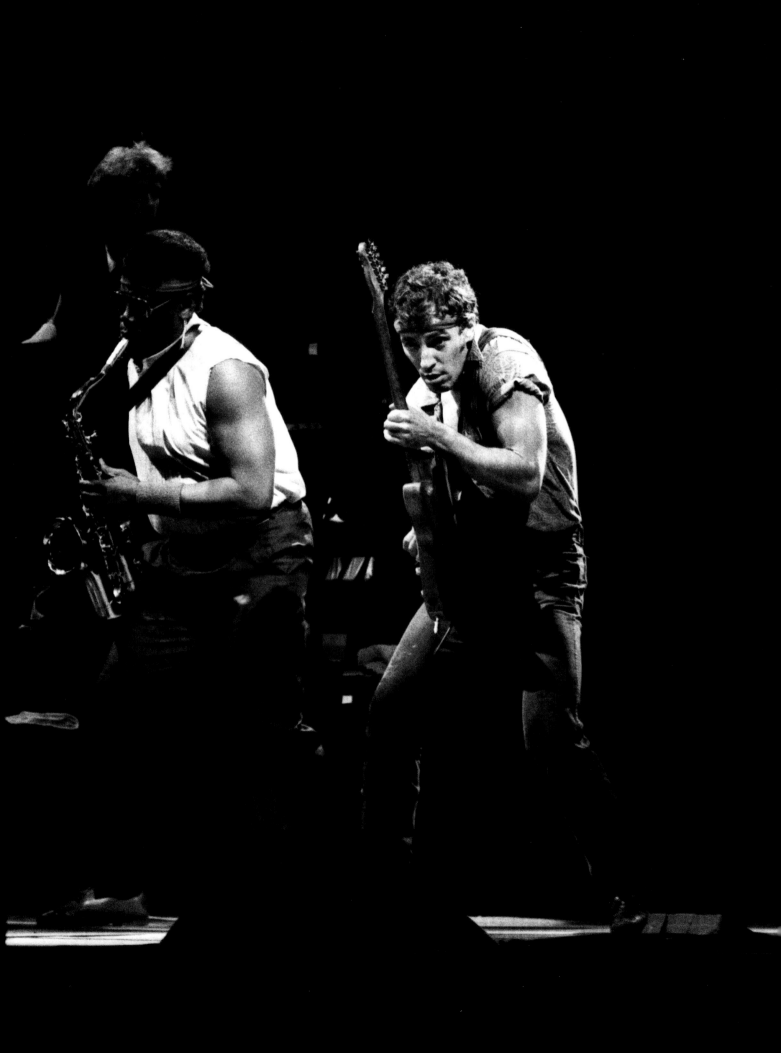

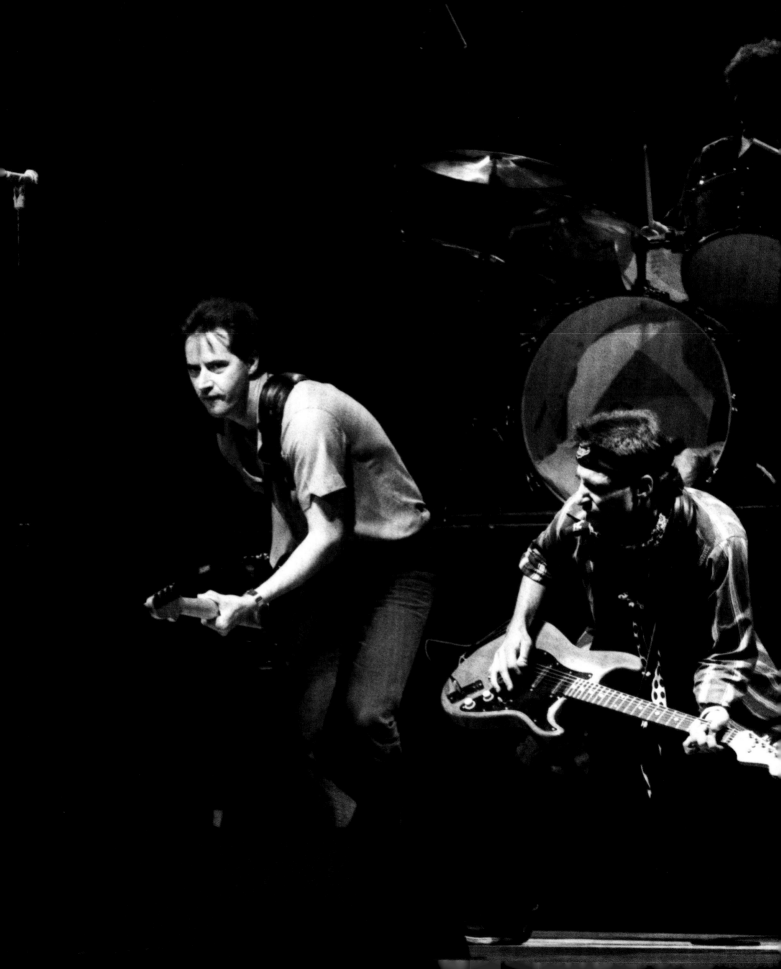

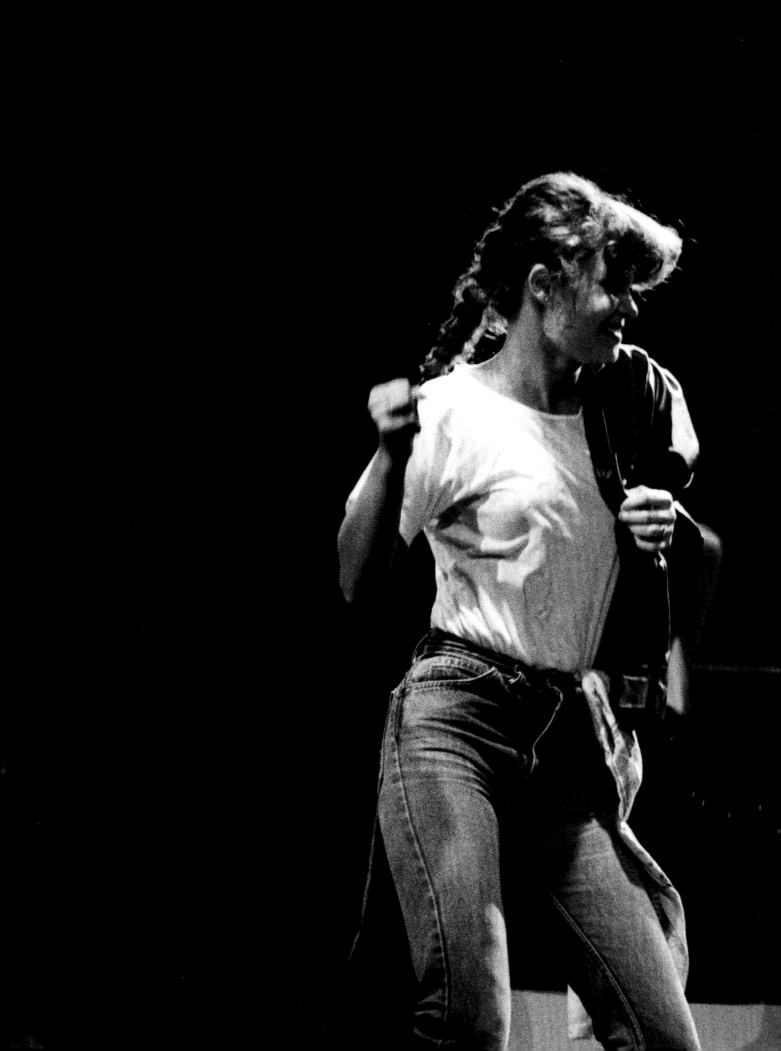

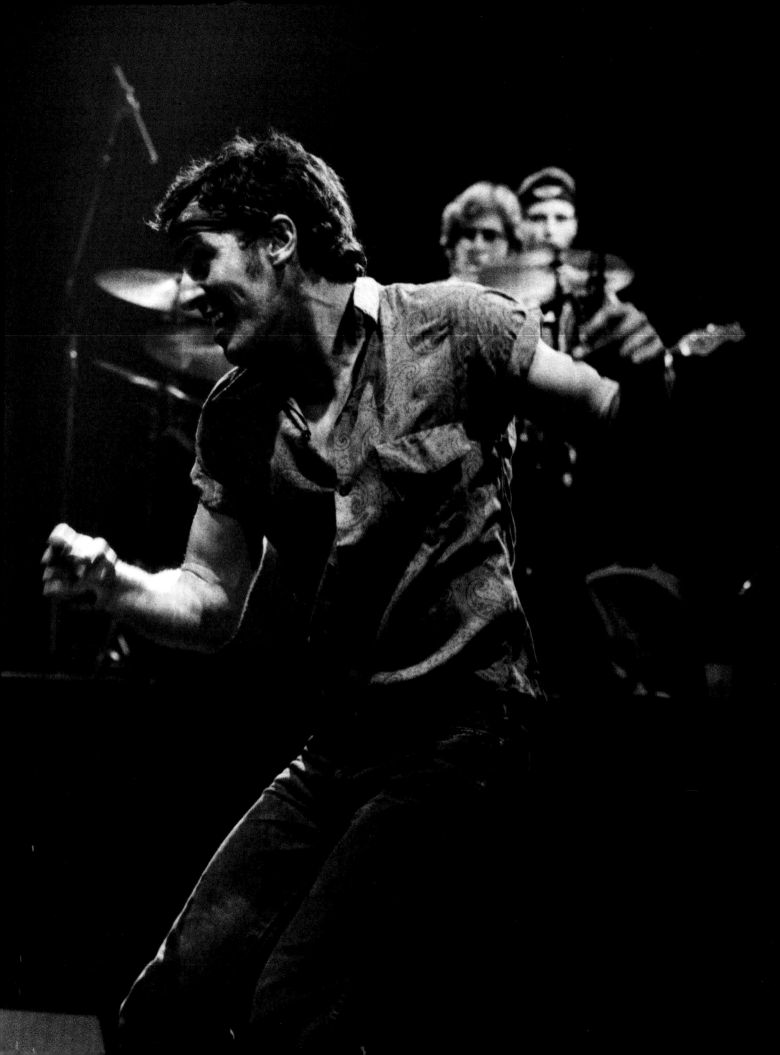

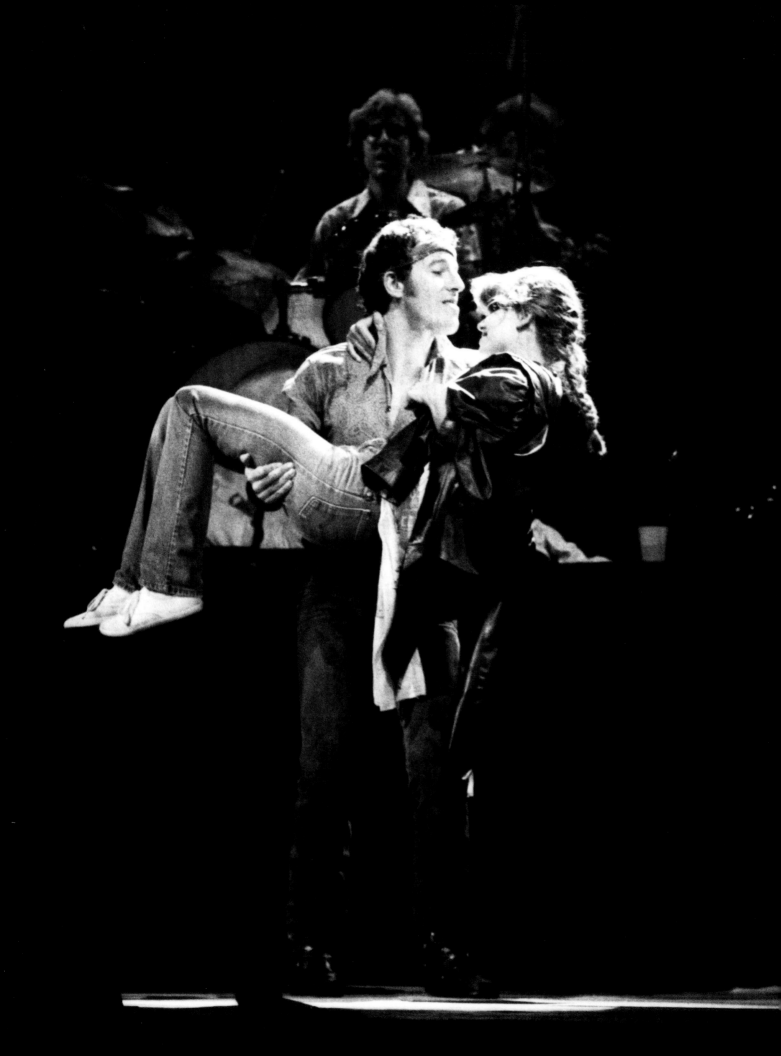

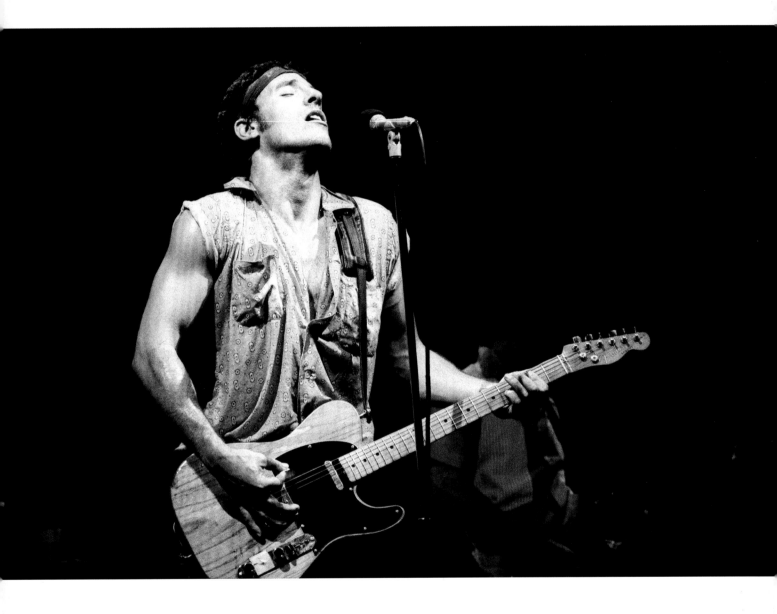

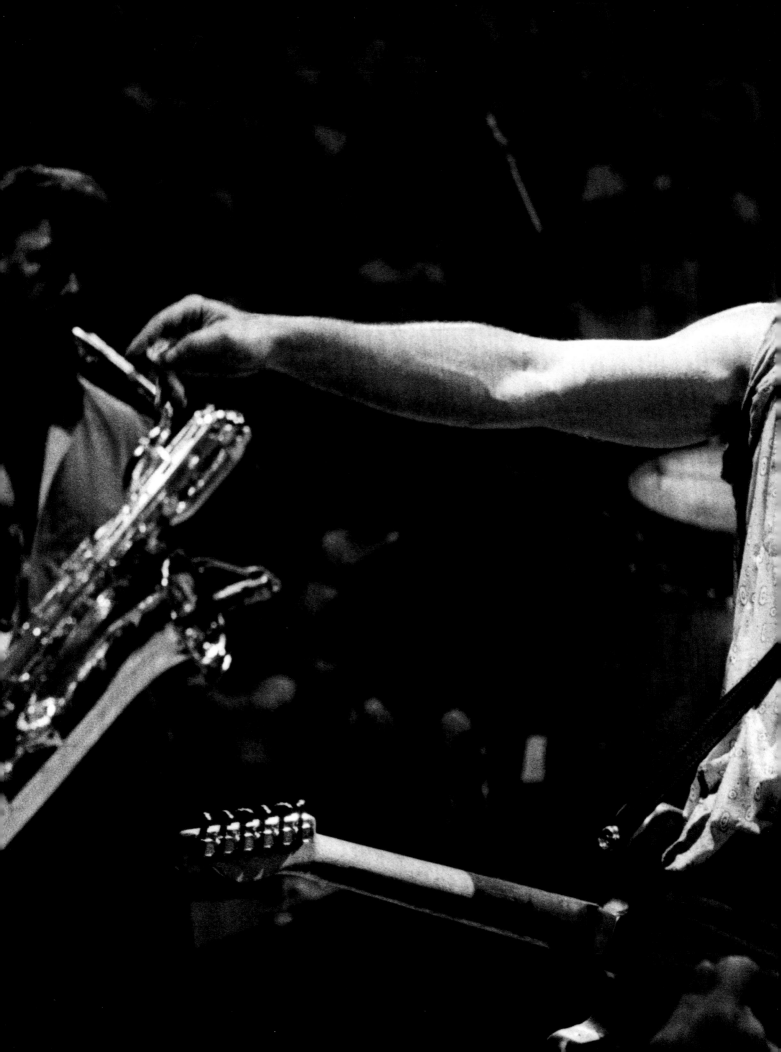

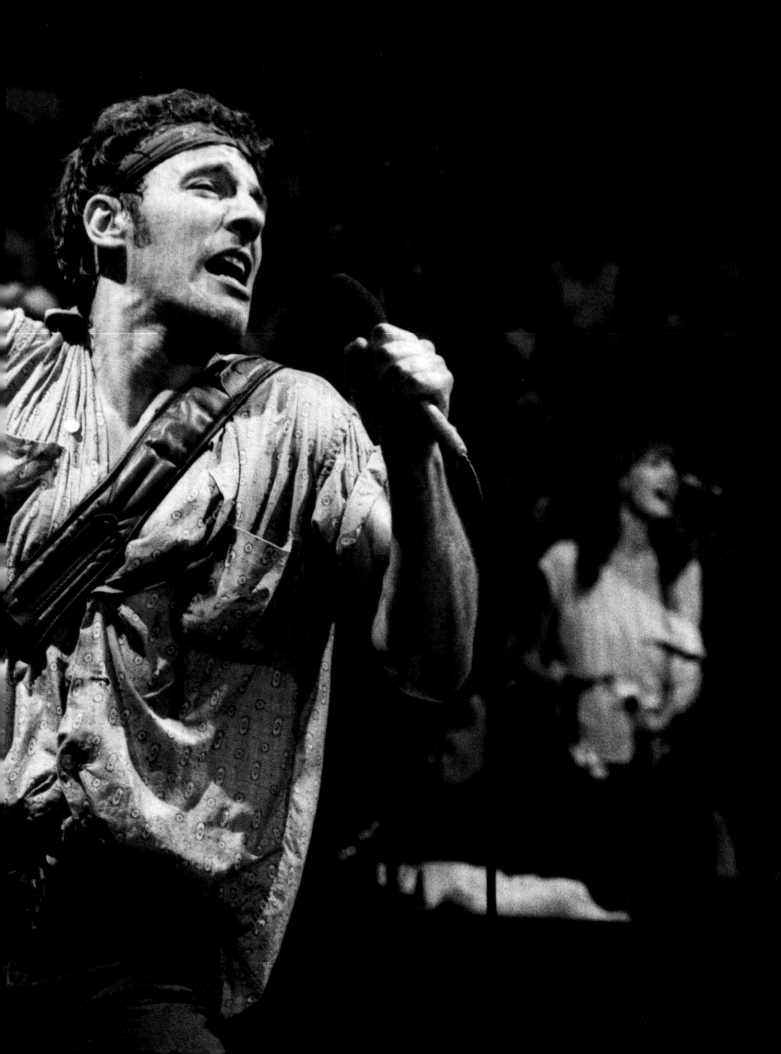

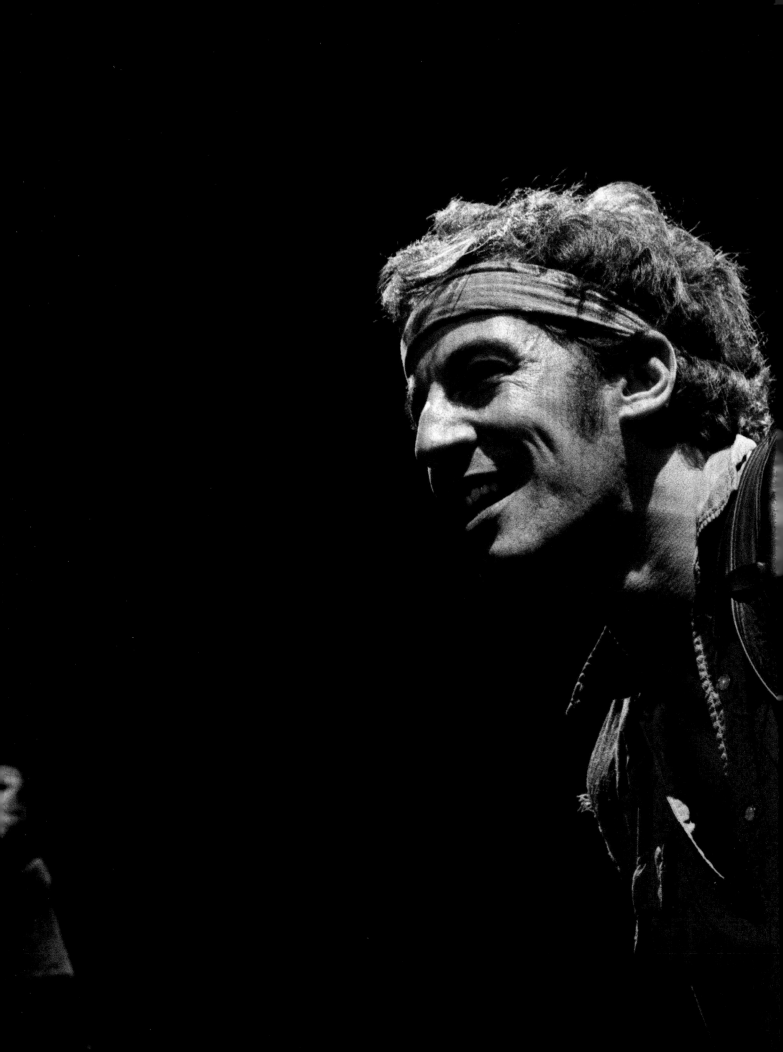

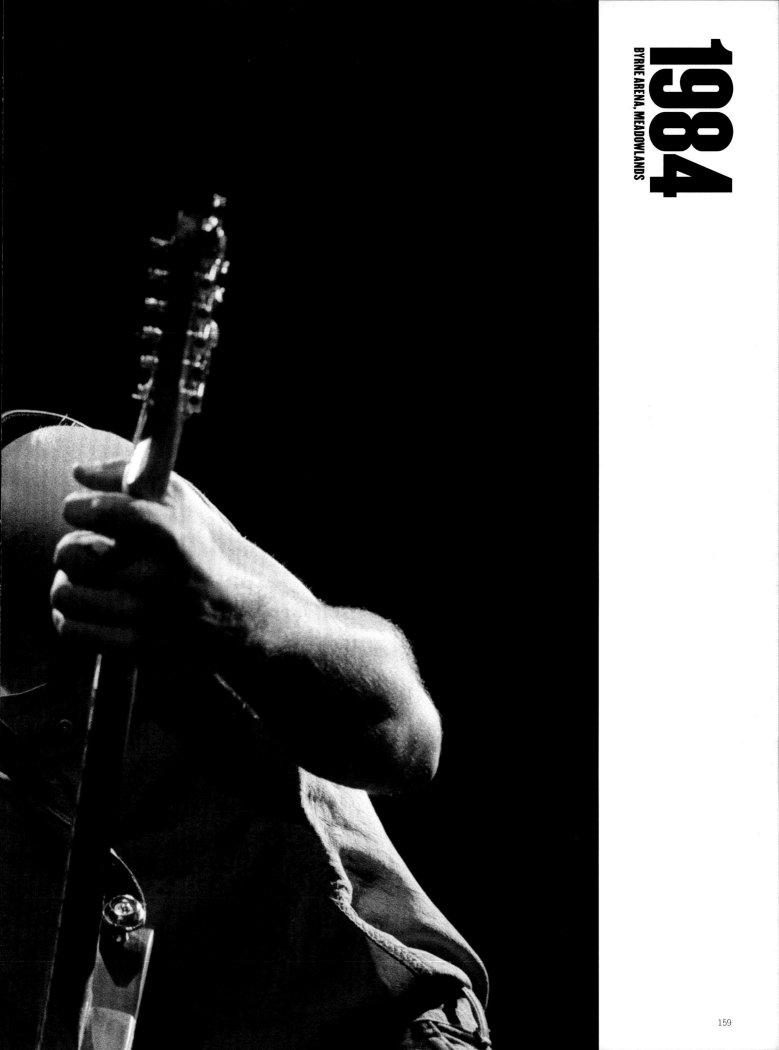

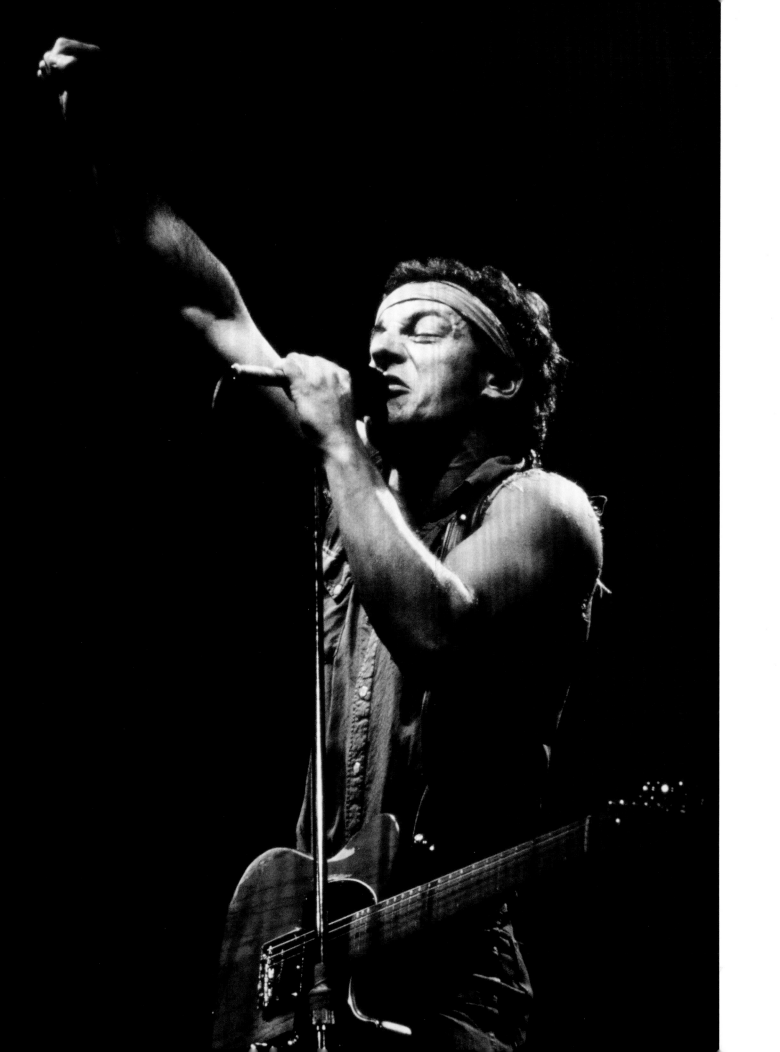

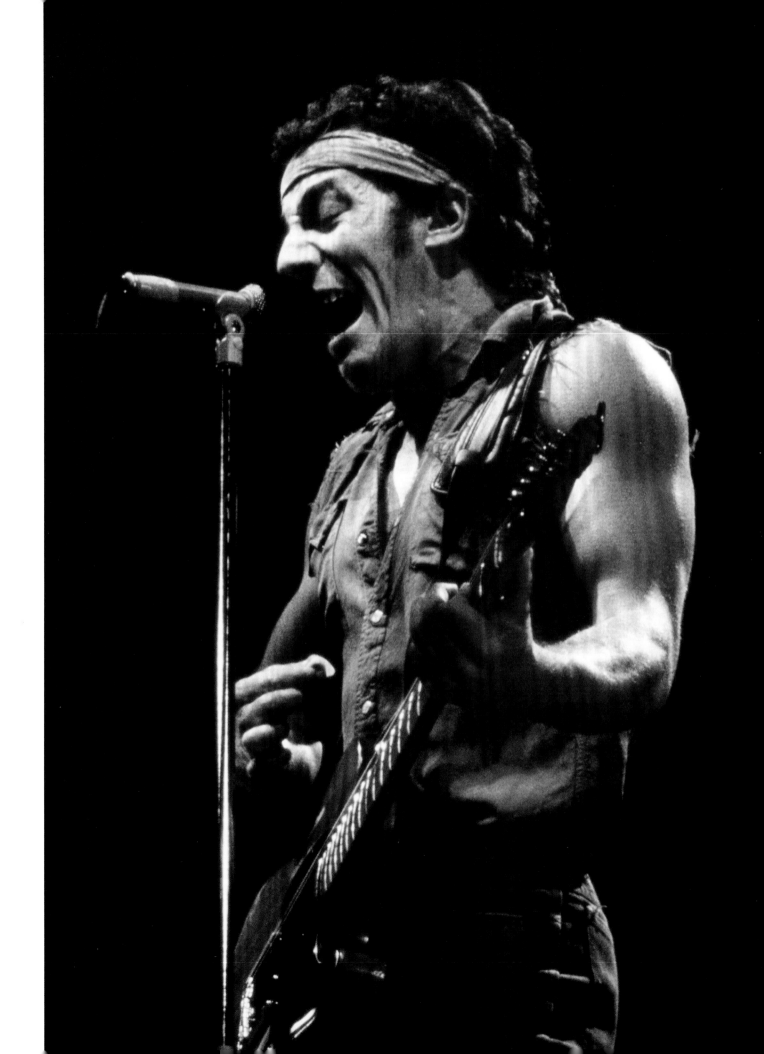

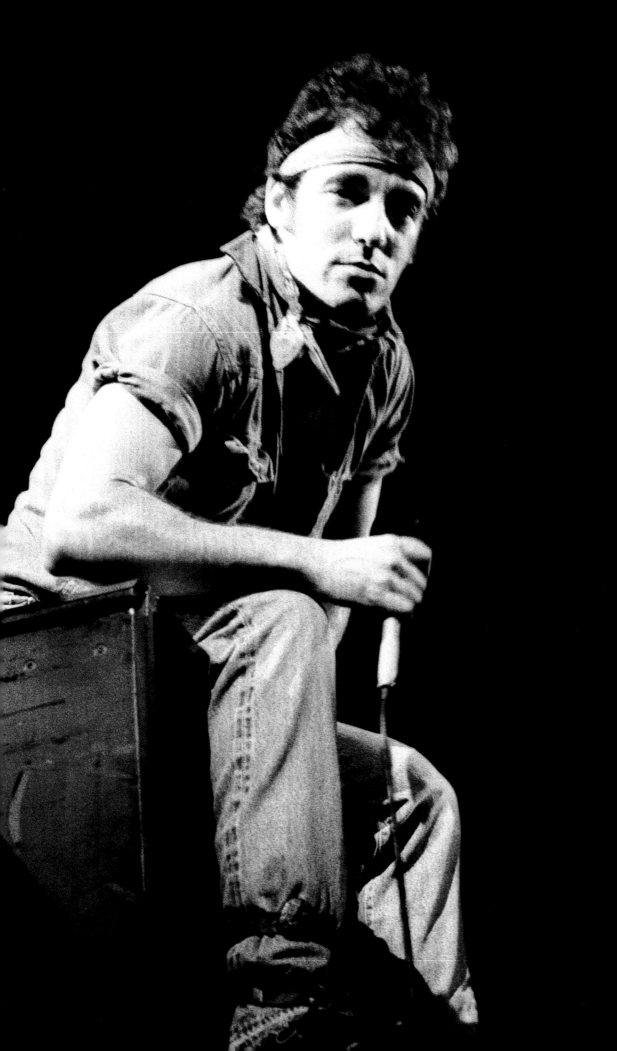

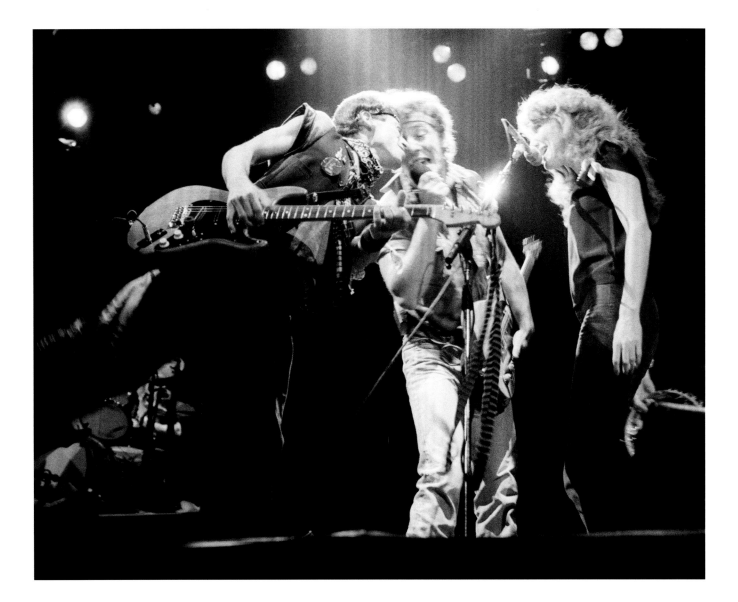

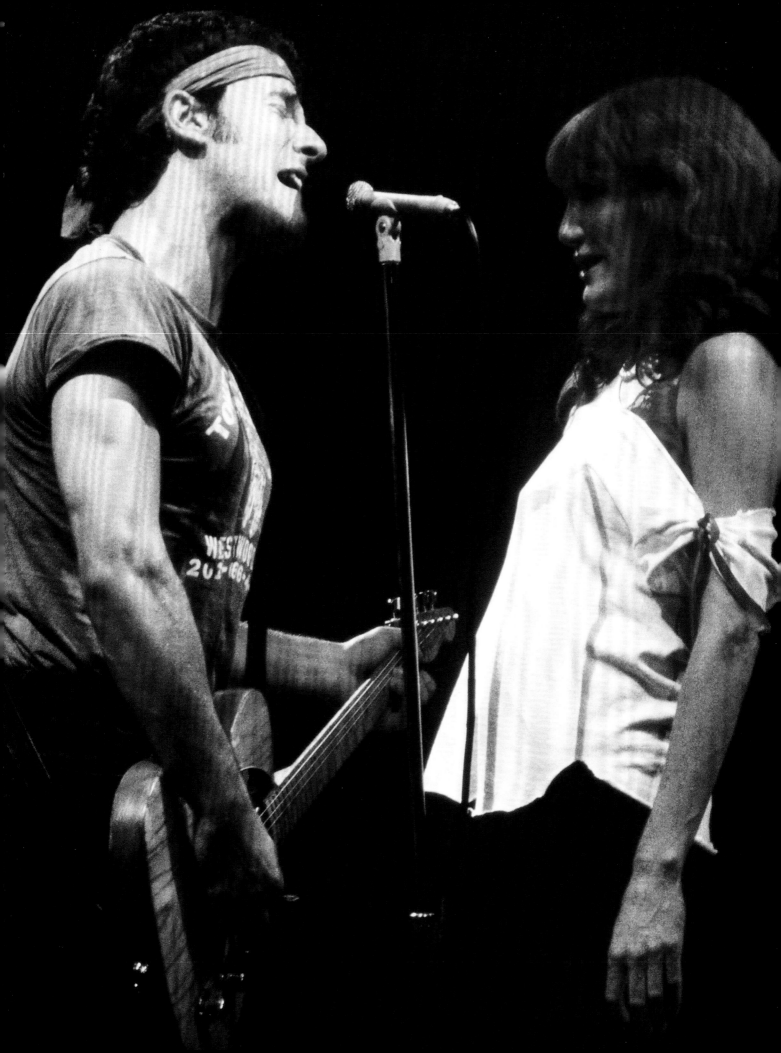

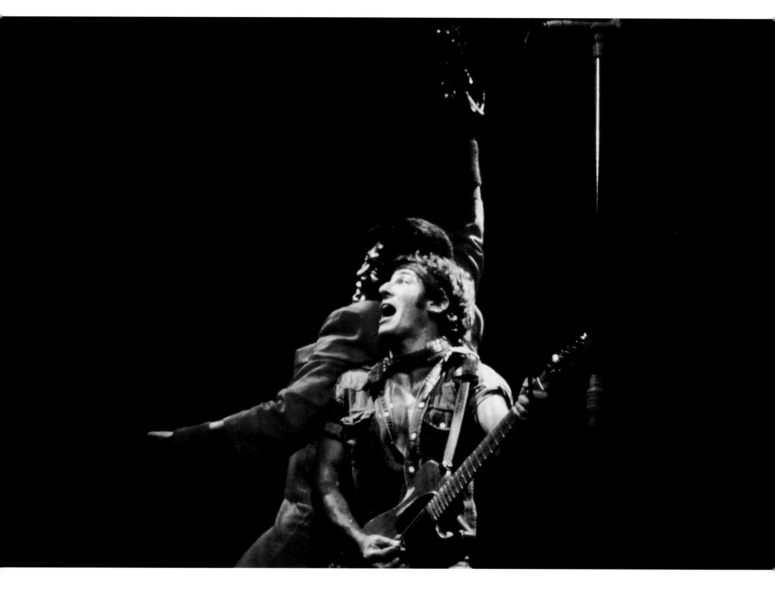

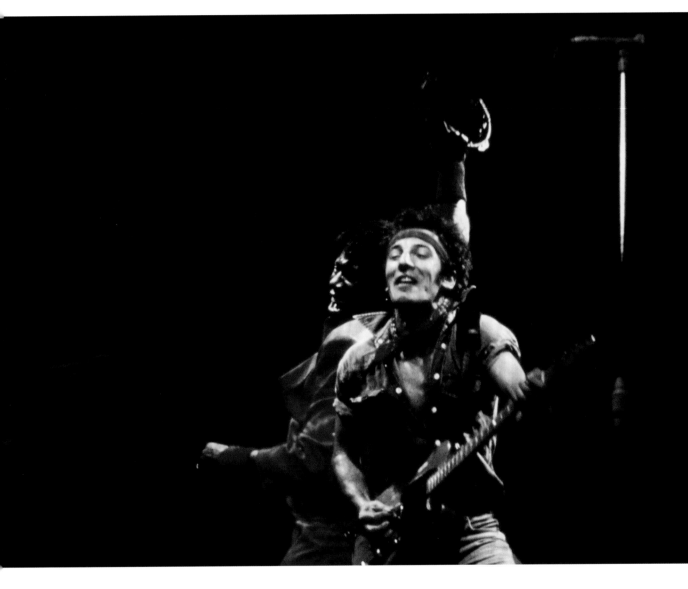

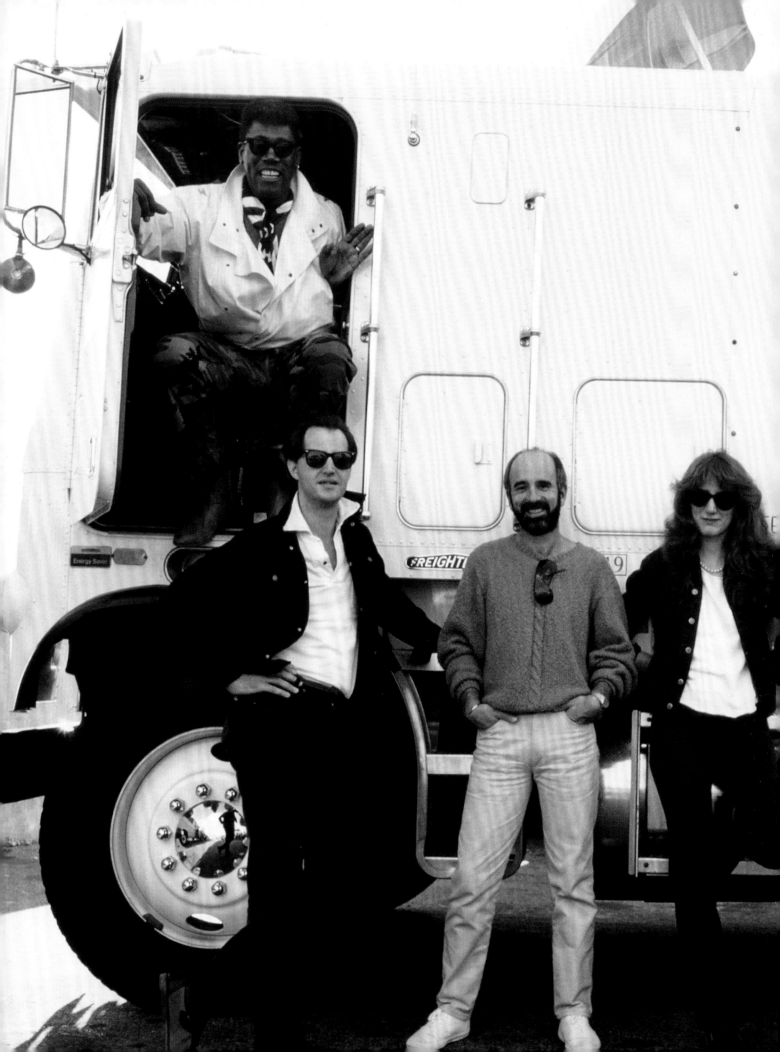

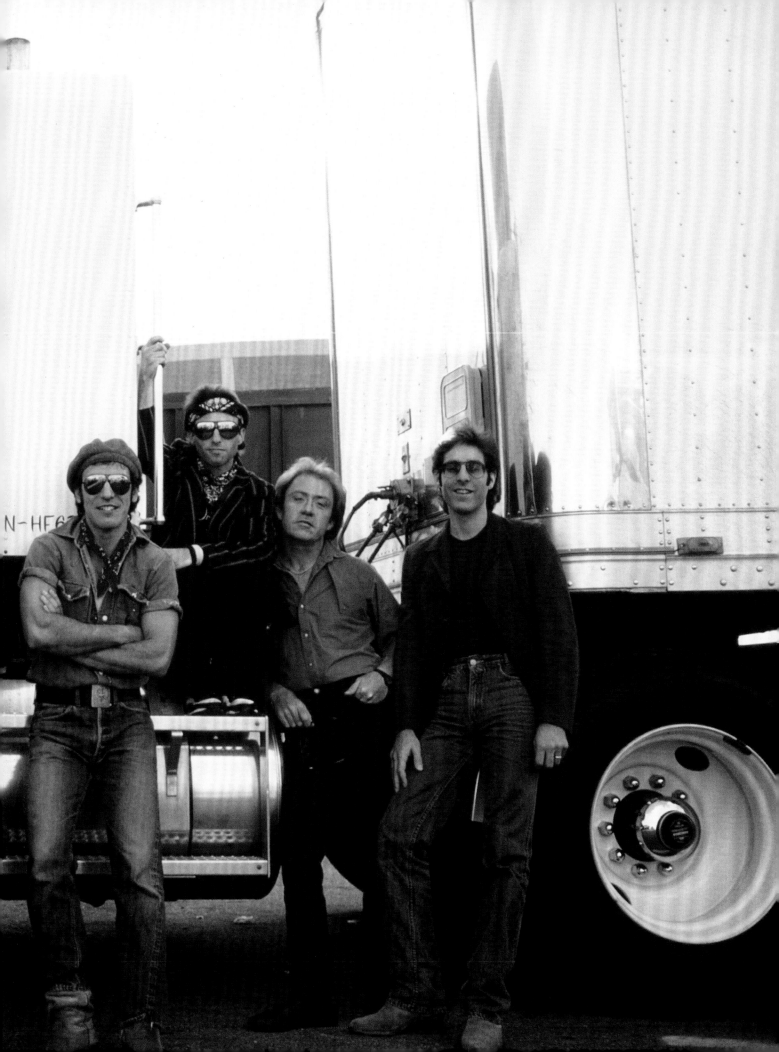

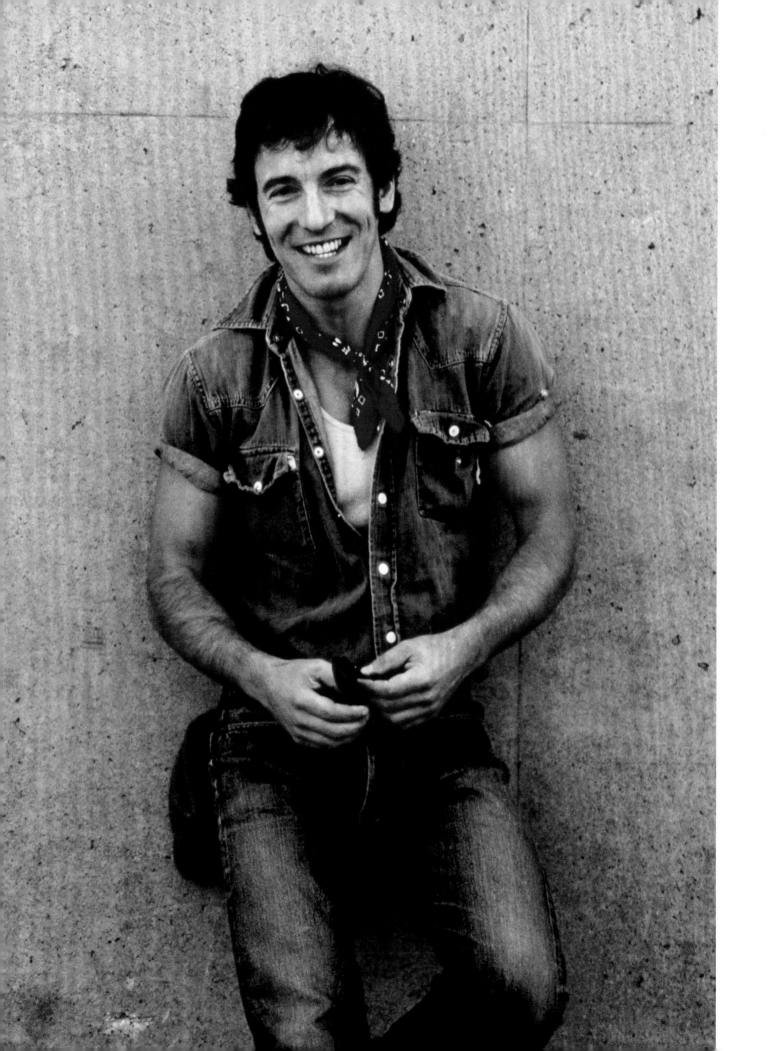

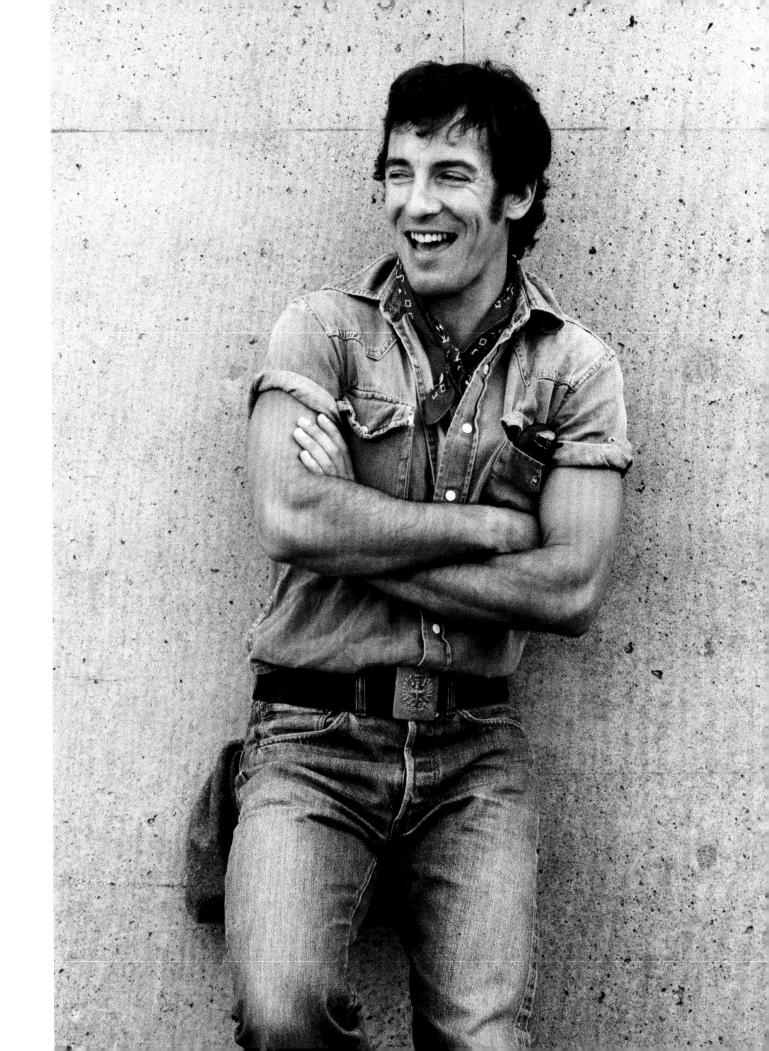

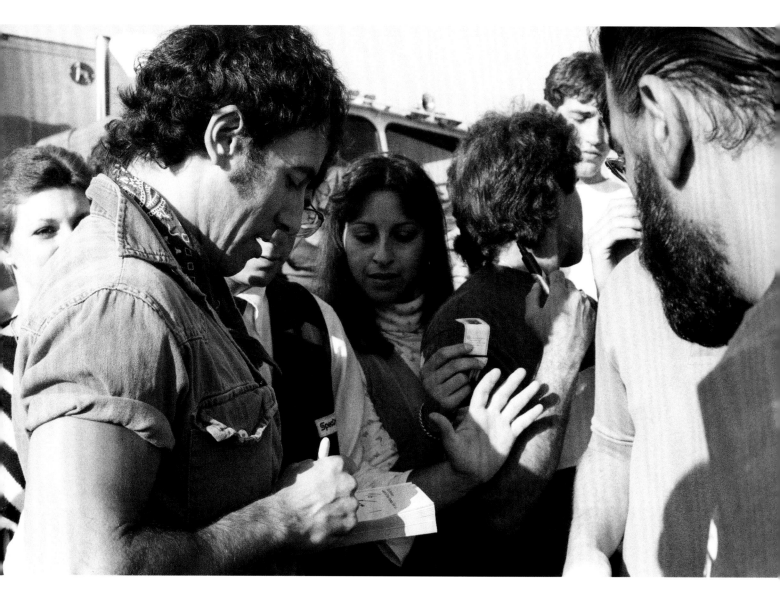

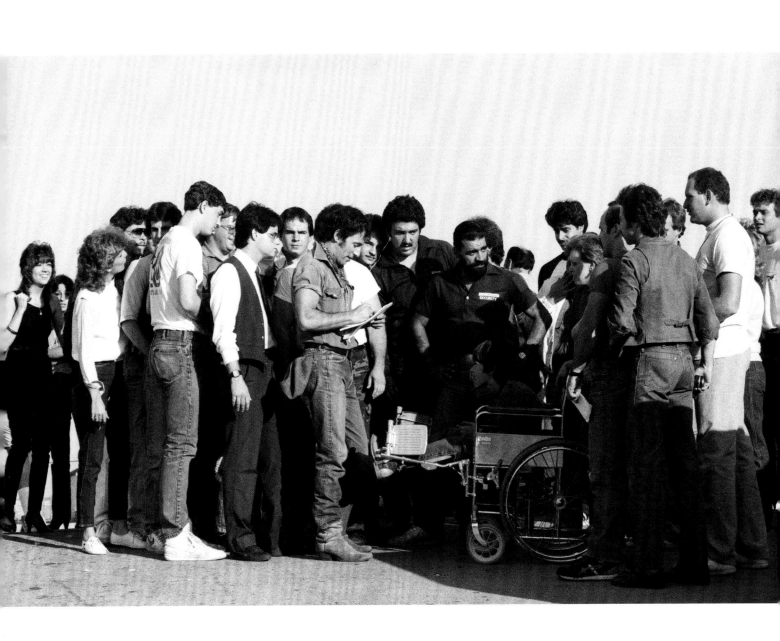

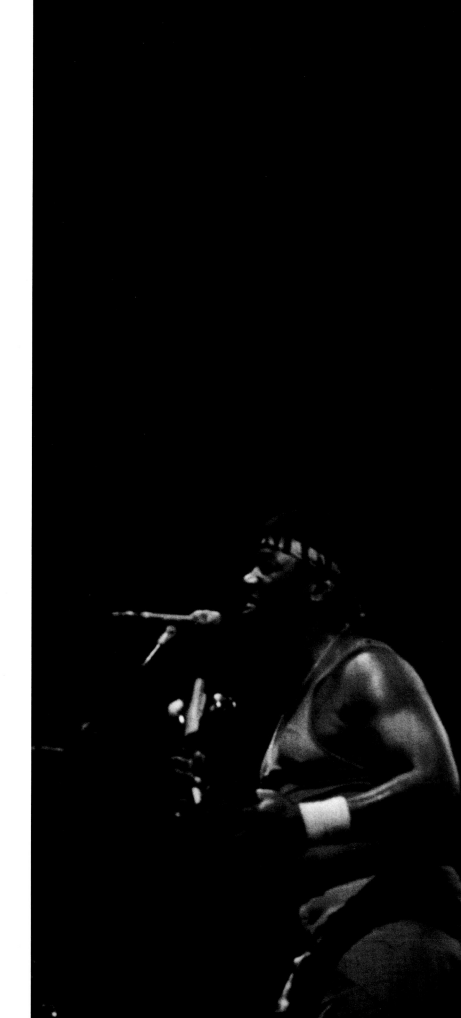

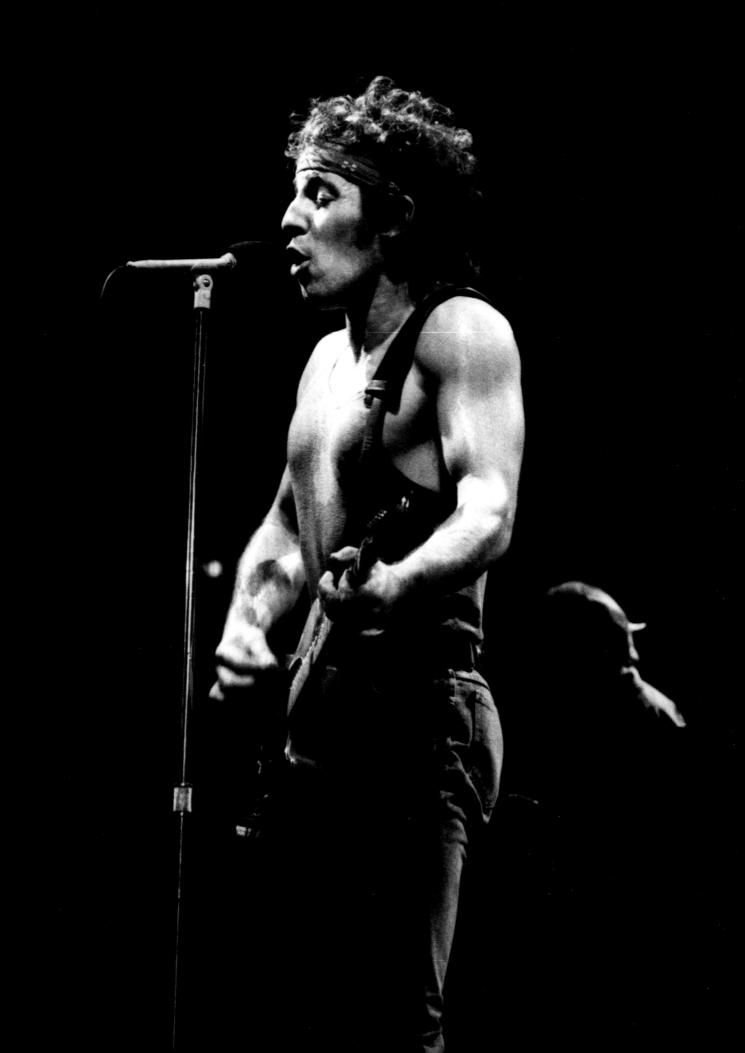

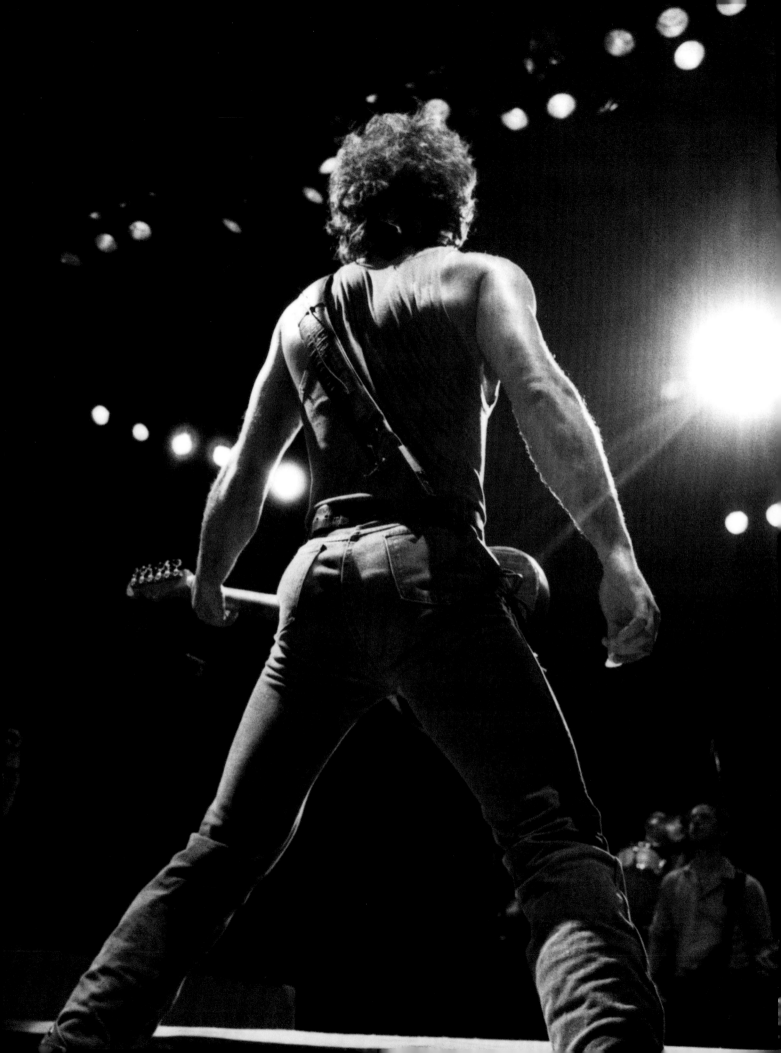

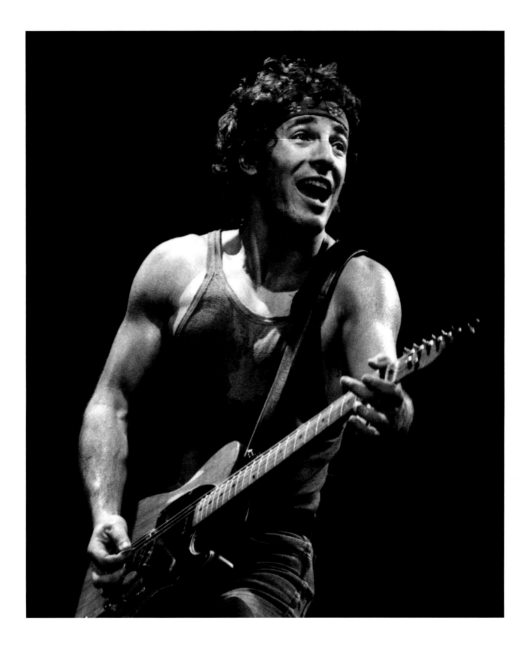

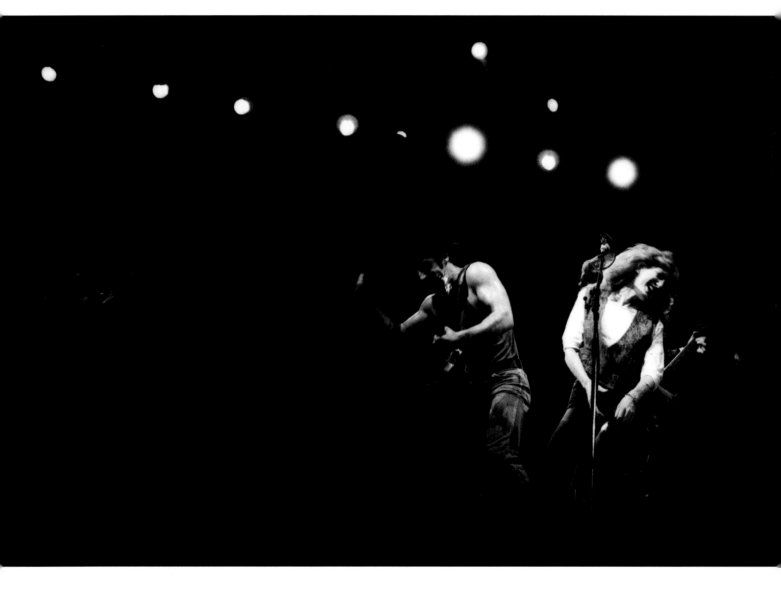

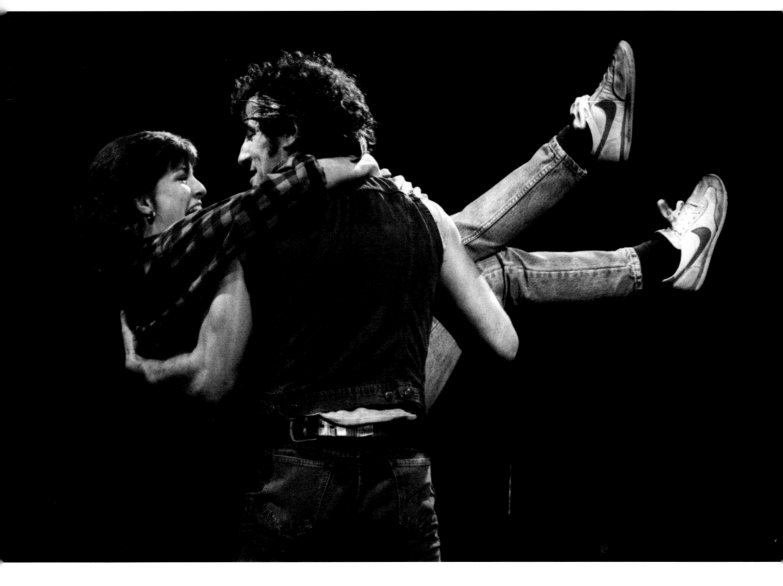

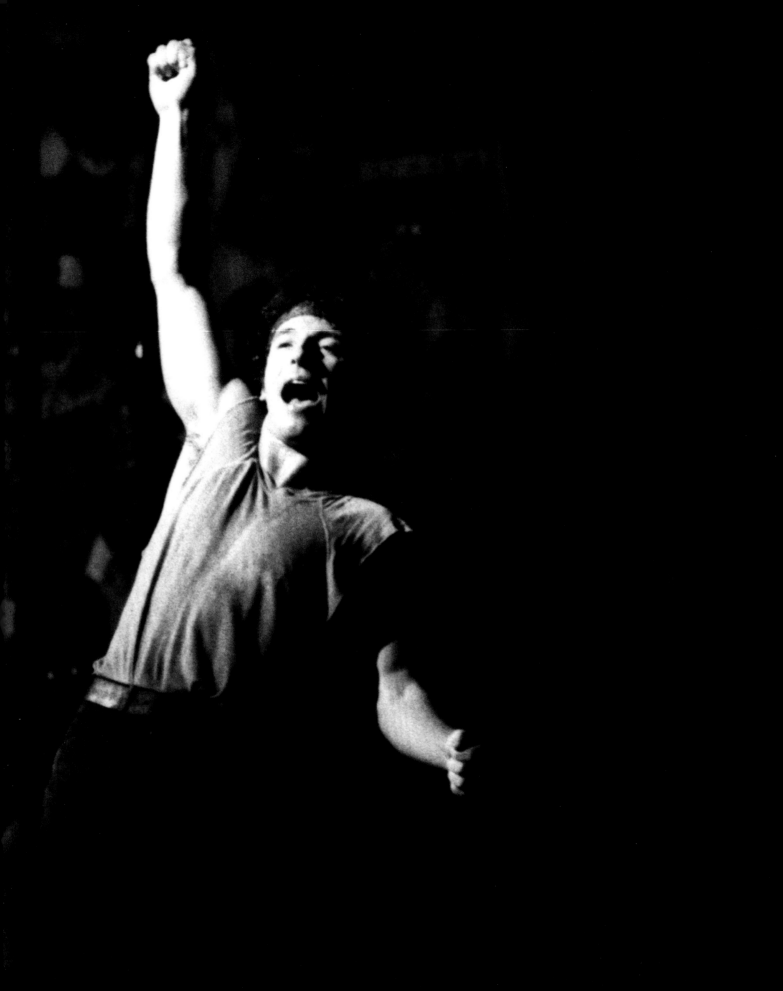

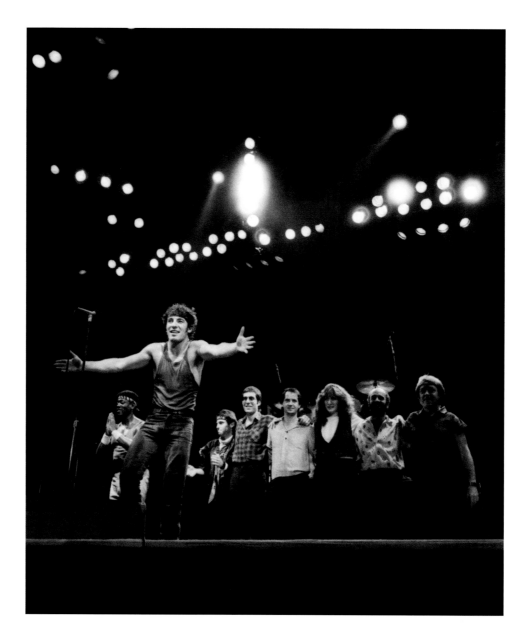

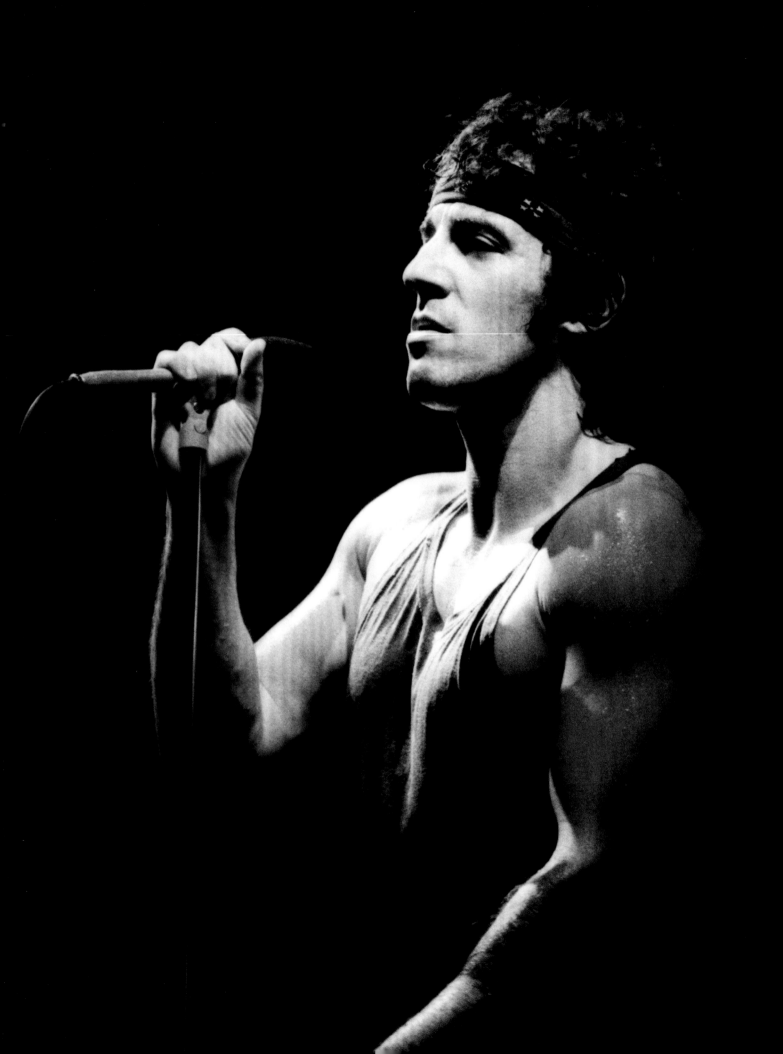

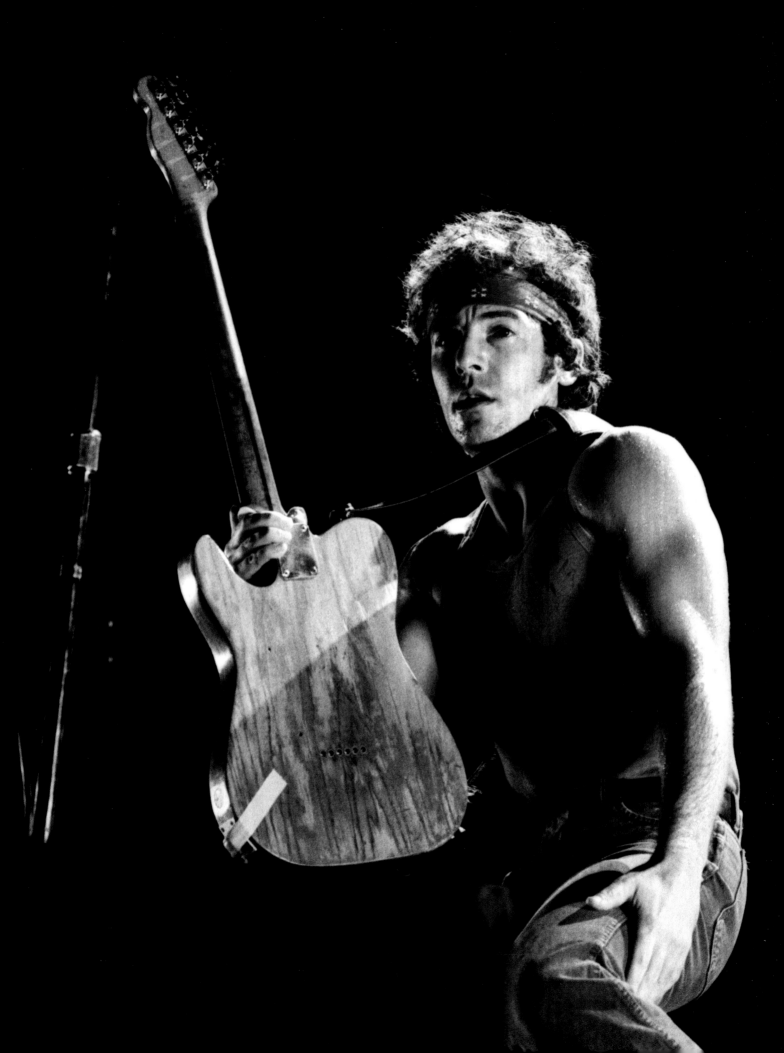

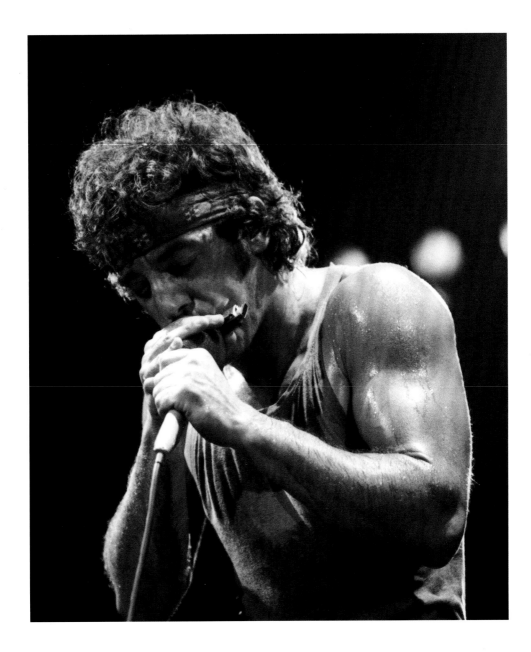

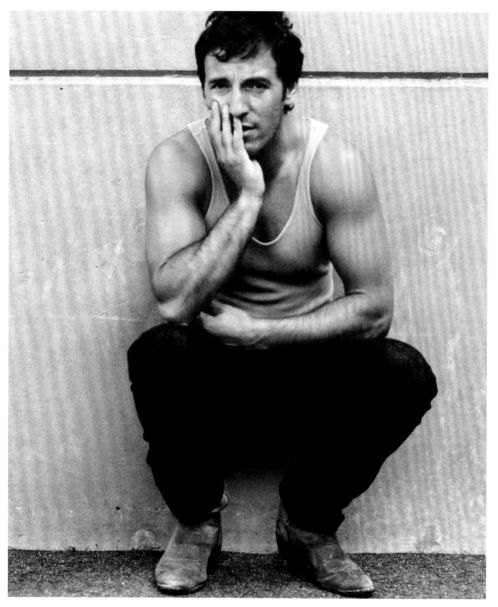

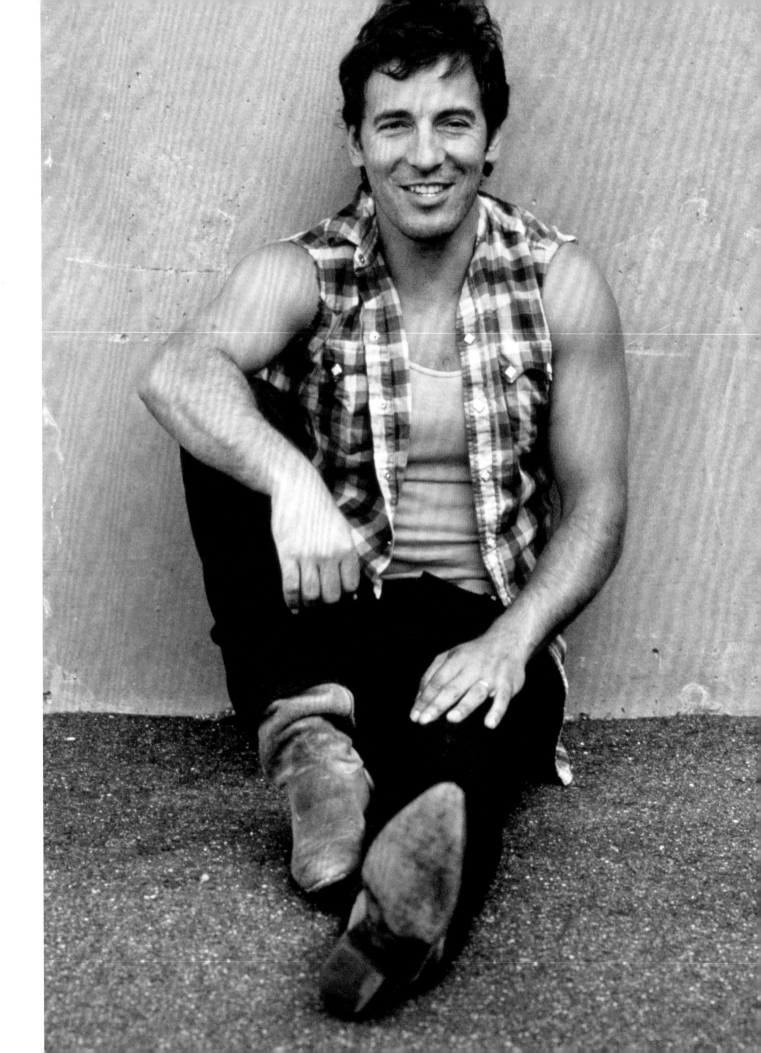

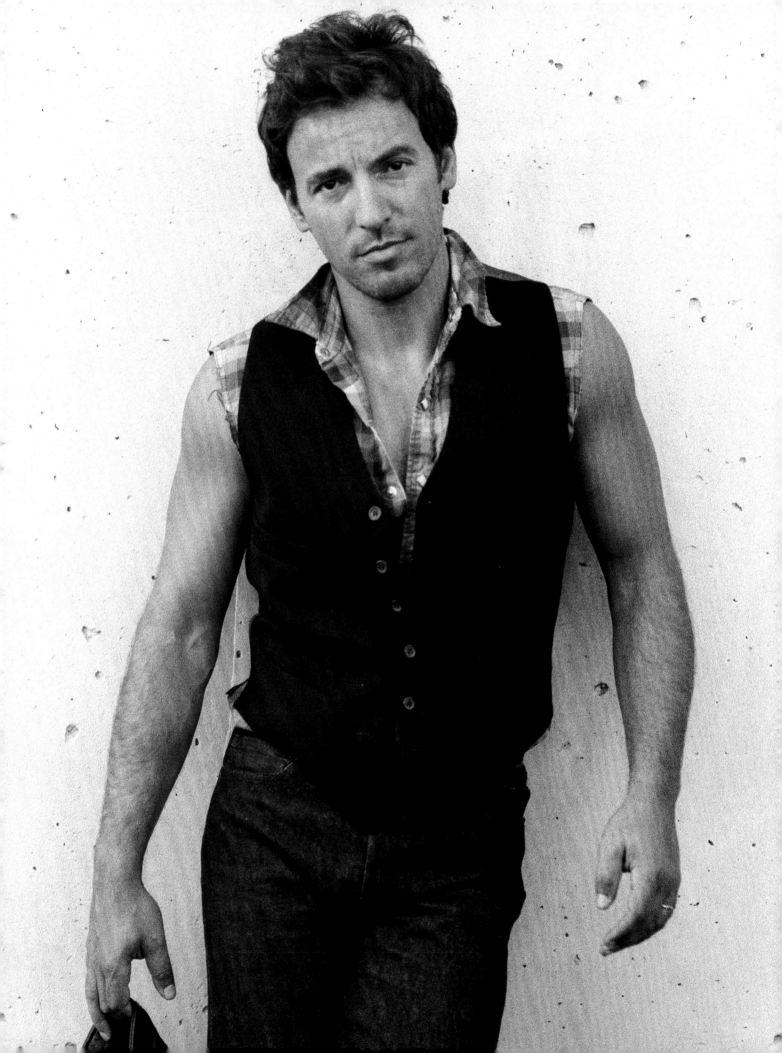

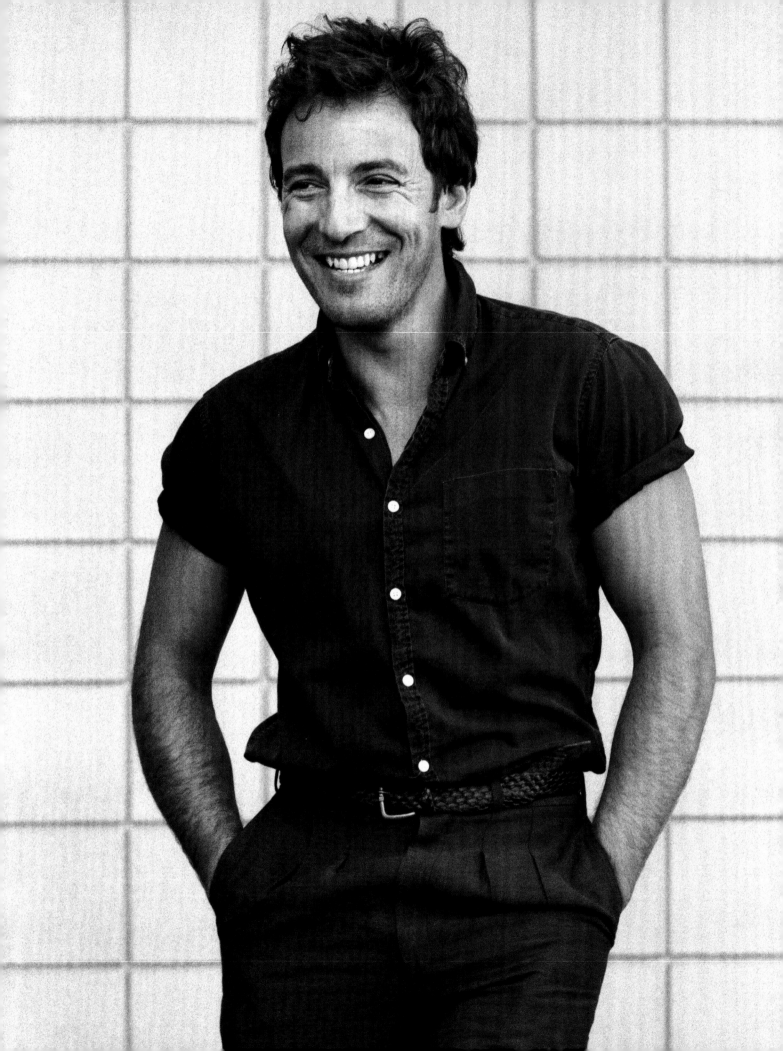

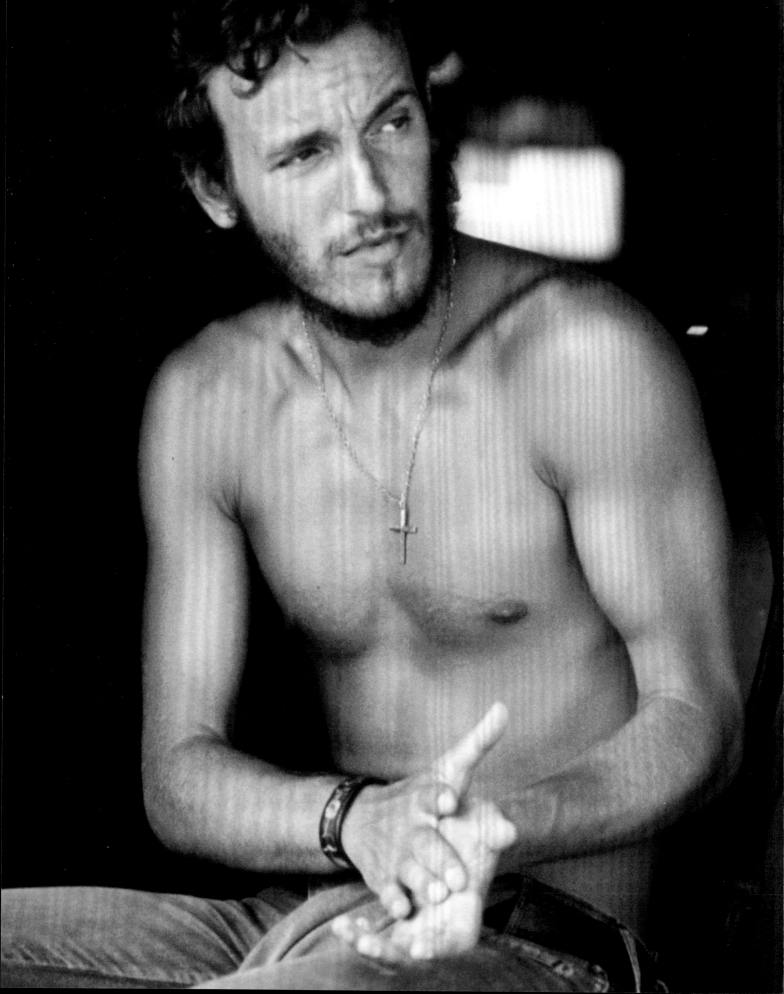

ACKNOWLEDGMENTS

I want to thank Peter Guralnick, author extraordinaire, for putting me and the David Gahr Estate together. Peter's work is always an important inspiration for me. Much thanks goes to Joel Siegel and the Estate of David Gahr. I am grateful to Bobby Ward, David Gahr archivist, whose passion and dedication to David Gahr's photographs is deep. Bobby's work with the Gahr archive has been invaluable to me. Thanks to photographer Daniel Brooks Johnson at the David Gahr Archive for his expert technical assistance.

A warm thank you to Charles Miers, Jessica Fuller, and Maria Pia Gramaglia at Rizzoli. Thank you, Charles, for your vision and for our long association, and to Jessica for guiding this book to publication and for always making it a pleasure to work together. Thank you to Maria Pia for keeping things rolling in Production. A big thank you to Maureen Orth for her foreword to this book. Maureen is a brilliant writer who was there when it all took off for Bruce and the E Street Band. Thank you to Opto Design for the terrific design of this book.

Thank you to my friend and frequent collaborator, photographer Frank Stefanko, for his own great photos of Bruce Springsteen, and for taking me to my first Springsteen concert. I want to also thank photographers Annie Leibovitz, Danny Clinch, Anton Corbijn, Mark Seliger, and Claude Gassian, who let me first show some of their photos of Bruce Springsteen in exhibitions at Govinda Gallery.

A special appreciation to Claire Hines at Govinda Gallery for her steady hand helping me get the job done. To David Murray at Govinda Gallery, ever steady, ever true. I am indebted to Michael Meyer for his constant support and enthusiasm for my work. Thank you to my wife Carlotta and her rock 'n' roll spirit.

I want to thank Bruce Springsteen for being the soul man that he is. And to all the musicians, past and present, in the E Street Band. Most of all, thank you to David Gahr, whose photographs document forever Bruce's promise of things to come and the fulfillment of that promise.

Chris Murray

First published in the United States of
America in 2018 by
Rizzoli International Publications, Inc.
300 Park Avenue South
New York, NY 10010
www.rizzoliusa.com

Rizzoli Editor: Jessica Fuller
Production Director: Maria Pia Gramaglia
Design: Opto Design

2018 2019 2020 2021 2022 / 10 9 8 7 6 5 4 3 2 1

Printed in China

ISBN-13: 978-0-8478-6234-4
Library of Congress Control Number: 2017947375

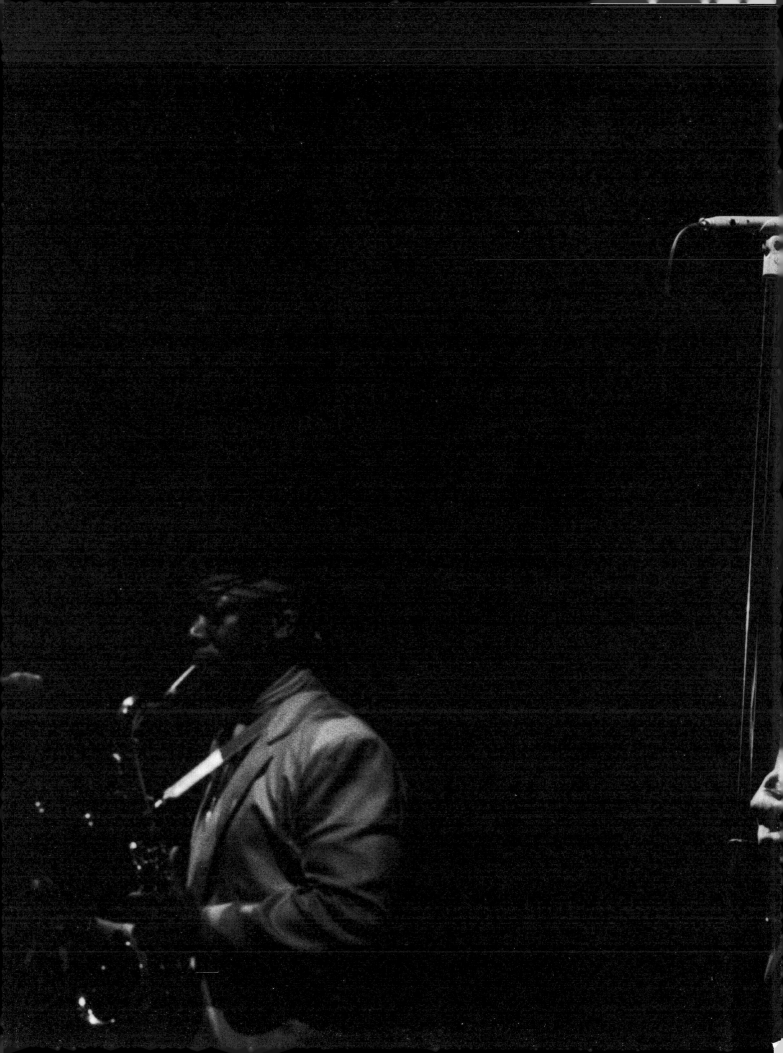